WHILE THE FIRES BURN

NEVADA RARIA. NEVADA HUARAPASCA. NEVADA HUAYACU. NEVADA GAJAP.
LOOKING NORTH FROM GLACIAR PASTORURI. CORDILLERA BLANCA. PERU
13 JANUARY 2016

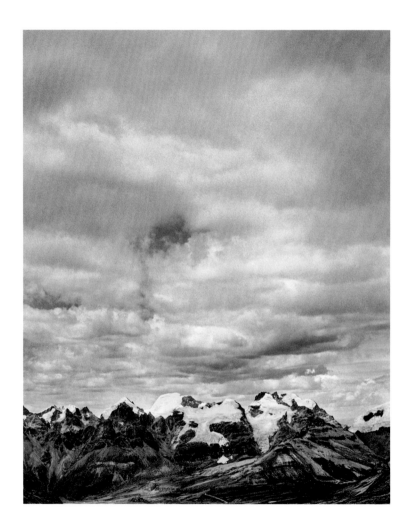

DANIEL SCHWARTZ

WHILE THE FIRES BURN

A GLACIER ODYSSEY

Thames & Hudson

On the cover:
Front: VERTIGO. GALMIGGLETSCHER, SWITZERLAND. 19 OCTOBER 2014
Back: GLACIERS OF MT. STANLEY SEEN FROM ACROSS MT. BAKER. RWENZORI, UGANDA.
14 NOVEMBER 2015

Endpapers:
OBERER GRINDELWALDGLETSCHER. SWITZERLAND. 23 SEPTEMBER 2014

While the Fires Burn © 2017 Thames & Hudson Ltd, London
Photographs, cartography art work and text © 2017 Daniel Schwartz
Sources of cited texts and other illustrations as per credits on pp. 230–31

Concept by Daniel Schwartz
Design by Martin Andersen / Andersen M Studio
www.andersenm.com
Scans by Laboratorium Media AG, Zürich.
www.laboratorium.ch

First published in the United States of America in 2017
by Thames & Hudson Inc., Fifth Avenue, New York,
New York 10110

www.thamesandhudsonusa.com

Library of Congress Control Number 2017931954

ISBN 978-0-500-54477-8

Printed and bound in China by Artron

WHAT FOLLOWS IS A GLACIOLOGY IN PICTURES

SHOWING THE REPERTOIRE OF GLACIERS
AS SHAPERS OF THE EARTH'S SURFACE AND INDICATORS OF ANTHROPOGENIC GLOBAL WARMING
AS VANISHING ARCHIVES OF CLIMATE HISTORY AND IMPERILLED STOREHOUSES OF RESOURCES
AS ARCHAEOLOGICAL SITES AND METAPHORS OF MEMORY

EXPLORING THE RELICS OF HOLOCENE GLACIATION AT THE JURA PIEDMONT
DOCUMENTING GLACIAL RETREAT BELOW THE ALPINE PEAKS
BECOMING CONTINUOUSLY DARKER SINCE THE END OF THE LITTLE ICE AGE
LEADING INTO THE MILIEU OF THE ANTHROPOCENE
TO THE COLLAPSING GLACIERS ON FOUR CONTINENTS

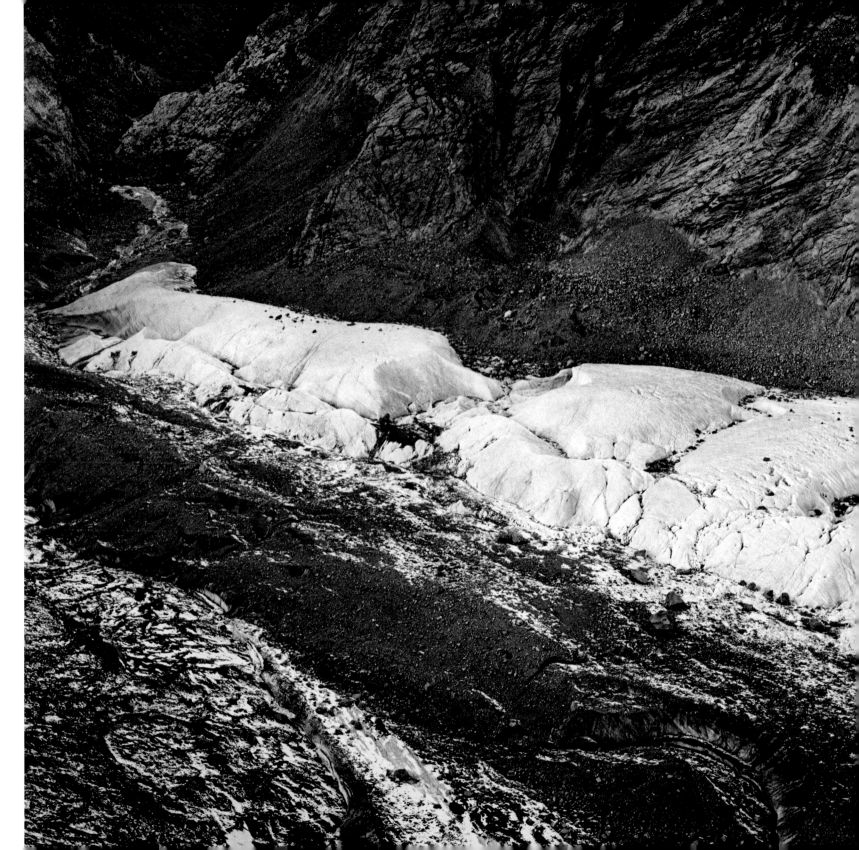

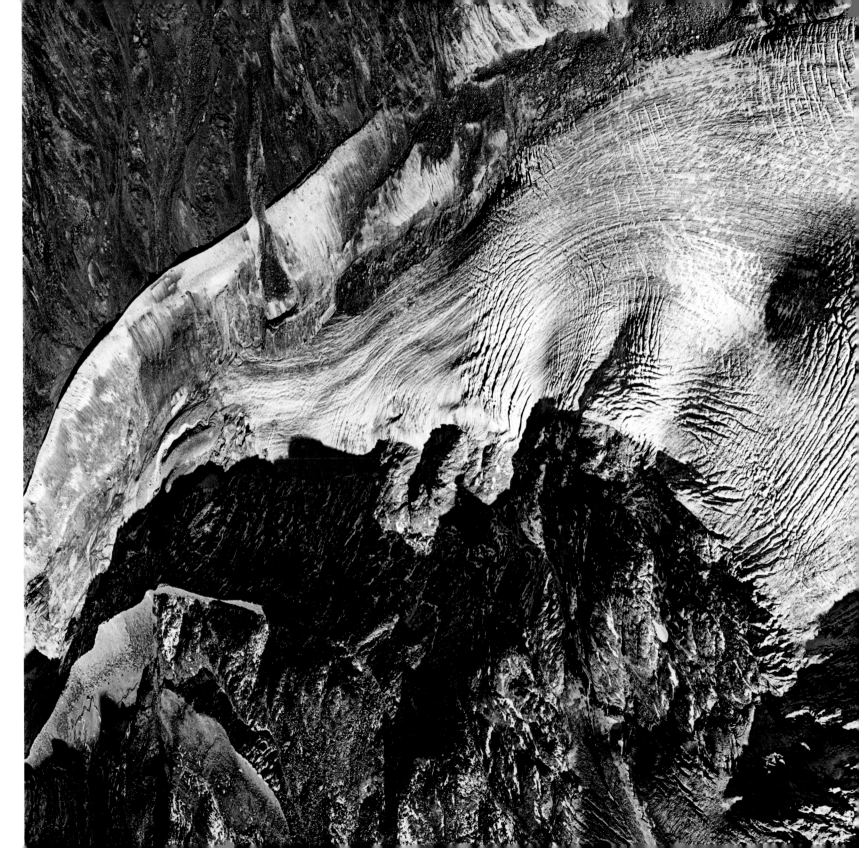

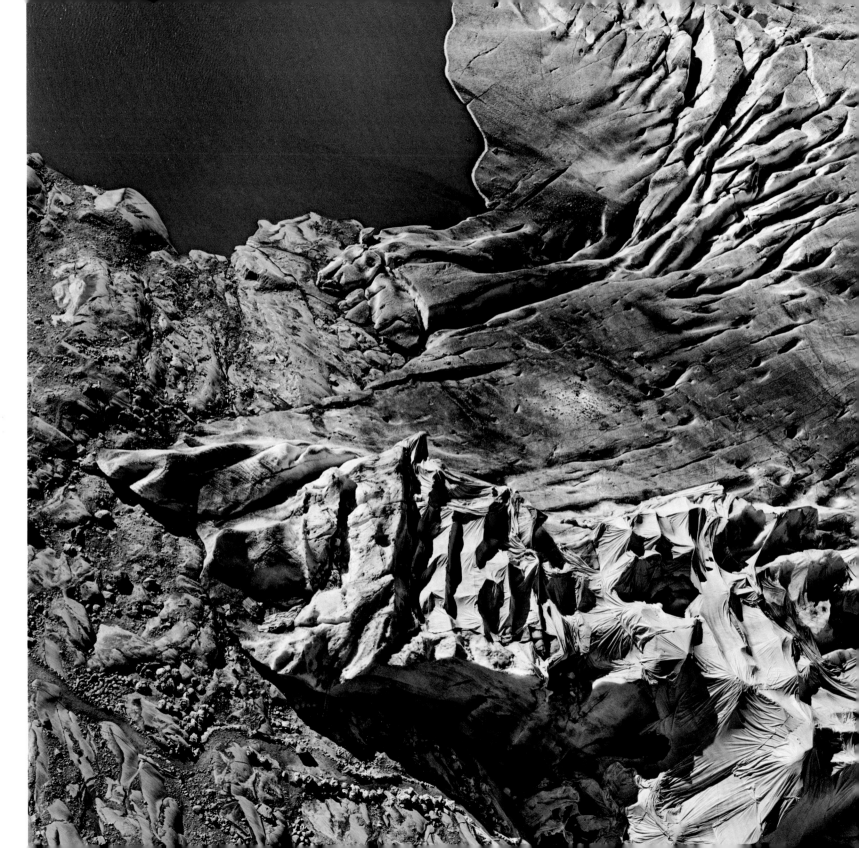

I

EQUATORIAL THAW: CORDILLERA BLANCA PERU

2016

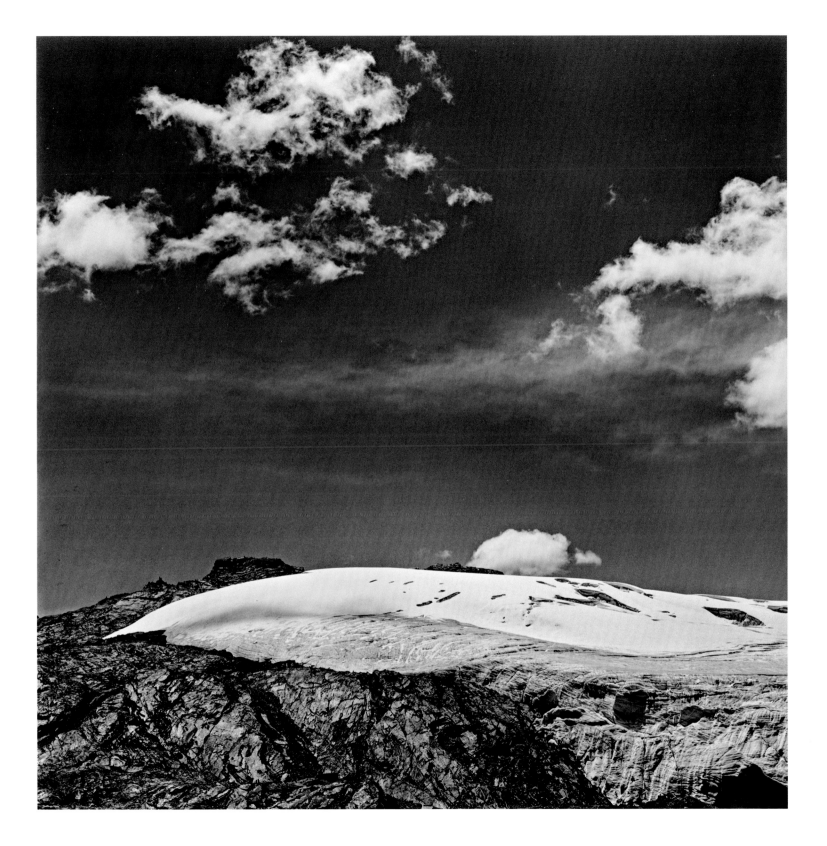

HUANDOY GLACIER COVERED WITH ROCK AND DEBRIS.
CORDILLERA BLANCA. PERU
5 JANUARY 2016

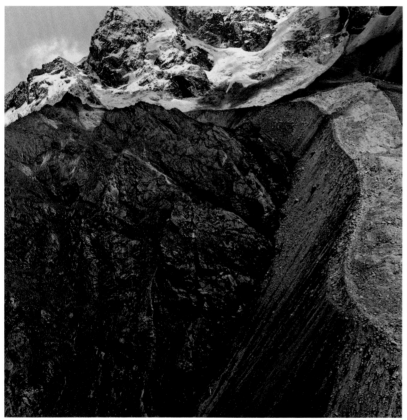 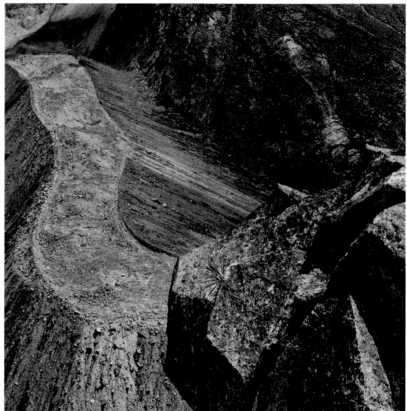

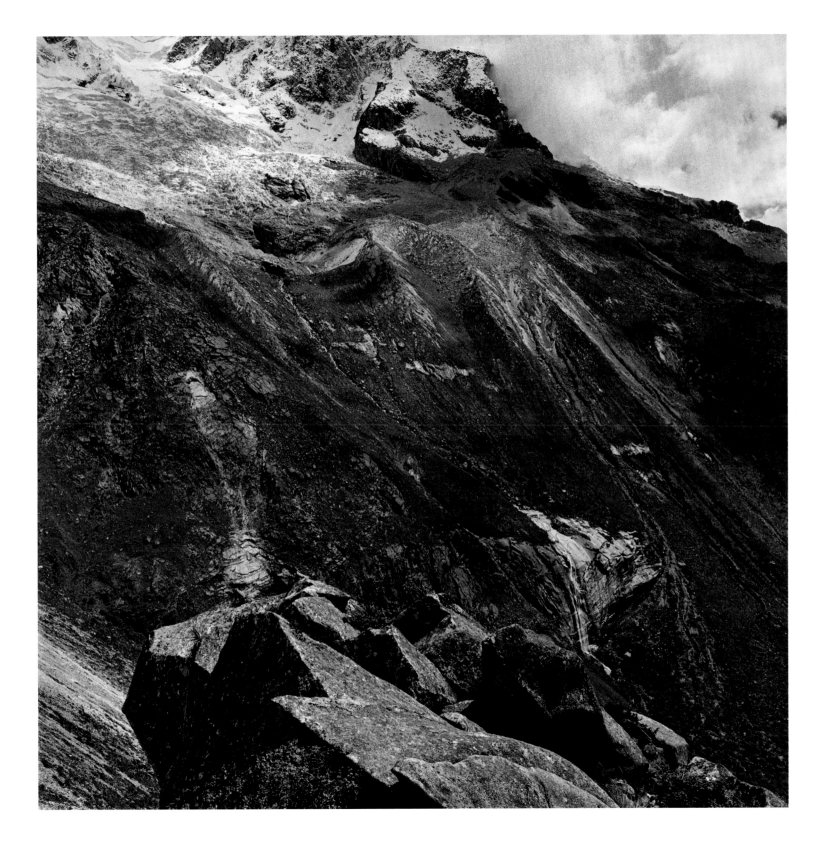

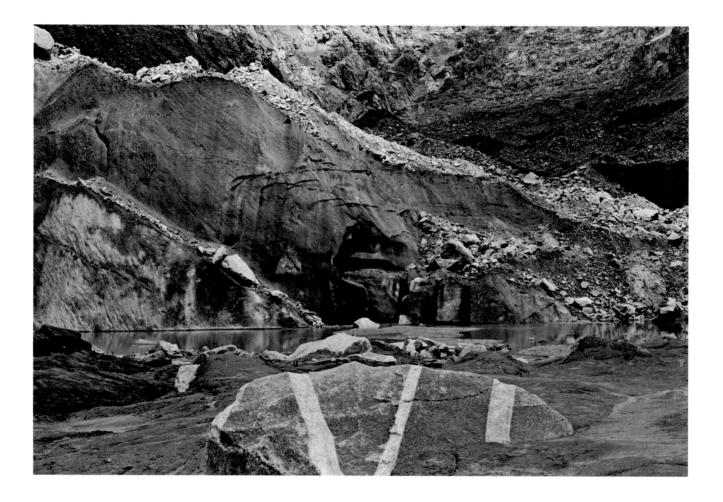

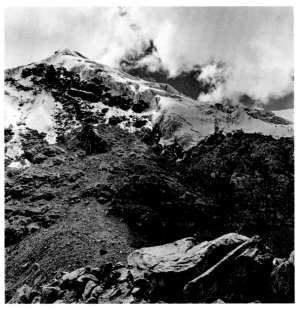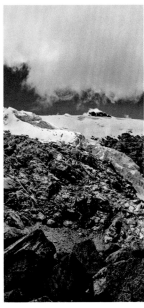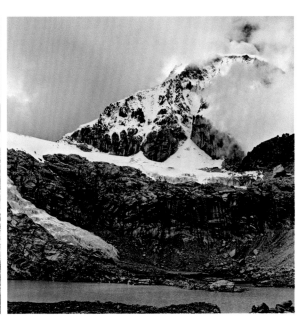

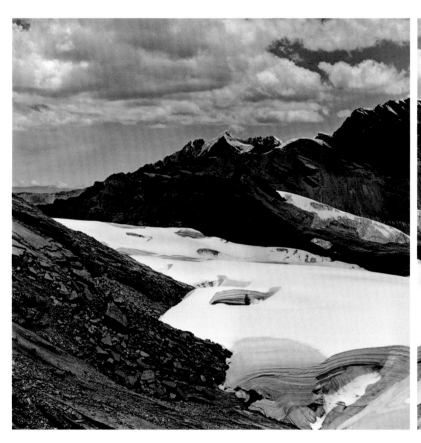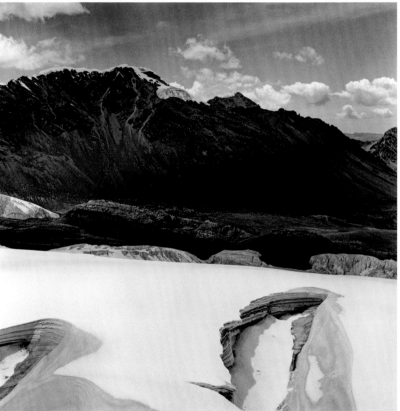

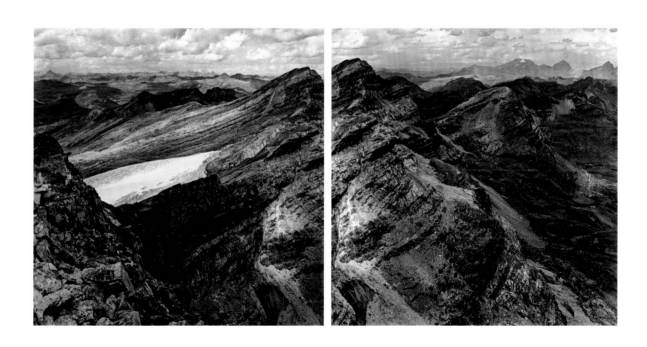

LOOKING AT A GLACIER FRONT TODAY

SEEING THE DEEDS OF OUR PAST

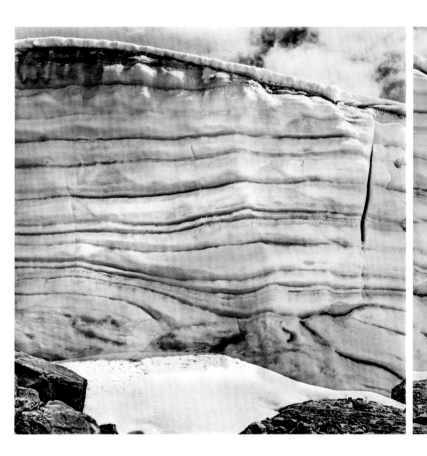
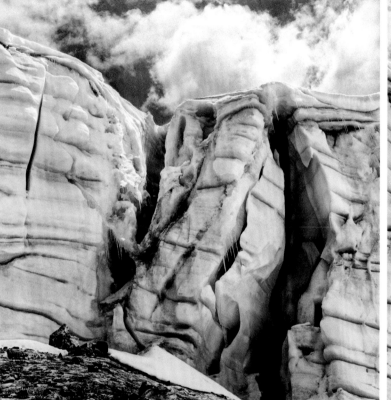
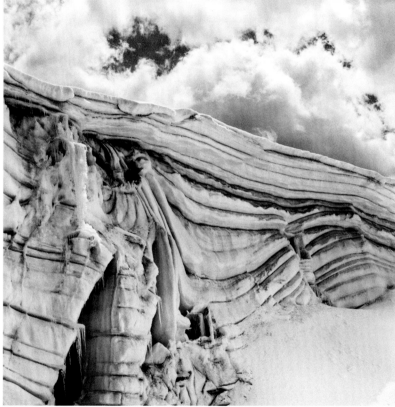

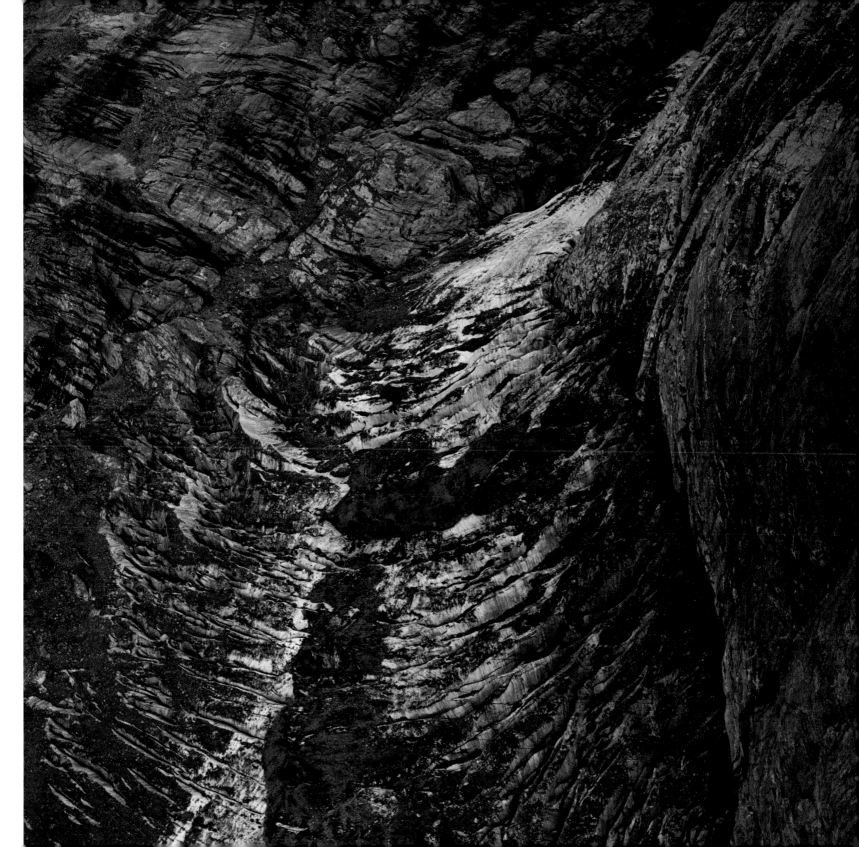

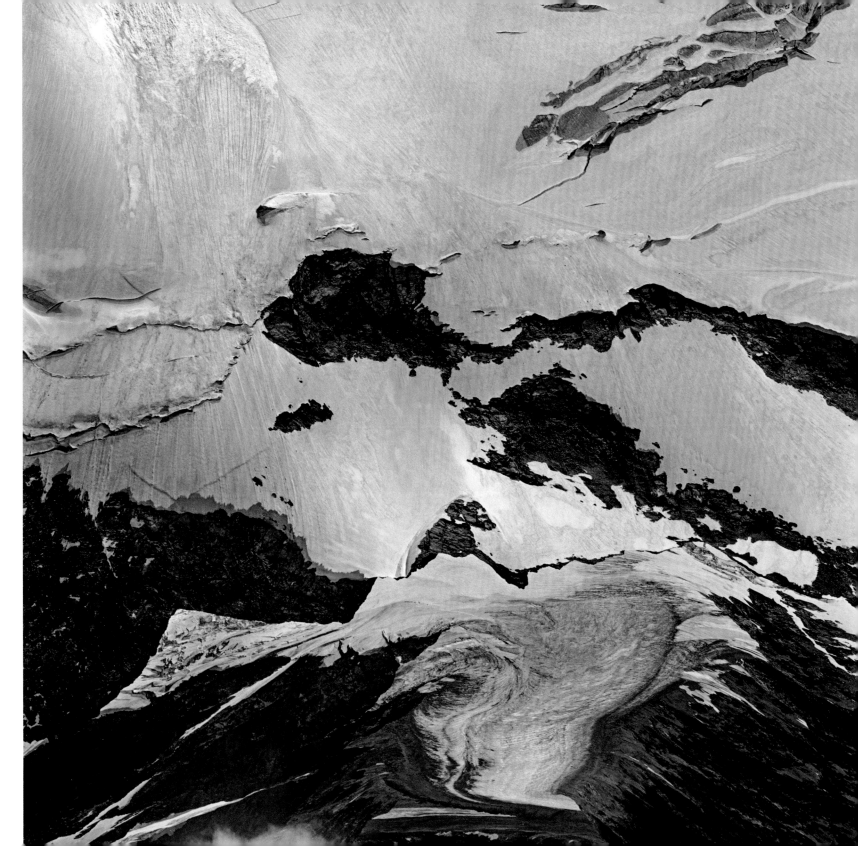

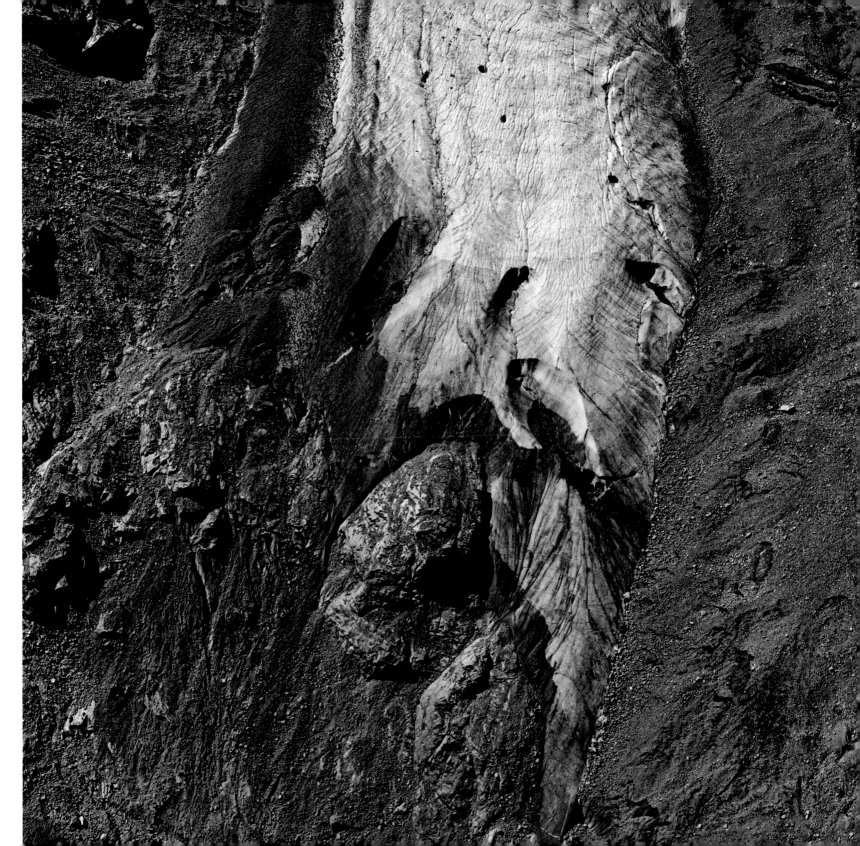

II

HOLOCENE: BORING HOLES IN BONES

11,500 YEARS B.P.–2016

WHEN THE GLACIER DIES

LIFE BEGINS

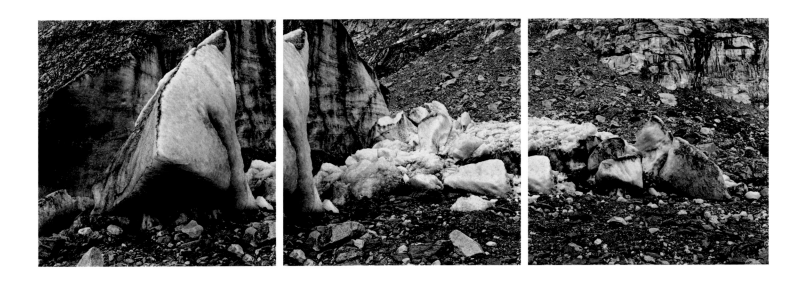

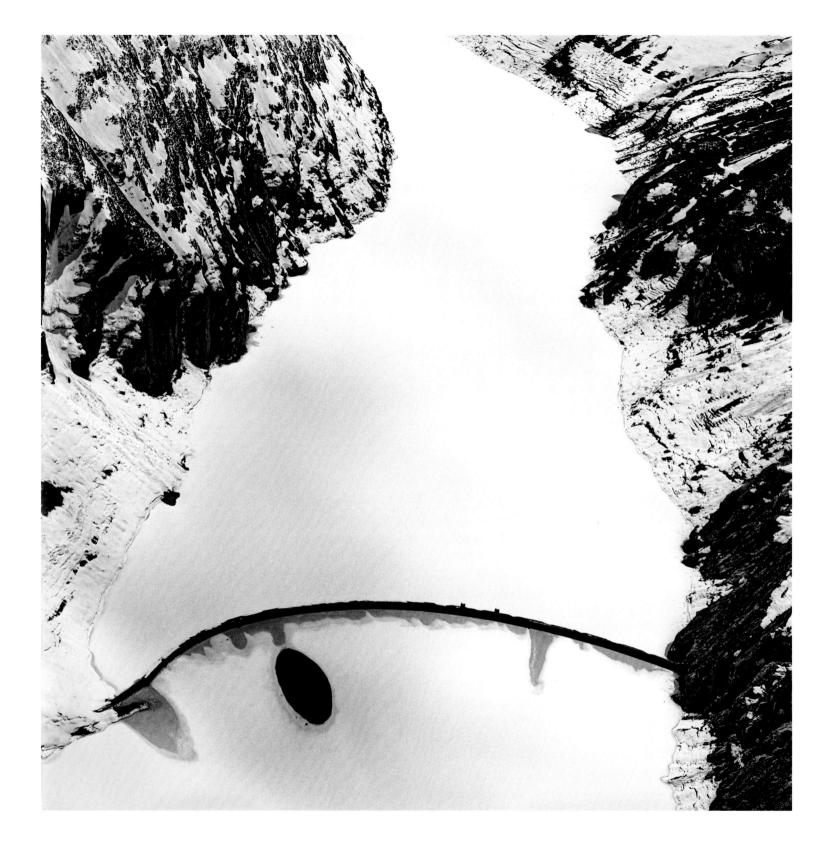

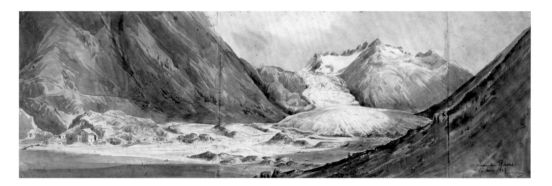

Henri Hogard: *Lower part, Rhône Glacier*. 26 August 1848

The watercolour depicts Rhône Glacier Little Ice Age Terminal Moraines. The oldest ridge in the foreground dates from 1602.

The crescentic ridges from 1818 and 1826, nearer to the clam-like tongue of the glacier, were overrun by the advancing ice until 1856, when the terminus reached the tallest moraine in the centre.

LAKE BIGATA AND HOLOCENE TERMINAL MORAINE.
NYAMUGASANI VALLEY. MOUNT LUIGI DI SAVOIA. RWENZORI. UGANDA
FLOATING ISLANDS OF TUSSOCKS DOTTING THE SURFACE OF THE LAKE
8 NOVEMBER 2015

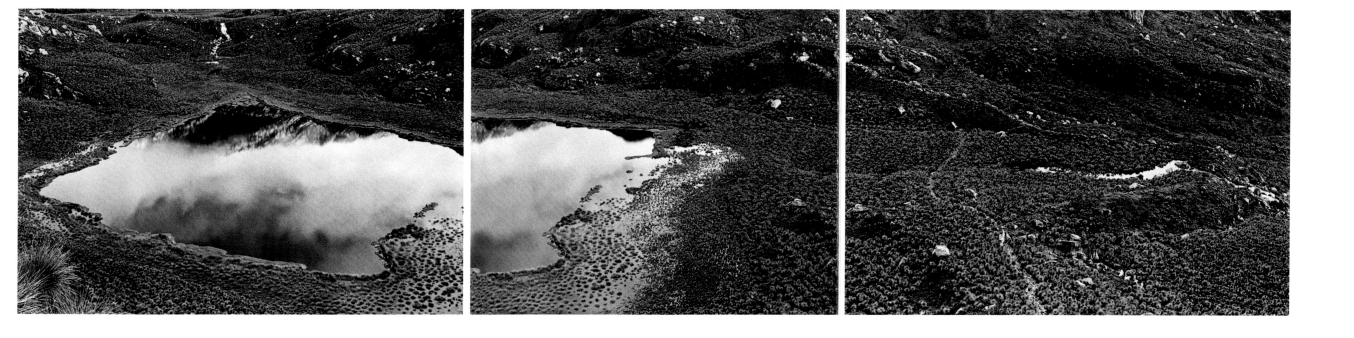

LAGUNA LLACA.
GLACIAL RETREAT MARKED BY TERMINAL MORAINES IN THE GLACIER FOREFIELD.
CORDILLERA BLANCA. PERU
4 JANUARY 2016

OPPOSITE
ERRATIC BOULDERS. QUEBRADA ISHINCA. CORDILLERA BLANCA. PERU
6 JANUARY 2016

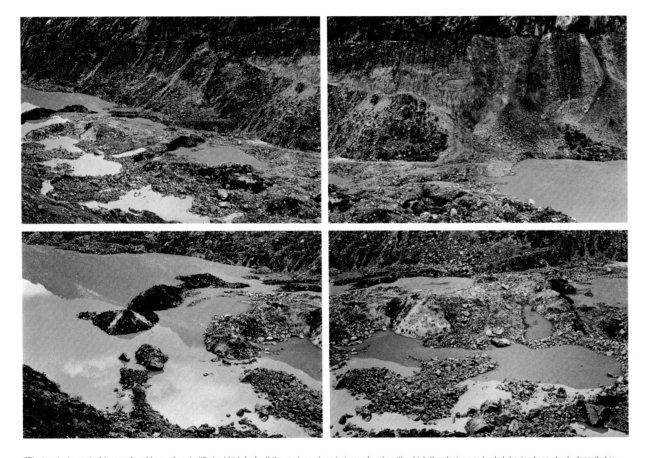

Survey of the Martinsflue Glacial Erratic Boulder Cluster (Rüttenen, Switzerland), 5 April 1946.
Location of Martinsflue Glacial Erratic Boulder: 47°13′29.4″ N / 07°32′21.6″ E; 607627 / 230438
(see pp. 52–54 and 61)

'[The terminal moraine] is a confused heap of unstratified rubbish [...]; all the mud, sand, and pieces of rock, with which the glacier was loaded, having been slowly deposited in the same spot where no running water interfered to sort them, by carrying the smaller and lighter particles and stones farther than the bigger and heavier ones. These terminal moraines often cross the valley in the form of transverse mounds, more or less divided into separate masses or hillocks by the action of the torrent which flows out from the end of the glacier. Such transverse barriers were formerly pointed out by Saussure, below the glacier of the Rhone, as proving how far it had once transgressed its present boundaries.'
Charles Lyell, *Elements of Geology*, 1865

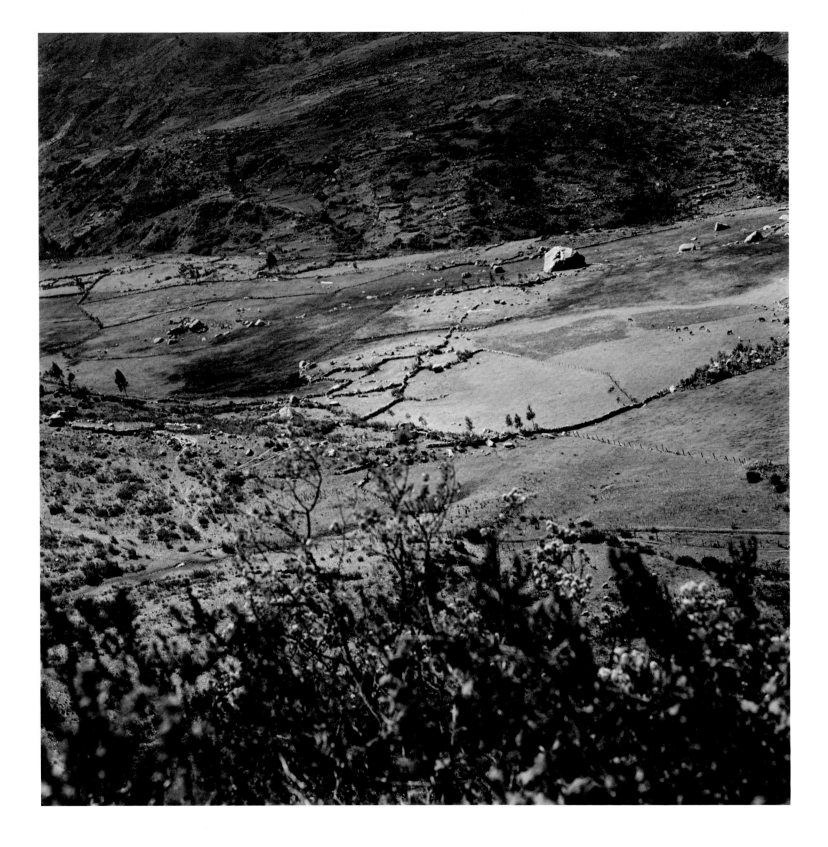

ADVANCES AND RETREATS

CYCLING DOWNSTREAM TO THE GARRISON TOWN

PAST THE PLACE WHERE THE WATER RAN THROUGH YOUR FINGERS
NO LONGER FUTURE NOT YET PAST
AS WE WALKED ALONG THE RIVERBANKS FOR THE FIRST TIME

THE PATH CROSSING BELOW THE N1 HIGHWAY BRIDGE
THE CONCRETE WALL SPRAYED WITH HOLLOW-EYED ALIENS

EVOKING GLACIAL HISTORY OF THE ALPINE FORELAND

BELOW THE PATH
BURIED UNDER LATE GLACIAL ICE MARGINAL FINE-GRAINED AGGRADATION
THE BRESTENBERG STADIAL MORAINE
LEGACY OF THE AARE/VALAIS GLACIER RETREAT 20,000 TO 18,000 YEARS B.P.
DEPOSITED ON SECOND-TO-LAST GLACIATION CLAYEY SILT
MOST LIKELY OLDER THAN 130,000 YEARS B.P.

THE MOLASSE BASIN SUCCESSIVELY OVERRUN BY PIEDMONT GLACIERS
EVIDENCE OF AT LEAST EIGHT BUT PROBABLY MORE FORELAND GLACIATIONS
OLDEST PLEISTOCENE DEPOSITS REFERRED TO AS DECKENSCHOTTER
CONSISTING MAINLY OF (GLACIOFLUVIAL) GRAVEL WITH INTERCALATED GLACIAL SEDIMENTS AND OVERBANK DEPOSITS

DURING OLDER AND YOUNGER EARLY PLEISTOCENE
AT LEAST FOUR GLACIAL ADVANCES
REACHING THE ALPINE FORELAND DURING HÖHERE DECKENSCHOTTER GLACIATIONS
(2.59–1.8 MILLION YEARS B.P.)

A MINIMUM OF TWO GLACIAL ADVANCES
OCCURRING DURING TIEFERE DECKENSCHOTTER GLACIATIONS
(1.8–0.8 MILLION YEARS B.P.)

BOTH PERIODS FOLLOWED BY PHASES OF PRONOUNCED AND SUBSTANTIAL FLUVIAL INCISION
ALONG THE HIGH RHINE AND ITS TRIBUTARY SYSTEMS OF AARE, REUSS AND LIMMAT
POSSIBLY CAUSED BY TECTONIC MOVEMENTS
AND PROBABLY ENHANCED BY FLUVIAL DYNAMICS DURING THE SECOND PERIOD
THE RE-DIRECTION OF THE ALPINE RHINE
FROM DANUBE TRIBUTARY AT ABOUT 700 M.A.S.L.
TO THE UPPER RHINE GRABEN AT ABOUT 250 M.A.S.L.

MOST EXTENSIVE GLACIATION (MEG) DURING MÖHLIN GLACIATIONS
(C. 780,000 YEARS B.P.)
FOLLOWED BY HABSBURG GLACIATION
(C. 300,000 YEARS B.P.)
UNCERTAIN HAGENHOLZ GLACIATION
RATHER EXTENSIVE BERINGEN GLACIATION
(180,000–130,000 YEARS B.P.)
BIRRFELD GLACIAL CYCLE
CONSISTING MAYBE OF TWO OR EVEN THREE PERIODS OF INDIVIDUAL ICE BUILD-UP AND MELT-DOWN
(C. 105,000, 65,000 AND 25,000 YEARS B.P.)
SEPARATED BY PHASES WITH RELATIVELY MILD TEMPERATURES

EVOKING GLACIAL HISTORY OF NORTHERN EUROPE

NORTHERN EUROPE
GLACIAL HISTORY DETERMINED BY NUMEROUS GENERALLY MUTED COOL PERIODS IN THE EARLY PLEISTOCENE
AND BY FIVE MAJOR COLD PERIODS EACH LASTING C. 100,000 YEARS DURING THE MIDDLE PLEISTOCENE
(780,000–126,000 YEARS B.P.)
EARLIEST PERIOD OCCURRING BETWEEN 650,000 AND 620,000 YEARS B.P.
DURING PROLONGED AND INTENSE COLD PERIOD OF MIS12 (C. 480,000–420,000 YEARS B.P.)
BALTIC ICE SHEET ADVANCING INTO CENTRAL EUROPE
BETWEEN 70,000 AND 50,000 YEARS B.P. LOBES OF THE INLAND ICE PERHAPS AGAIN BEYOND THE BALTIC
FURTHER INLAND-ICE BUILD-UPS BETWEEN 35,000 AND 25,000 YEARS B.P.
WHEN SEA-ICE COVERED THE NORTH ATLANTIC MUCH MORE EXTENSIVELY THAN TODAY

MEANWHILE

TRANSFORMATION OF THE APE-LIKE *AUSTRALOPITHECUS AFARENSIS*
WALKING AND TRAVELLING THROUGH TREES
INTO THE HAIRLESS SWEATING ENDURANCE RUNNER OF THE OPEN SAVANNAH
BEATING SCAVENGING CARNIVORES TO THE CARRION
INCESSANTLY IN PURSUIT OF RAPIDLY EXHAUSTED FURRED GAME
BEFORE SPEAR AND NET REDUCED THE NEED TO RUN

INITIAL HOMININ COLONIZATION OF ASIA AFTER ABOUT 2 MILLION YEARS B.P.

1.2 MILLION YEARS B.P.
THE EARLIEST EVIDENCE FOR HOMININS IN EUROPE FROM ATAPUERCA IN WHAT IS NOW SPAIN
BY C. 700,000 YEARS B.P. EPISODIC DISPERSAL AS FAR NORTH AS THE 53RD PARALLEL

AFTER 600,000 YEARS B.P. EXPANSION OF ACHEULEAN INDUSTRY
FROM THE LEVANT AS FAR AS WHAT IS NOW KNOWN AS KOLKATA
FIRST STANDARDIZED TRADITION OF TOOLMAKING THROUGH A PROCESS OF LITHIC REDUCTION
DIFFERENT TYPES OF BIFACIAL AXES, CLEAVERS AND PICKS
REFLECTING VARYING ADAPTATION TO CHANGING ENVIRONMENTS

FOOTSTEPS

ADVANCES OF SCANDINAVIAN INLAND ICE INFLUENCING THE CLIMATE IN EUROPE
VEGETATIONAL ZONES SHIFTING
ANIMAL POPULATIONS RESPONDING
FORMATION OF VEGETATIONAL AND MAMMALIAN SOUTHERN REFUGIA

WITHIN GLACIAL AND INTERGLACIAL STAGES
SHORT SEVERE CLIMATIC OSCILLATIONS OF A FEW MILLENNIA
DISRUPTING HOMININ SETTLEMENT IN MID-LATITUDES AS MUCH AS
LONGER SHIFTS BETWEEN GLACIALS AND INTERGLACIALS

REGIONS PERMANENTLY OCCUPIED DURING COLDEST PARTS OF GLACIAL CYCLES
QUALIFYING AS GLACIAL REFUGIA WITH CORE POPULATIONS
OTHERWISE REGIONS OF PERIPHERAL SETTLEMENT
WITH POPULATIONS VIABLE ONLY DURING INTERGLACIAL OR INTERSTADIAL PERIODS

GLACIAL REFUGIA NOT RETREAT AREAS BUT AREAS OF SURVIVAL

MIDDLE PLEISTOCENE HOMININS
HOMO HEIDELBERGENSIS
RESPONDING TO SEVERE CLIMATIC AND ENVIRONMENTAL DISRUPTION
AS WELL AS TO CHANGES IN AVAILABILITY AND PRODUCTIVITY OF RESOURCES
GRADUALLY IMPROVING SURVIVAL SKILLS
CO-OPERATIVE BIG-GAME HUNTING AFTER 500,000 YEARS B.P.

MIDDLE PLEISTOCENE EUROPE PROBABLY MOST FREQUENTLY OPEN TO HOMININ IMMIGRATION
AND RE-COLONIZATION FOLLOWING LOCAL EXTINCTION DURING GLACIAL MAXIMA

DURING INTERGLACIAL AND INTERSTADIAL CONDITIONS
IMMIGRATION ROUTES FROM NORTH OF THE BLACK SEA
FROM REFUGIA IN THE CAUCASUS AND IN THE LEVANT THROUGH TURKEY
ACROSS AEGEAN AND IONIAN LAND BRIDGES INTO THE BALKANS

AS IN ASIA
EARLY SETTLEMENT IN EUROPE
A REPEATING NARRATIVE OF REGIONAL EXPANSION AND ABANDONMENT
CONTRACTION IN SOUTHERN REFUGIA
EXPANSION FROM THEM IN WARMER PERIODS AND SUBSEQUENT RE-COLONIZATION
THE PROCESS VARYING IN EACH CLIMATIC CYCLE

NORTHERN EUROPE A POPULATION SINK
WITH AVERAGE REPRODUCTION RATE BELOW REPLACEMENT LEVEL
MIGRATION FROM REGIONS QUALIFYING AS POPULATION SOURCE
A PRECONDITION FOR PERMANENT SETTLEMENT

SOURCE POPULATIONS OCCUPYING REFUGIA
IN THE ITALIAN AND IBERIAN PENINSULAS AND THE BALKANS
AS WELL AS WHAT IS NOW SOUTHWEST FRANCE AND SOUTHERN GERMANY
MAYBE EVEN IN SOUTHWEST ASIA AND THE BLACK SEA BASIN
GIVING RISE TO AND HELPING TO SUSTAIN SINK POPULATIONS NORTH OF THE ALPS
REELING FROM HIGH RATES OF LOCAL EXTINCTION

POPULATIONS CONSISTING OF SMALL SUBSISTENCE GROUPS OF 25
IN FULL GLACIAL PERIODS 60 TO 100
IN INTERSTADIALS 100 TO 120
40 PER CENT OF POPULATION OF REPRODUCTIVE AGE
SIZE OF MATING NETWORKS UNKNOWN
POPULATION LEVELS AND GROWTH RATES PROBABLY EXTREMELY LOW

DURING THE MIDDLE PLEISTOCENE MAXIMA AND FOR UNKNOWN PERIODS
EUROPE PERHAPS COMPLETELY UNINHABITED
WHAT IS NOW BRITAIN ABANDONED FOR 80 PER CENT OF THE LAST 500,000 TO 600,000 YEARS
DUE TO REPEATED GLACIAL ADVANCE

ON A EURASIAN CONTINENTAL SCALE
INTEGRATED RECORDS OF CLIMATIC CHANGES OVER THE LAST 2 MILLION YEARS
AND ARCHAEOLOGICAL RECORDS
FROM A WIDE RANGE OF ENVIRONMENTAL AND CHRONOLOGICAL CONTEXTS
FOSTER AN UNDERSTANDING OF THE HUMAN RESPONSE TO LONG-TERM CLIMATE CHANGE
RESPONSES IN MIDDLE PLEISTOCENE BRITAIN AND TAJIKISTAN
TO BE MODELLED ACROSS GLACIAL AND INTERGLACIAL CYCLES

GROUP OF HUNTERS STALKING IBEX AND WILD HORSES
LEAVING BEHIND SEWING NEEDLES MADE OF BONE
AS WELL AS A PIERCED SHELL INDICATING CONTACT AND EXCHANGE WITH ANOTHER GROUP
IN WHAT IS NOW KNOWN AS THE MAGDALENIAN CULTURE SITE OF THE RISLISBERG CAVE IN THE ÖNSINGEN GORGE
THOUGH NO FOOTPRINTS
EITHER IN THE PROGLACIAL ZONE OR IN THE TREELESS TUNDRA COVERING THE ALPINE FORELAND

UNLIKE THE PARALLEL TRACKWAYS FOSSILIZED IN VOLCANIC ASH
ALLOWING RECOGNITION OF SOFT-TISSUE ANATOMICAL FEATURES SUCH AS BIG TOE AND HEEL
TRACES OF THREE FULLY BIPEDAL EARLY HOMININS
WHO CROSSED THE SAVANNAH OF LAETOLI
NORTHERN TANZANIA
ON A RAINY DAY
BETWEEN 3.8 AND 3.4 MILLION YEARS B.P.

IN THE ALPS
THE PEAK OF LAST GLACIAL MAXIMUM (LGM C. 24,000–22,000 YEARS B.P.)
BROADLY SYNCHRONOUS WITH THE GLOBAL ICE-VOLUME MAXIMUM
GLACIERS DISAPPEARING FROM THE FORELAND NOT LATER THAN 17,500 YEARS B.P.
AVERAGE SUMMER TEMPERATURE RISING TO 10 °C

QUATERNARY TIME
SUDDENLY PUNCTUATED
YOUR VOICE MY NAME
RESOUNDING FROM THE OPPOSITE BANK OF THE RIVER

FOR AT LEAST FIFTY-FIVE PER CENT OF THE PAST 10,000 YEARS
THE ALPINE GLACIERS WERE SMALLER THAN IN 2005

GLACIER EXTENT IN THE FORELANDS AND ICE COVER IN THE ALPS AT THE PEAK OF THE LAST GLACIAL MAXIMUM.
VALAIS AND AARE GLACIERS COVERING THE SWISS MITTELLAND. THE RHAETIAN GLACIER REACHING THE LAKE
CONSTANCE AREA.

Heinz Leuzinger. *Relief drawing of Switzerland during the last Ice Age*, plate 6, *Atlas der Schweiz*, 1969–70

III

LAST GLACIAL MAXIMUM: COLD WORLD PRESENT IN ABSENTIA

20,000 TO 18,000 YEARS B.P.–2015

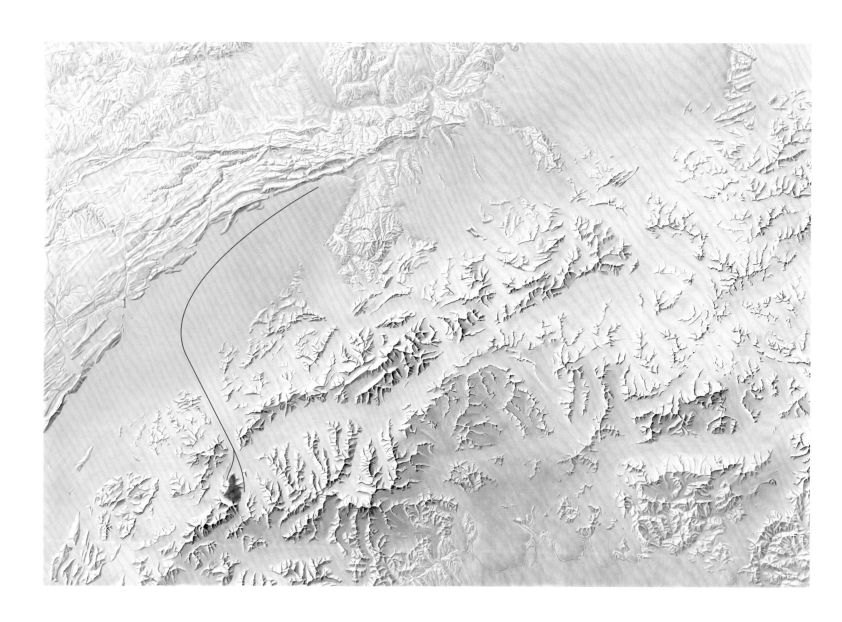

ERRATIC BOULDER JOURNEY

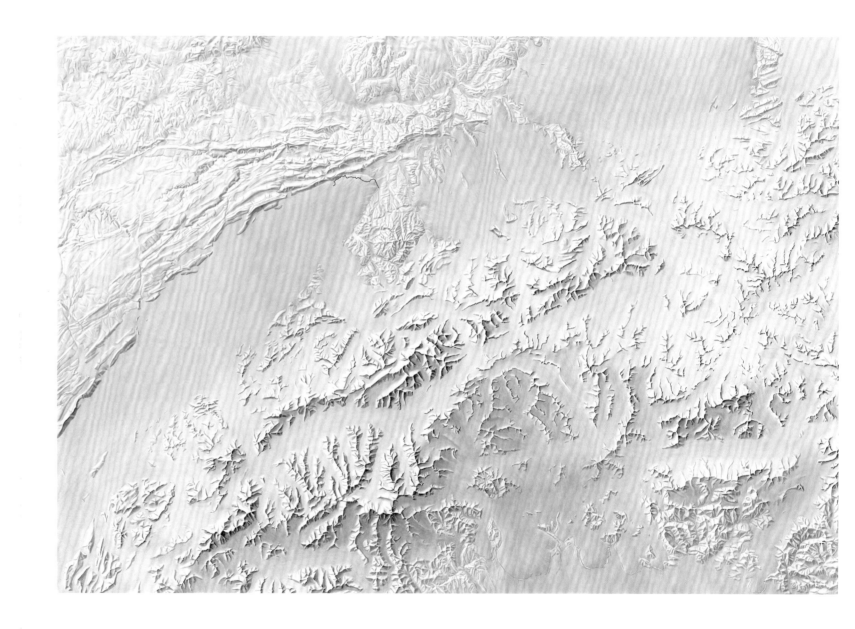

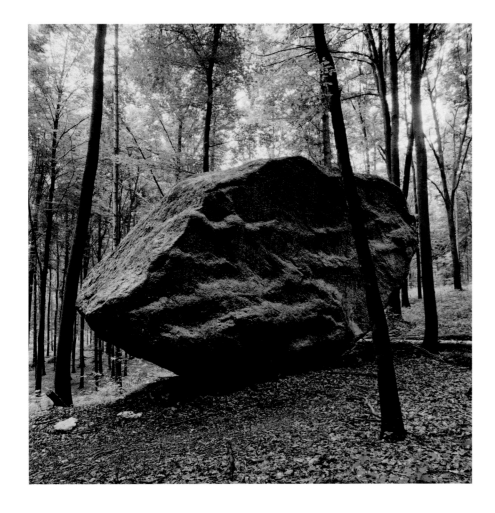

FROM THE CHAMONIX VALLEY TO THE SOUTHERN FOOTHILLS OF THE JURA MOUNTAINS
FROM AN ALTITUDE BETWEEN 2,300 AND 2,500 DOWN TO 532 M.A.S.L.
OVER A PERIOD OF APPROXIMATELY 4,800 YEARS
WITH THE MEAN FLOW SPEED OF A GRAIN OF ICE OF 30 METRES PER YEAR
COVERING A DISTANCE OF APPROXIMATELY 145 KILOMETRES AS THE CROW FLIES

2012

THE LAST GLACIAL MAXIMUM CONTAINED IN A WALK OF SEVEN HOURS AND TWENTY-FIVE LIVES

BIRTHDAYS OF PASSERS-BY RECORDED
WHILE WALKING FROM LANGENDORF TO LANGENTHAL
CONTOURING THE LOBE OF THE ICE CAP COVERING THE ALPINE FORELAND AT THE PEAK OF THE LAST GLACIATION 21,500 YEARS BEFORE PRESENT
LIFETIMES TOTALLING 953 YEARS

6 MAY 2012

22.12.2010
14.10.1972
29.04.2004

04.11.1922
22.10.1954 11.01.2007
28.09.1920

14.09.1985

23.10.1955

12.09.1982

04.06.1964
29.11.1967

08.09.1969

15.11.1943

18.06.1944

17.03.1993
05.08.1994

LANGENDORF

27.12.1979

25.10.1966

10.12.2002 10.02.1976

25.03.1970

30.11.1990

28.09.1993
09.11.1986

LANGENTHAL

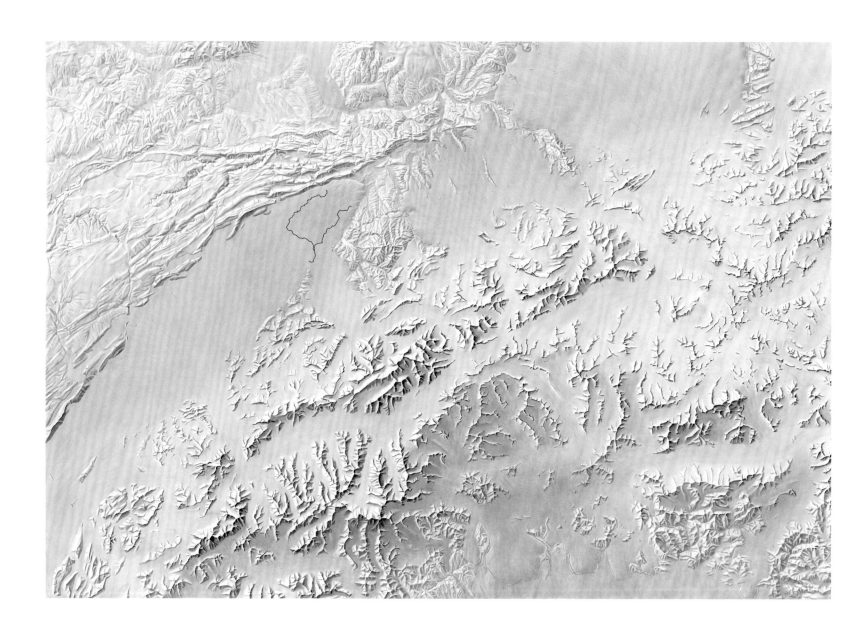

ERRATIC BOULDER HISTORIES

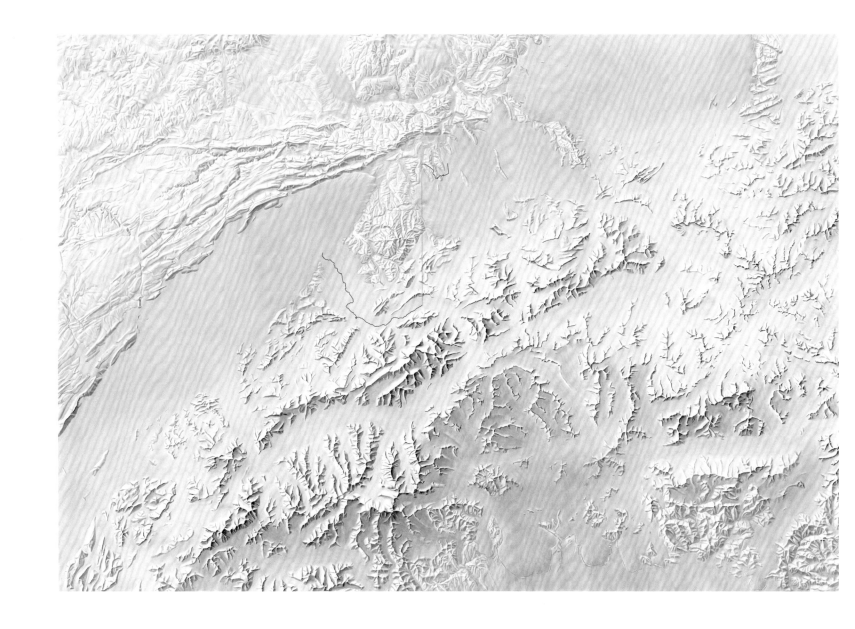

FIVE KILOGRAMS OF SAMPLES FROM THE MARTINSFLUE ERRATIC BOULDER
COLLECTED BY TWO GEOLOGISTS
TO DETERMINE DEPOSITIONAL AGE BY COSMOGENIC NUCLIDE SURFACE-EXPOSURE DATING*
AND TO DELINEATE THE FARTHEST EXTENT OF THE LAST GLACIAL MAXIMUM
ON THE LEFT-LATERAL MARGIN OF THE SOLOTHURN LOBE

HAMMER AND CHISEL SCARS DRESSED WITH FOREST SOIL
TWO BICYCLES THAT MADE THE JOURNEY FROM THE MARTINSFLUE ERRATIC BOULDER TO BERN

26 MAY 2012

TWO BICYCLES THAT MADE THE JOURNEY FROM BERN TO THE STEINHOF ERRATIC BOULDER
SPARED RECYCLING DURING CONSTRUCTION OF THE HERZOGENBUCHSEE–BURGDORF RAILWAY IN 1855/1857

THOUSANDS OF ALPINE FORELAND ERRATIC BOULDERS
LOST TO QUARRYING IN ROMAN TIMES AND THE SYSTEMATIC CLEARANCE OF FARMLAND IN THE 18TH CENTURY
THE STEINHOF ERRATIC BOULDER DEFIED DEMOLITION ATTEMPTS WITH DYNAMITE
OBTAINED DEPOSITIONAL AGE 21,050 +/– 860 YEARS B.P. REPRESENTING A MINIMUM AGE FOR THE START OF DEGLACIATION
ON THE RIGHT-LATERAL MARGIN OF THE SOLOTHURN LOBE

23 JUNE 2012

*Postscript 2016
The samples revealed that the Mont Blanc granite boulder made the journey in three stages
First stage from Mont Blanc massif pick-up point to somewhere en route to Solothurn
with an exposure time of 265,000 years at unknown location
Second stage in the course of the next glacier advance in upside-down position
with an exposure time of 90,000 years at unknown location
Third stage during the Last Glacial Maximum to present location c. 20,000 years ago
Total travel time: 375,000 years
This scenario being the simplest of several possibilities

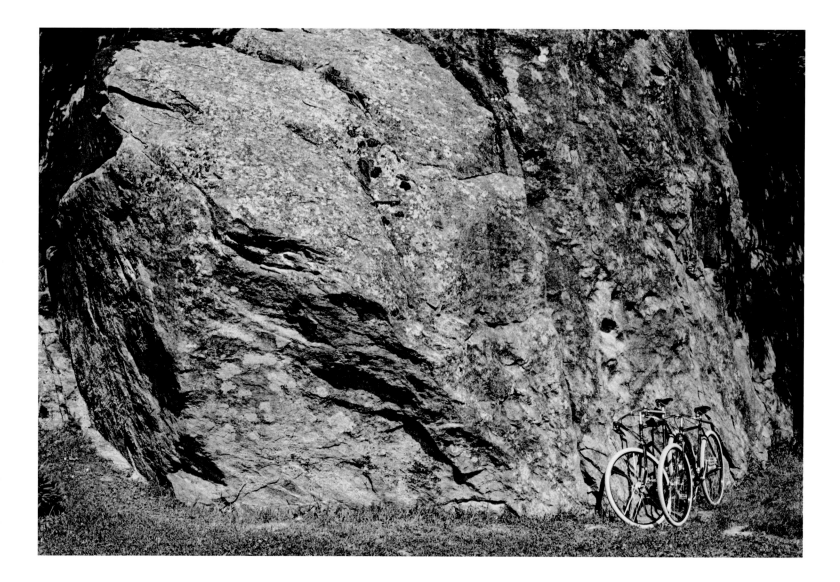

IMAGINARY LINE

CONNECTING

THE POINT OF ARRIVAL OF A BICYCLE TOUR
FROM THE RÖMERSTEIN ERRATIC BOULDER NEAR LENZBURG TO SCHÖFTLAND
WITH THE POINT OF DEPARTURE OF A BICYCLE TOUR
FROM THE GIESSBACH FALLS TO BERN

THE LOBE OF THE REUSS GLACIER WITH THE FLOW OF THE AARE GLACIER

26 MAY 2012

EVOKING

THE HIGHLY PROBABLE EXISTENCE OF AN ICE CAP
BETWEEN 2.59 AND 2 MILLION YEARS B.P.
FAR MORE EXTENSIVE THAN THE LAST GLACIAL MAXIMUM
AND POSSIBLY COVERING THE ALPINE PEAKS

DAYS APART FROM ONE ANOTHER

19 JUNE 2012

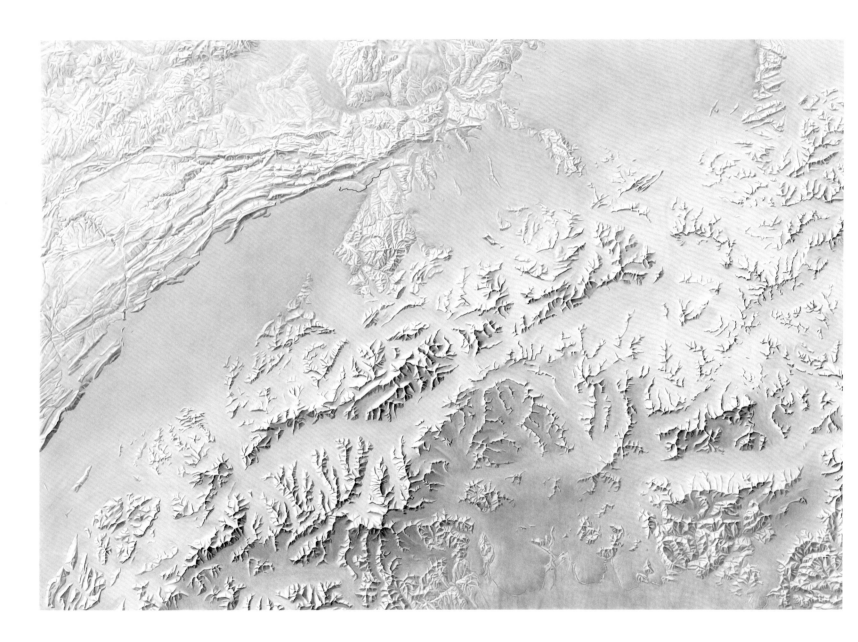

Solothurn Lake during the Würm ice age glaciation,
c. 15,000 B.P., with outlines of today's three Sub-Jurassic lakes.

SILENCE FROM THE PAST

ATTISWIL
STANDING ALONE IN A FIELD THE FREISTEIN ERRATIC BOULDER
OBJECT OF PAGAN WORSHIP
FLINT STONE TOOLS AND POTSHERDS FOUND NEARBY
SANCTUARY FROM VIGILANTISM DURING THE MIDDLE AGES
THE FEEL OF MONTBLANC GRANITE
ASYLUM SECURED UNDER DIVINE PROTECTION

BETWEEN WANGEN AN DER AARE AND AARWANGEN
THE RIVER UNTAMED UNTIL THE SMALL BARRAGE ABOVE AAREMATTE
LATE-GLACIAL AND EPIGENETIC CHANNEL
MEANDERING BETWEEN LÄNGWALD AND SPICHIGWALD
OBLONG MOLASSE HILLS
SHOULDERING OLDER STAGE MORAINES OF THE AARE/VALAIS GLACIER
DEPOSITED BEFORE 130,000 YEARS B.P.
DOWNSTREAM FROM THE BARRAGE
MEADOWS AND WOODS AND FIELDS
PROFILE SHAPED
BY THE CENTRAL LOBE OF THE LANGENTHALER SCHWANKUNG
UNASSERTIVE EASTERNMOST ADVANCE OF THE GLACIER
DURING THE LAST GLACIAL MAXIMUM
FRAGMENTED RIM OF MORAINES
ERRATIC BOULDER HORIZON AT MEINISWIL

WOLFWIL
1946–1948
SITE OF A WORKSHOP SET UP BY MY FATHER
ON BEHALF OF THE SCINTILLA ELECTRIC TOOLS COMPANY
TWO DOZEN PEOPLE MANUFACTURING ELECTROMAGNETIC COILS
COMPONENT OF THE OERLIKON, BÜHRLE & CO
IPSOPHON TELEPHONE RECORDING MACHINE
PROBABLY REPRESENTING THE FIRST AUTOMATED USE
OF PLAYBACK MECHANISM WITH REMOTE ACCESS
LOW DEMAND LEADING TO DISCONTINUED PRODUCTION
SPEAKING MACHINES SUSPECT

FULENBACH
FORENBAN GRAVEL PITS
EXTRACTION OF LAST GLACIATION GRAVEL
SITE OF THE FIND ONE MONTH AGO OF A FRAGMENTED MAMMOTH TUSK
EXPOSED AFTER HAVING TRAVELLED ALONG NINE CONVEYOR BELTS

AARBURG
THE RIVER FOLLOWING THE SOUTHERN FOOT OF THE BORN
THE COURSE A CONSEQUENCE OF OLDER GLACIAL OUTWASH
PLUGGING THE ORIGINAL VALLEY IN THE GÄU
BEYOND THE RIVER BEND THE GORGE
THAT CUTS THROUGH THE SOUTHERNMOST ANTICLINE
OF THE JURA FOLD-AND-THRUST BELT
THE RIVER DRAINAGE CHANNEL OF THE WESTERN ALPINE FORELAND
FLOWING NORTHWARDS

OLTEN
MARKING THE DOWNSTREAM GATE OF THE GORGE NEAR OLTEN
THE STONE-PILLARED GALLOWS
ERECTED 600 YEARS AGO IN A PRETENCE OF LAW AND ORDER
WHEN THE FABRIC OF SOCIETY WAS FLIMSY
AND SURVIVAL MIGHT DEPEND ON CRIME
IN THE EVENT OF CROP FAILURE AND AN ENSUING GRAIN SHORTAGE
RESULTING FROM CLIMATIC FLUCTUATIONS
AFFECTING THE COURSE OF HISTORY
AS THE MEDIEVAL WARM PERIOD GAVE WAY
TO A COOLING TREND AND EXTREME WEATHER SIGNALS
SUCH AS THE 1383 DÜNNERN FLOOD
FORCING TROOPS FROM SOLOTHURN AND BERN
TO ABANDON THEIR SIEGE OF OLTEN
THEIR RETREAT FOLLOWED SWIFTLY
BY THE FACE-SAVING CAPTURE OF METZINA WAECHTER
D WELLER OF THE AARE GORGE
AND HER SENTENCING TO BURN AT THE STAKE AS THE WITCH OF OLTEN
HAVING MAGICALLY CAUSED THE GREAT RAIN

EPISODE
FORESHADOWING THE THIRTY YEARS WAR
WHEN MILITARY OPERATIONS WORSENED ECONOMIC CONDITIONS
MOBILITY AND MALNUTRITION SPREAD DISEASE AS THE PRINCIPAL KILLER
AND ADVERSE CLIMATE CHANGE PHENOMENA LED TO APOCALYPTICISM
MAKING THE LUNACY OF EMOTIONALLY DISTURBED ARCHONS
A POLITICAL RISK
MELANCHOLY ROOTED IN DESPAIR AND FEAR THE SYMPTOMATIC SICKNESS
SORCERY THE CRIME OF THE LITTLE ICE AGE

9 MARCH 2014

Hans Schwartz. *Motorcycle race, Olten* 1948/1949

LAKE IN MIND

SUB-JURASSIC LAKES OF BIENNE NEUCHÂTEL MORAT
RELICS OF THE SOLOTHURN LAKE
— AS SOME DARE POSTULATE —

SHALLOW EARLY LATE-GLACIAL LAKE
THAT EXPANDED 15,000 YEARS B.P.
WHEN THE AARE/VALAIS GLACIER RETREATED

RIDING OUR BICYCLES INTO THIS LAKE
BEFORE EMBARKING ON A TOUR OF THREE CONTINENTS
TO FATHOM THE FATE OF DISTANT GLACIERS

9 JUNE 2015

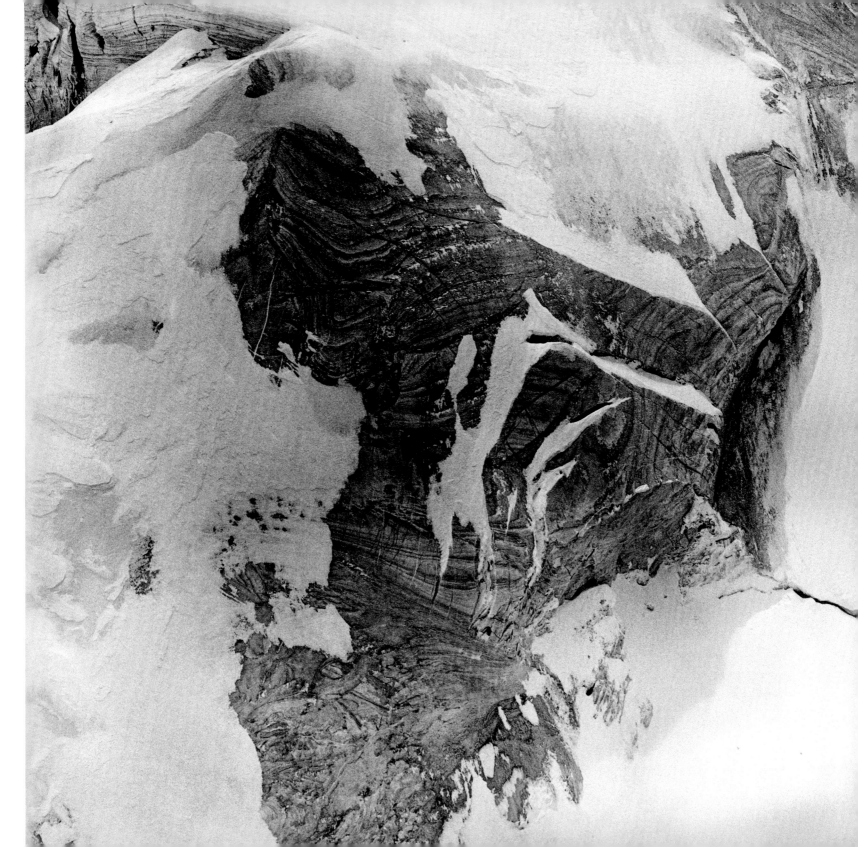

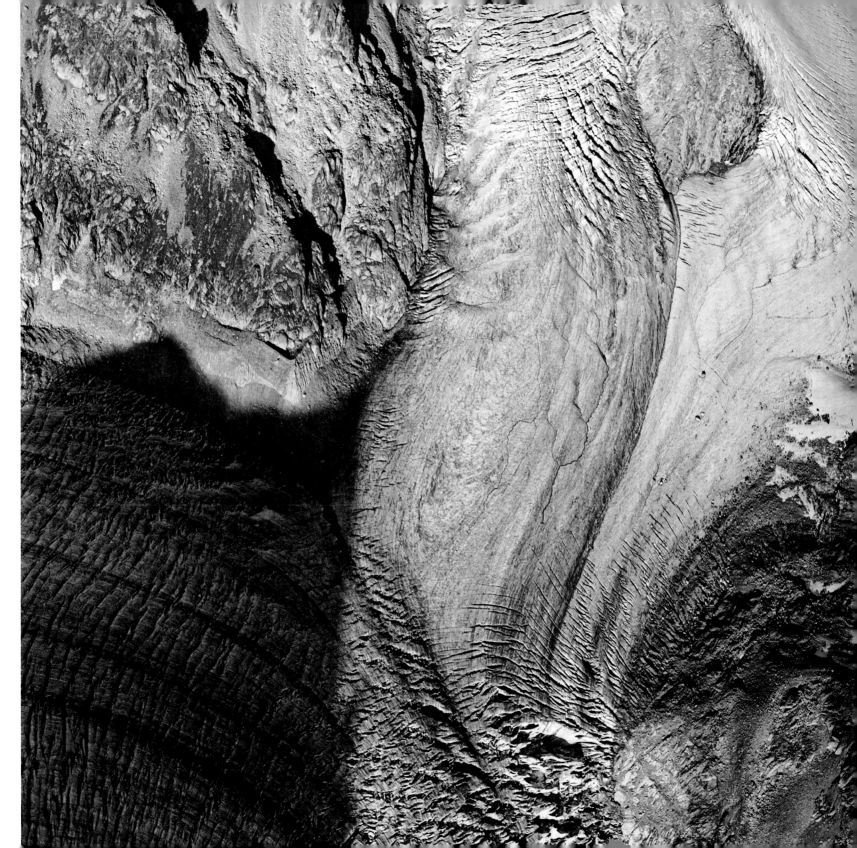

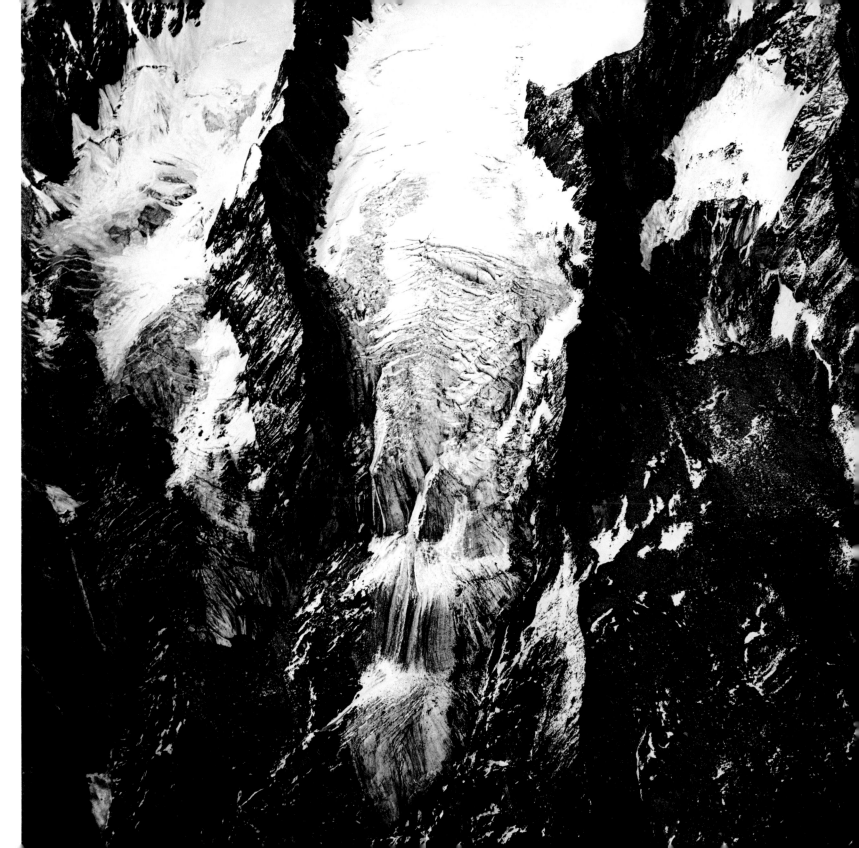

IV

THEATRUM ALPINUM: ALLALIN GLACIER – OBSERVATIONS SERVING MEMORY

1860/63–2014

FROM THE 17TH TO THE EARLY 20TH CENTURY
ALLALIN ICE AVALANCHES
CAUSING AT LEAST TWO DOZEN OUTBURST FLOODS
FROM THE MORAINE-DAMMED LAKE OF MATTMARK

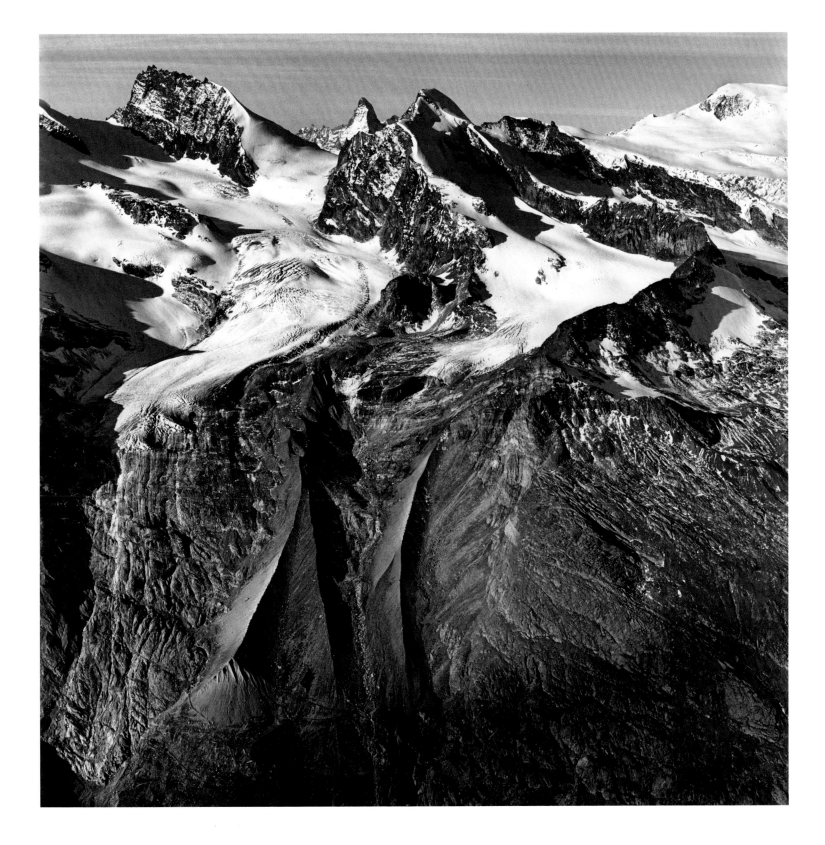

OBSERVATIONS SERVING MEMORY

Adolphe Braun. *Mattmarksee*. 1867. The lake a result of the advance of the orographically right-hand moraine of the Allalin Glacier blocking the River Vispa in 1818.

Unknown photographer. *Mattmark*. 10 October 1910. Terminus of the Allalin Glacier.

Unknown photographer. *Mattmark*. 1934. The orographically right-hand moraine of the Allalin Glacier.

Unknown photographer. *Mattmark*. 1946. Terminus of the Allalin Glacier after the rapid retreat around 1940.

30 AUGUST 1965, 5.15 P.M.
ALLALIN ICE AVALANCHE KILLING EIGHTY-EIGHT MATTMARK DAM BUILDERS

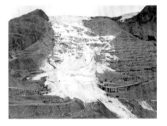

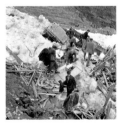

Unknown photographer. *Mattmark*. 10 a.m., 3 September 1947

Unknown photographer. *Mattmark*. 19 September 1964. Dam construction site at the foot of the orographically right-hand moraine of the Allalin Glacier.

Peter Kasser. *Mattmark*. Date unknown. Debris of the Allalin ice avalanche of 30 August 1965 totalling c. 2 million cubic metres.

Unknown photographer. *Mattmark*. 31 August 1965. Rescue operation underway at the barracks of the dam construction site destroyed by the Allalin ice avalanche of 30 August 1965.

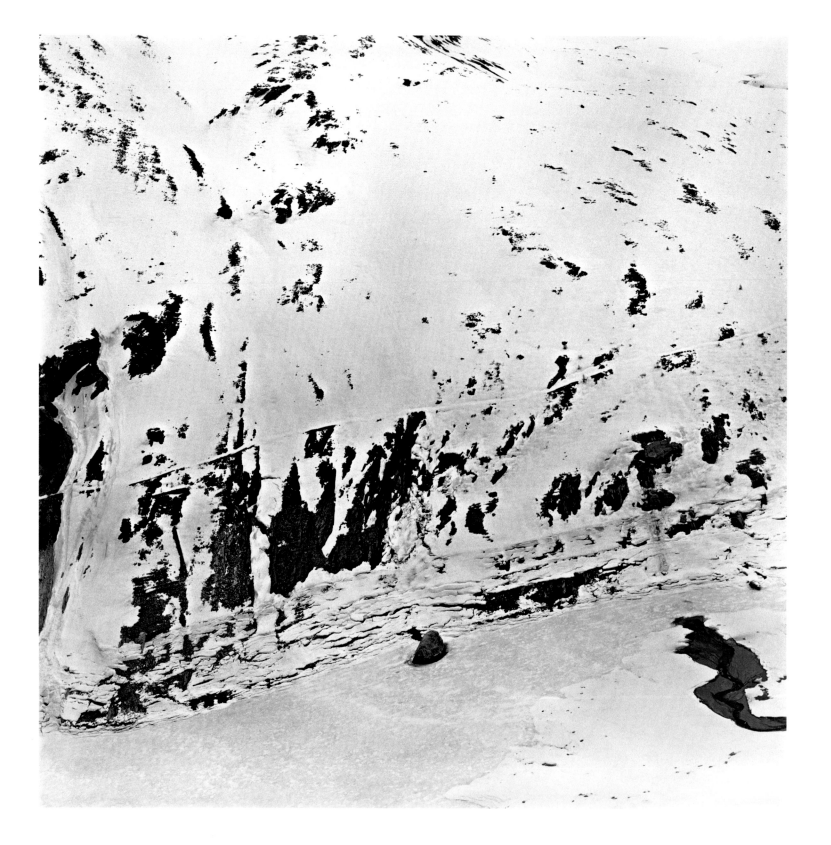

25 JUNE 1969
COMPLETION OF THE DAM
RESERVOIR SUBMERGING THE PIERRE BLEU ERRATIC BOULDER

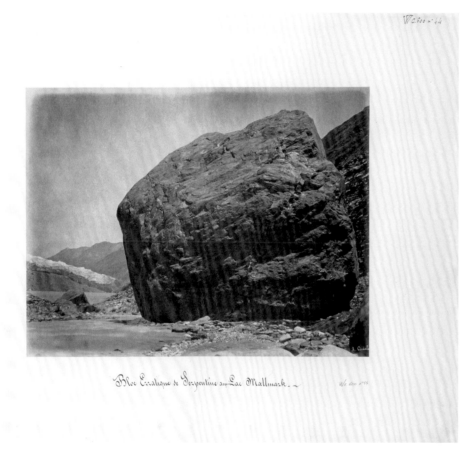

Aimé Civiale. *Serpentine Erratic Boulder at Mattmark Lake*. 1860–63.
A deposit of the Schwarzberg Glacier in the former Mattmark meadow, the serpentine boulder known as the Pierre Bleu or Blauer Stein has a volume of 6,600 cubic metres and is one of the largest erratic boulders in the Alps.

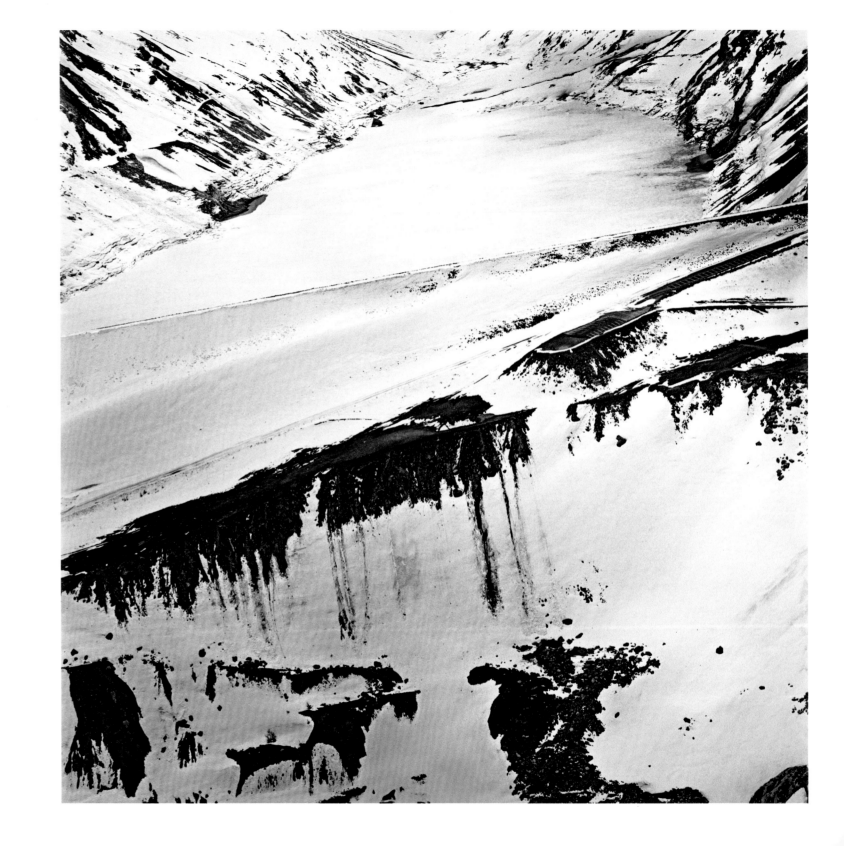

NOT FOREVER

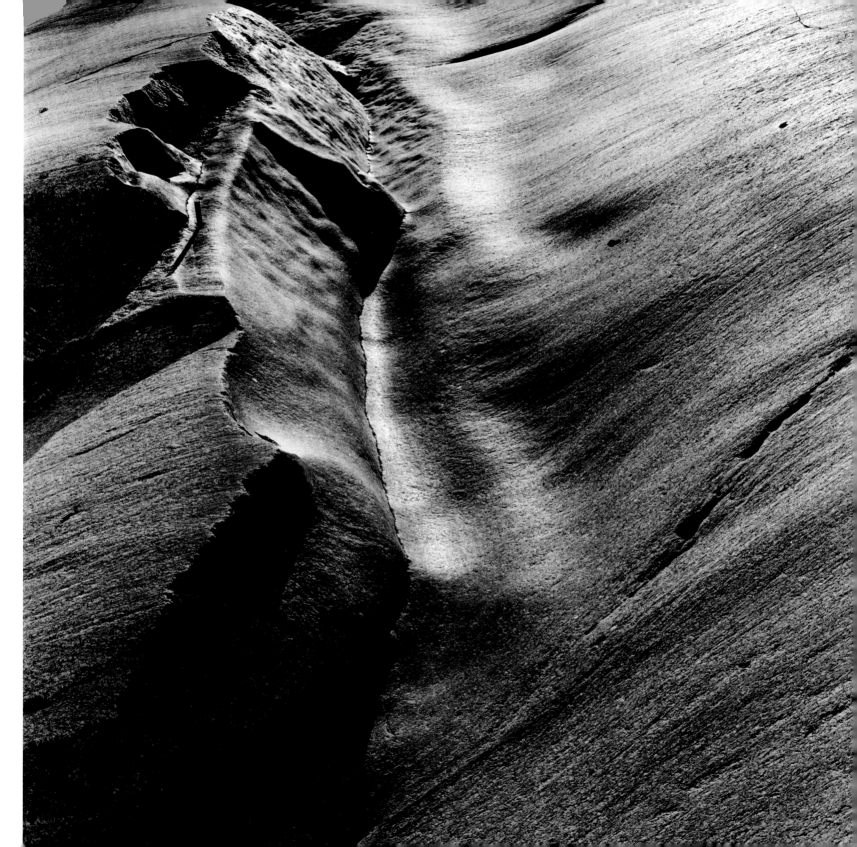

GLACIAL EROSION OF THE ALPS
DATING BACK TO AT LEAST 0.9 MILLION YEARS B.P.

RECONSTRUCTION OF THE ALPINE TOPOGRAPHY PRIOR TO GLACIATION
SUGGESTING INCREASE OF VALLEY-SCALE RELIEF
AND DECREASE OF MEAN ELEVATION

'Other blocks and pebbles, being fixed in the ice, and firmly frozen into it, are pushed along the bottom of the glacier, abrading, polishing, and grooving the rocky floor below, while each stone is reciprocally flattened, polished, and striated on its lower side. As the forces of downward pressure and onward propulsion are enormous, each small grain of sand, if it consist of quartz or some hard mineral, scratches and polishes the surface, whether of the underlying rock or of the boulder which impinges on it, as a diamond cuts glass or as emery powder polishes steel. The striæ which are made, and the deep grooves which are scooped out by this action, are rectilinear and parallel to an extent never seen in those produced on loose stones or rocks, where shingle is hurried along a torrent.' Charles Lyell, *Elements of Geology*, 1865

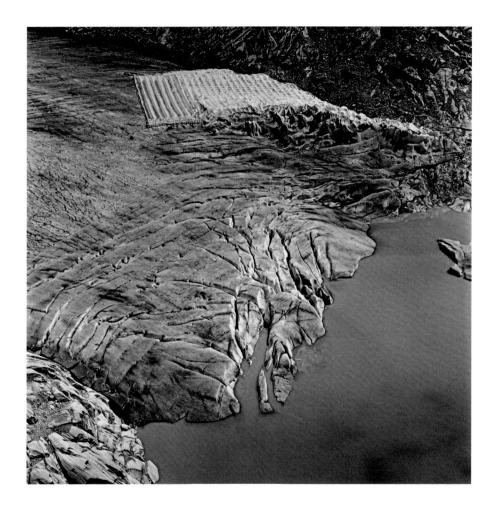

V

THEATRUM ALPINUM: RHONE GLACIER – RETREAT AND COLLAPSE

1546–2100

Paul-Louis Mercanton. *Rhône Glacier Front 1874–1913*. 1916

OPPOSITE:
Samuel Wiesmann. *Rhône Glacier Disappearance 2000–2100*. 2012

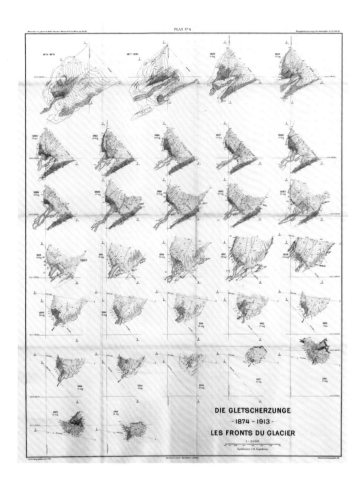

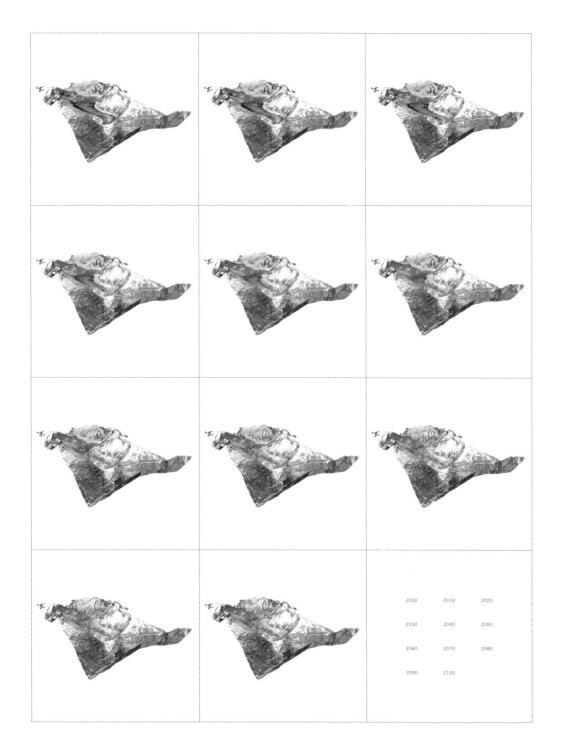

2000 2010 2020

2030 2040 2050

2060 2070 2080

2090 2100

UNDER THE GLACIER THE FUTURE TAKING SHAPE

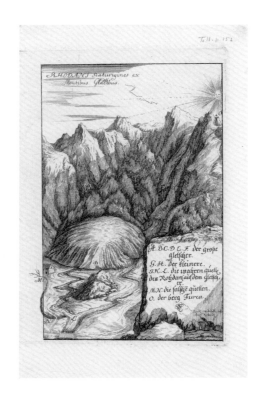

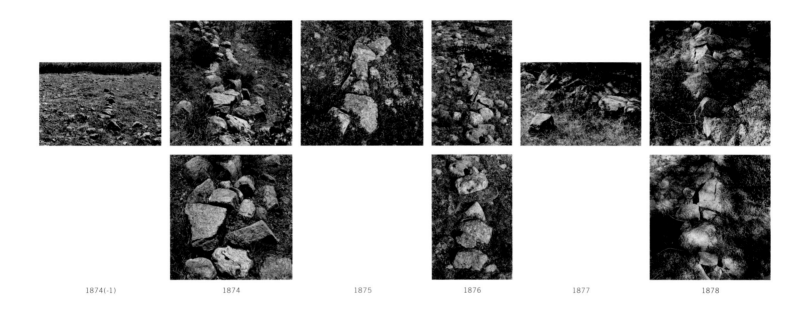

1874(-1)　　　　　　1874　　　　　　　1875　　　　　　　1876　　　　　　　1877　　　　　　　1878

STONES FOR SCIENCE

Paul-Louis Mercanton. *Rhône Glacier Yellow Stone Line 1874–1892*. 1916

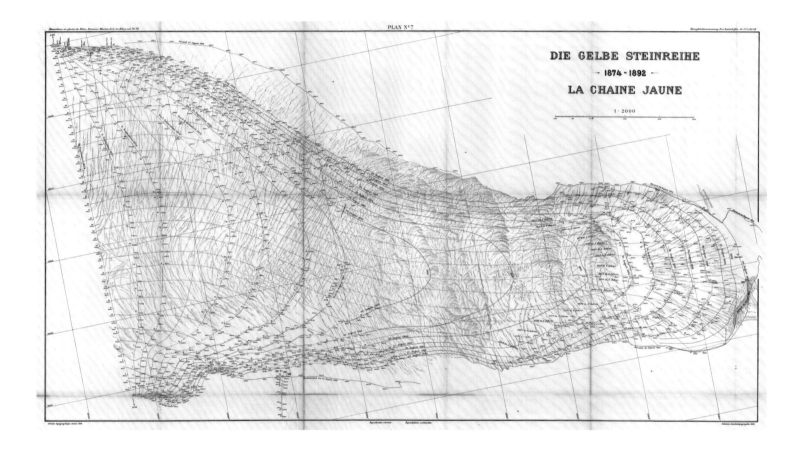

STONES CONNECTING TIME

1874
14 SEPTEMBER
FIFTY-ONE LARGE STONES
COLOURED YELLOW AND NUMBERED
MAPPED AS THE YELLOW CHAIN OF THE MERCANTON RHONE GLACIER SURVEY
CONDUCTED BETWEEN 1874 AND 1915
PLACED 20 METRES APART PRODUCING A STRAIGHT LINE OF 995 METRES
WITH WHICH TO MEASURE THE ICE FLUCTUATIONS IN THE SURFACE FLOW FIELD

1885
27 AUGUST
THIRTEEN OF THE STONES NUMBERED 19 TO 33
FOUND SCATTERED ACROSS THE ICE CATARACT COVERING THE ESCARPMENT
THEIR POSITIONS MAPPED
VISUALIZING THE PARABOLIC SPEED DISTORTION OF THE YELLOW CHAIN
ALONG THE LONGITUDINAL CENTRE LINE OF THE GLACIER

1985
(14 SEPTEMBER)
THE DAY YOU ARE BORN

CUMULATED LENGTH CHANGE OF THE GLACIER
ALONG THE CENTRAL LONGITUDINAL PROFILE SINCE 1885
MINUS 981 METRES

2012
27 AUGUST
THE TERRAIN OF THE ESCARPMENT
EXPOSED SINCE 1955
PREVENTING YOU FROM FOLLOWING THE LINE OF STONES
MAPPED THE SAME DAY 127 YEARS BEFORE

2012
31 AUGUST
LOOKING FOR STONE NO. 28
ONE OF THE NINE
FORMING THE FINAL LINE OF THE MERCANTON RHONE GLACIER SURVEY
MAPPED ON 30 AUGUST 1892
I AM LOSING MY WAY IN THE ALDER BRUSH
COVERING THE GLACIER FOREFIELD BELOW THE ESCARPMENT

LINKING A BIOGRAPHY WITH A GLACIAL CHRONOLOGY –
AS AMBIGUOUS AN ENTERPRISE AS
THE DEFINITION OF A GLACIER BOUNDARY

GLETSCH SWITZERLAND
2012

CONTOURS OF ICE CRYSTALS LOCKED IN A CANNIBALIZING STRUGGLE

A 500-YEAR CHRONICLE OF COMPRESSION AND GLACIAL FLOW

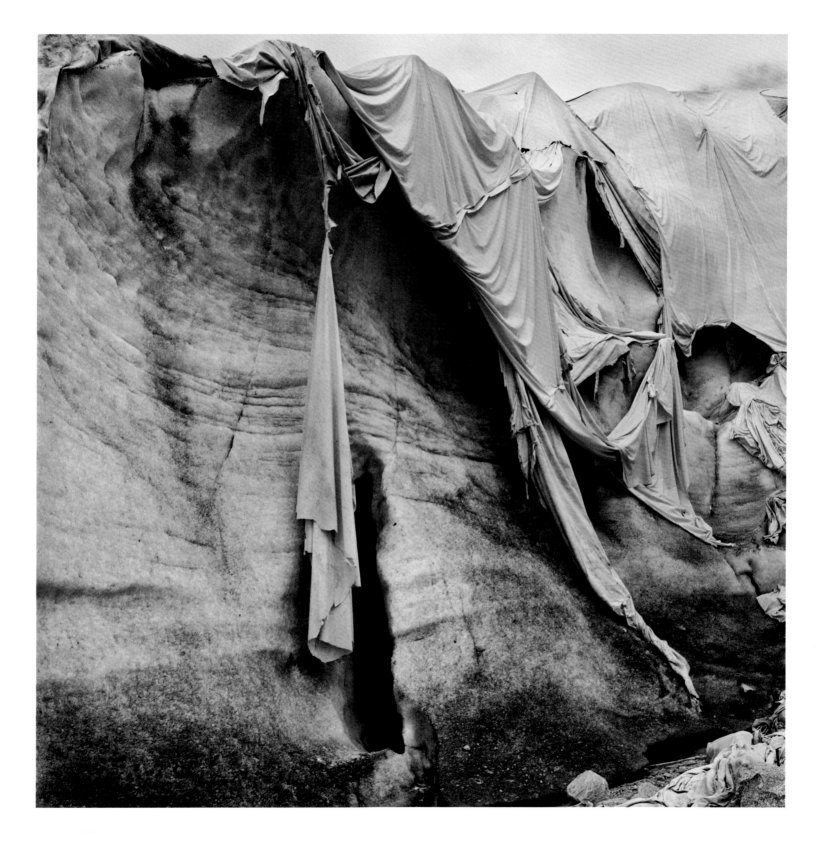

DISPATCH FROM THE LITTLE ICE AGE

In July and August 1546 Sebastian Münster (1488–1552) travelled on horseback from Basel by way of Solothurn to Lake Geneva and up the Rhône Valley, crossing the Furka Pass and returning to Basel by way of Zurich. He traversed the Rhône glacier on 4 August.

'On August 4, 1546, as I was riding towards Furka, I came to an immense mass of ice. As far as I could judge it was about two or three pikes lengths thick, and as wide as the range of a strong bow.* Its length stretched indefinitely upwards, so that you could not see its end. To anyone looking at it it was a terrifying spectacle, its horror enhanced by one or two blocks the size of a house which had detached themselves from the main mass. White water flowed out of it so full of particles of ice that a horse could not ford it without danger. This watercourse marks the beginning of the river Rhone.'
Sebastian Münster, *Cosmographia universalis*, 1544 (from first Latin edition of 1552, English translation 1972)

* The 16th century Swiss pike measured between 4.6 and 5 metres. The glacier ended in a steep front 10–15 metres high and c. 200 metres wide.

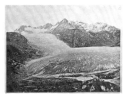

Gustave Dardel. *Rhône Glacier. August 1849*. Reproduction by Maison Braun, Clément et Cie from the lost daguerreotype 1893.

Emil A. F. Nicola. *Rhône Glacier. Summer 1874*.

Leonz Held. *Rhône Glacier. 24 August 1888*.

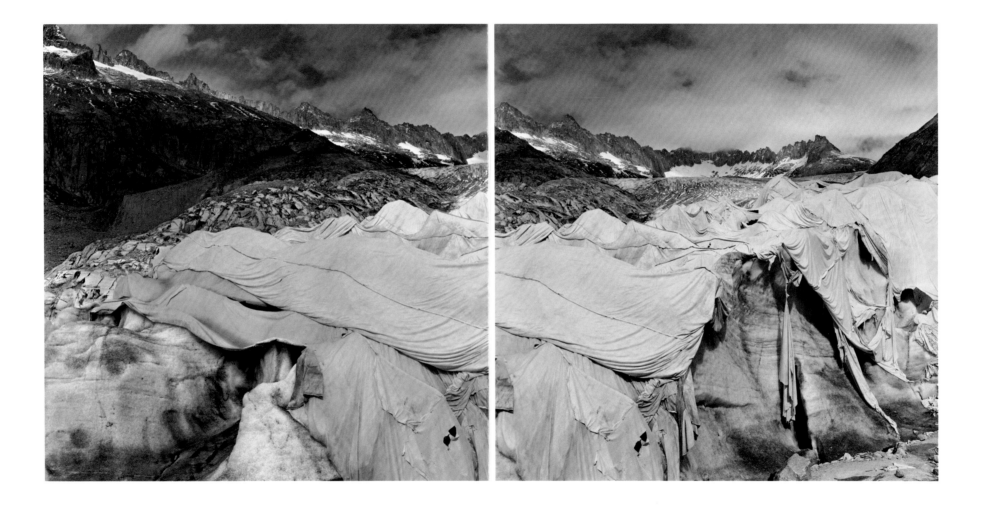

AS HISTORICAL SITES GLACIERS ONCE GONE DO NOT COME BACK

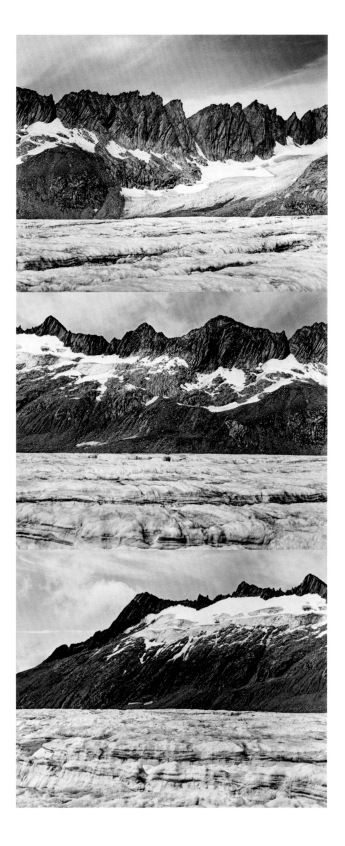

12 AUGUST 2014 PHOTOGRAPHER ON GLACIER
RHONEGLETSCHER EXPOSING IMAGES
672 757 / 162 364 THROWING SEALED FILM CAPSULE INTO CREVASSE
46°36'51'' N / 08°23'30'' E

ONE HUNDRED YEARS PHOTOGRAPHER FORGOTTEN
GLACIER PERISHED
FROM NOW CAPSULE ACCIDENTALLY FOUND
FROZEN IMAGES PROCESSED PERHAPS

VI

HINDUKUSH KARAKORUM: FAILURE IN THE MOUNTAINS

2010–2016

BATURA GLACIER. KARAKORUM. PAKISTAN
10 OCTOBER 2016
OPPOSITE: MORAINES OF WAR. TASHKURGAN. HINDUKUSH. AFGHANISTAN
10 JANUARY 2010

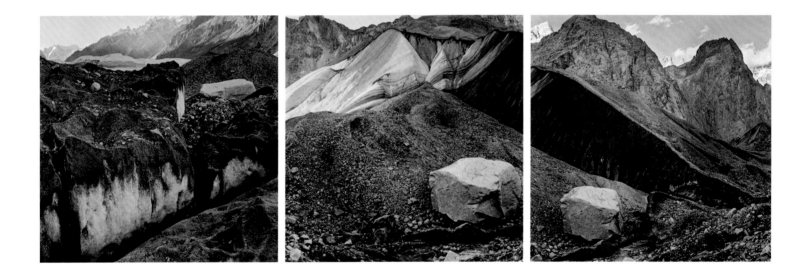

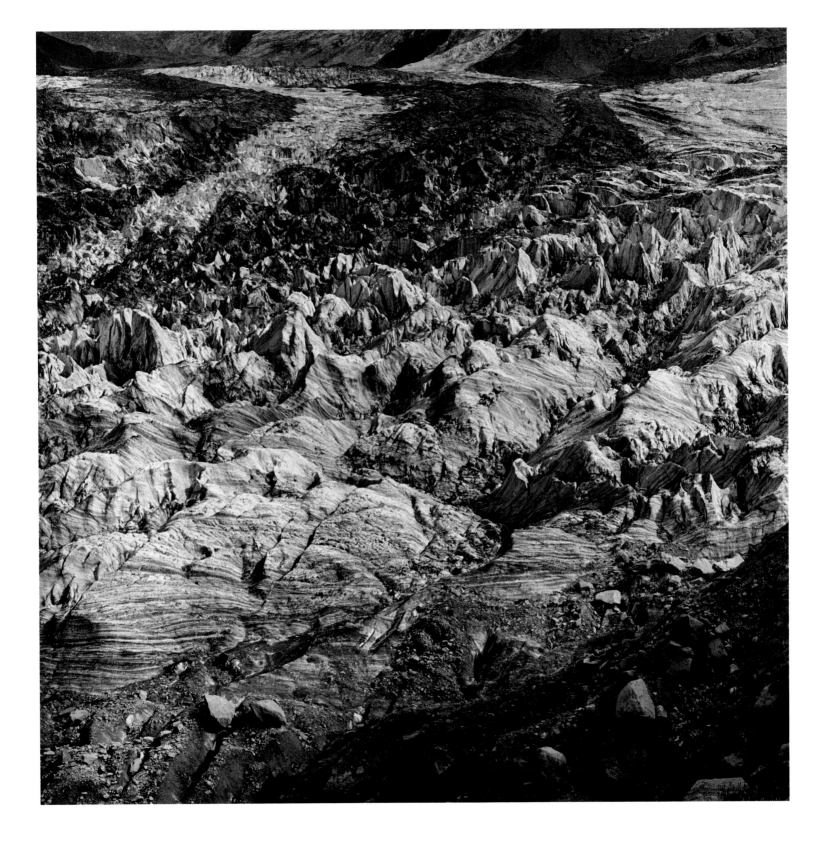

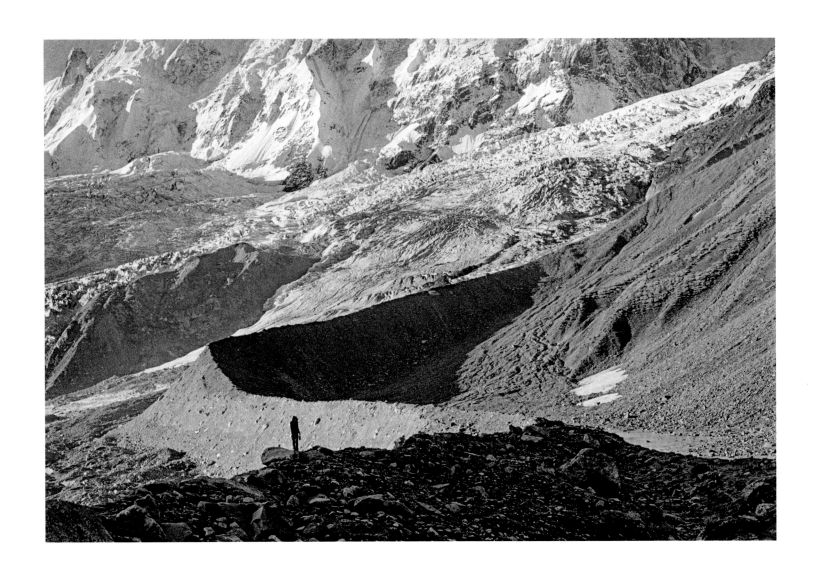

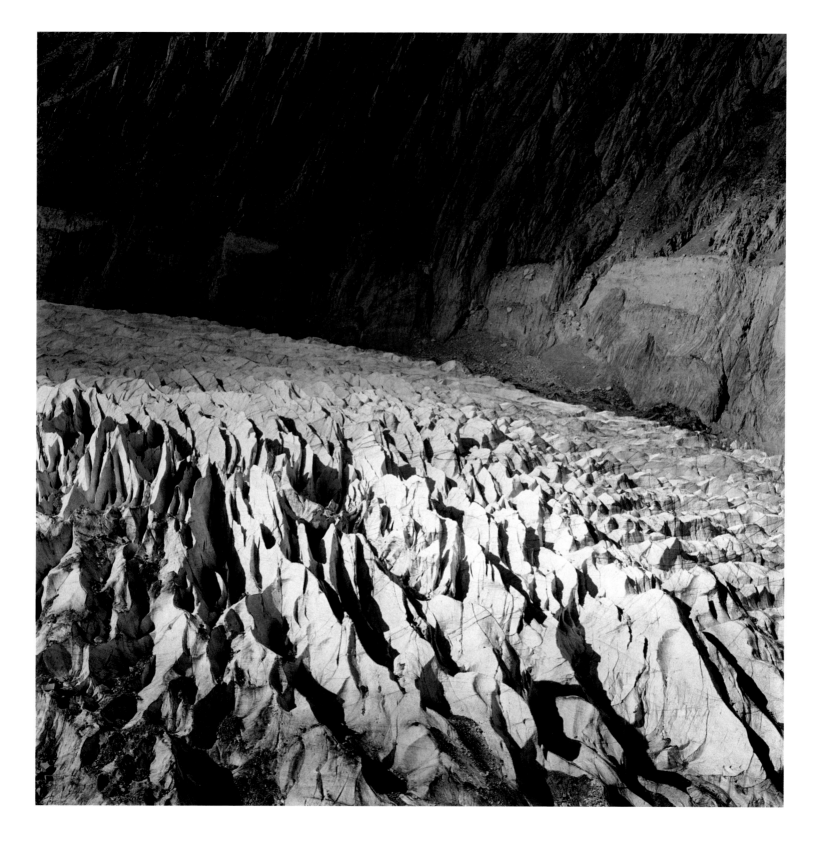

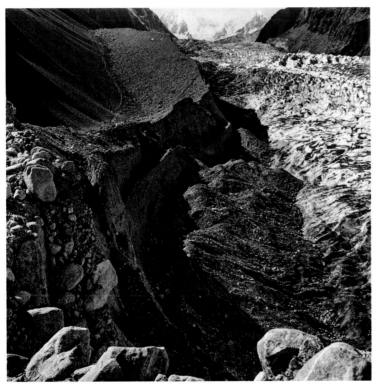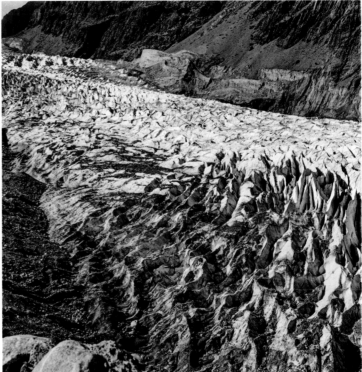

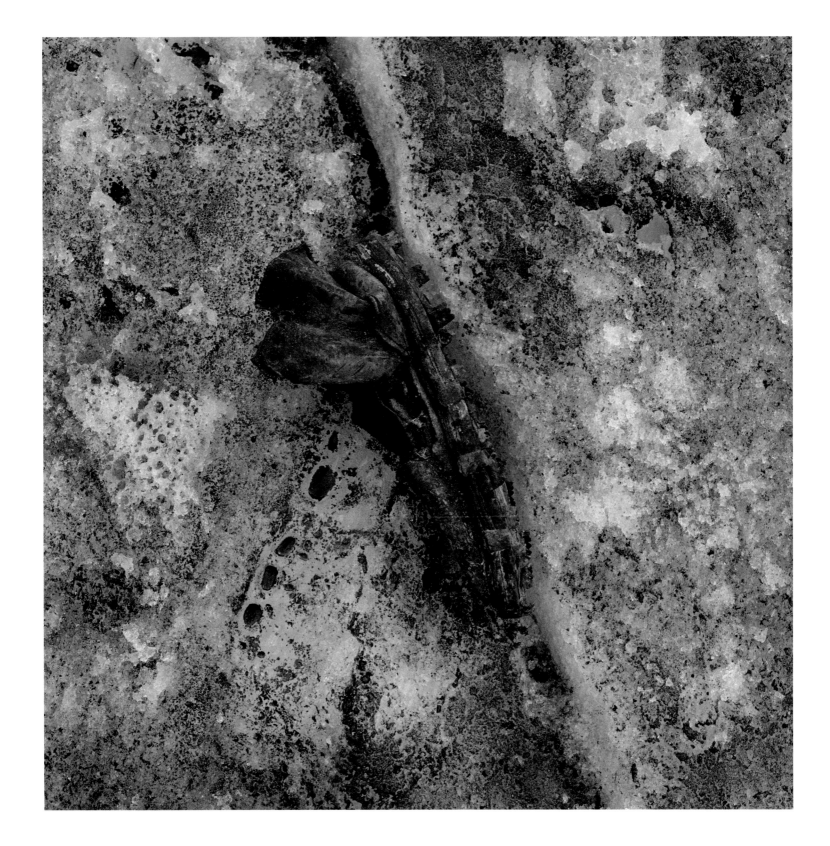

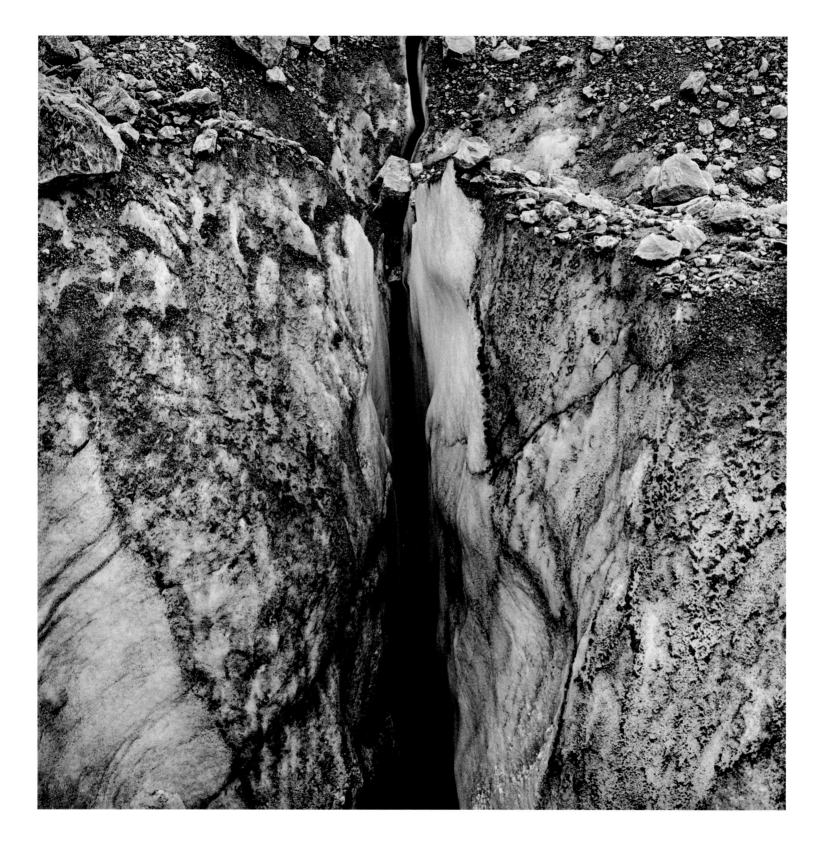

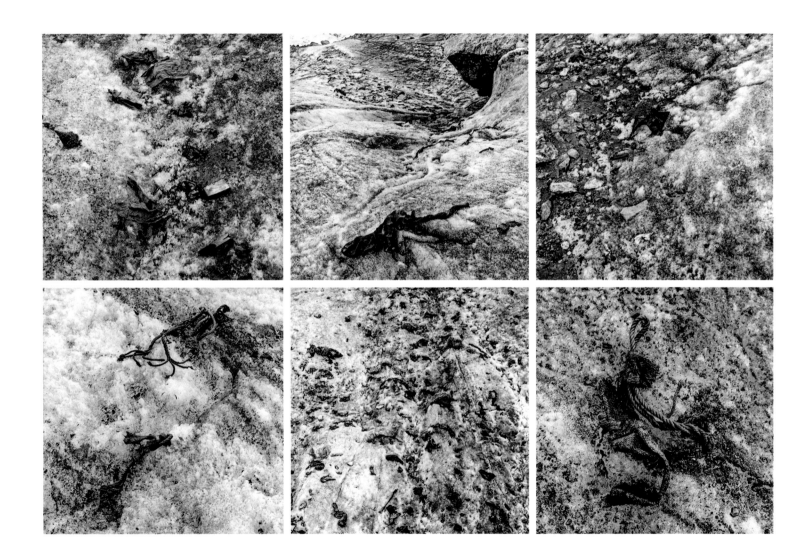

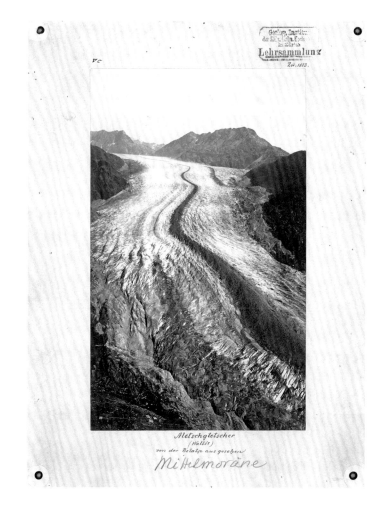

Francis Frith. *Aletsch Glacier (Wallis) seen from the Belalp.* c. 1880

FINDS OF THE GERMAN NANGA PARBAT EXPEDITIONS OF 1934 OR 1937.
MADE ON 26/27 SEPTEMBER 2015 ON RAIKOT GLACIER. NANGA PARBAT. KARAKORUM. PAKISTAN

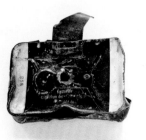
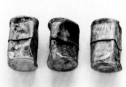
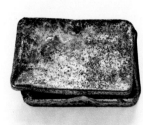

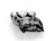
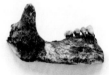

OPPOSITE PAGE (LEFT TO RIGHT)
SIEMENS 16MM FILM TIN
THREE CANISTERS OF AGFA 35MM FILM (EXPOSED OR UNEXPOSED)
SIEMENS 16MM FILM TIN (UNUSED)
FRAGMENT OF JAWBONE WITH FOUR TEETH
FRAGMENT OF JAWBONE WITH THREE TEETH (ONE WITH GOLD CROWN)
SKULL FRAGMENT
TUBE, LID OF A MEDICINE TIN, BATTERY
SWASTIKA, MOST LIKELY FROM THE SHAFT OF AN ICE-PICK
FRONT PART OF LEICA COMPACT CAMERA-CASE LINED WITH FELT

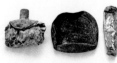
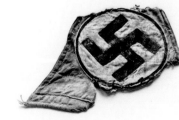
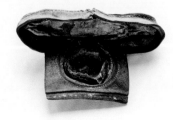

VII

THEATRUM ALPINUM: ALETSCH GLACIER – DEAD MEN TELLING TALES

C. 1880–2015

EMBEDDED MOVEMENT

AS LOW AS FIFTEEN METRES ABOVE THE GLACIER
AS LIKELY AS NOT FLYING OVER THE PLACE
WHERE
THE MORTAL REMAINS OF THREE OF FOUR ALPINISTS FROM THE LÖTSCHENTAL
THE BROTHERS
JOHANN, FIDELIS AND CLETUS EBENER
ACCOMPANIED BY THEIR NEIGHBOUR MAX RIEDER
LAST SEEN AT DAWN ON 4 MARCH 1926
WILL BE FOUND ACCIDENTALLY
TOGETHER WITH SCATTERED PERSONAL BELONGINGS
THE NEXT DAY
AFTER BEING MISSING FOR EIGHTY-SIX YEARS
FOUR-FIFTHS OF THE RESIDENCE TIME TO ELAPSE
BETWEEN THE MOMENT
THE ICE CRYSTAL MELTS ONTO THE SURFACE OF THE GLACIER
AND ITS DISCHARGE AT THE FRONT

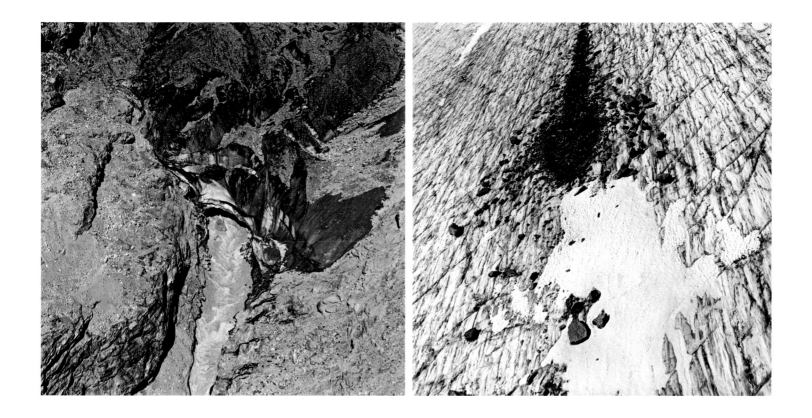

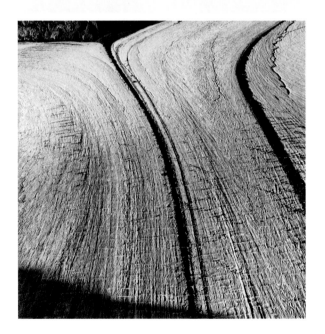

PRECEDING PAGES:
PERSONAL BELONGINGS FOUND TOGETHER WITH THE CORPSES OF THE THREE EBENER BROTHERS ON 28 JUNE 2012
LÖTSCHENTALER MUSEUM. KIPPEL. SWITZERLAND
26 APRIL 2013

KONKORDIAPLATZ. 19 OCTOBER 2014
ALETSCHGLETSCHER. 23 SEPTEMBER 2014
KONKORDIAPLATZ. 19 OCTOBER 2014

This page and opposite:
Text and map after Guillaume Jouvet and Martin Funk, *Modelling the trajectory of the corpses of mountaineers who disappeared in 1926 on Aletschgletscher, Switzerland*,
in *Journal of Glaciology*, 2014

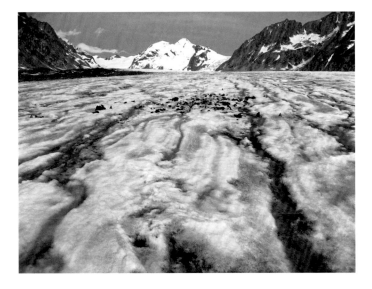

Anonymous photographer. *The site of the find before the police cleared it*. 28 June 2012

IN THE ICE

MODELLING THE SPACE-TIME TRAJECTORY BENEATH THE SURFACE OF ALETSCHGLETSCHER
OF THE CORPSES OF CLETUS, FIDELIS AND JOHANN EBENER
WHO DISAPPEARED IN PROLONGED SEVERE WEATHER CONDITIONS ON THE ALETSCHGLETSCHER AFTER 4 MARCH 1926

USING THE TIME-DEPENDENT RECONSTRUCTED VELOCITY FIELD FROM THE FULL-STOKES ICE FLOW MODEL
BY INTEGRATING BACKWARDS IN TIME THE ICE VELOCITY FIELD
STARTING FROM THE KNOWN LOCATION WHERE THE SKELETONS WERE FOUND AT THE GLACIER SURFACE ON 28 JUNE 2012
OBTAINING AN UPSTREAM END POINT OF IMMERSION ~10.5 KILOMETRES AWAY
IN A RECTANGULAR AREA REPRESENTING APPROXIMATELY 0.6 PER CENT OF THE ENTIRE ALETSCHGLETSCHER
AND A FALL IN ALTITUDE OF ~800 METRES

CONCLUDING THAT ALONG THE JOURNEY THE CORPSES
WERE REGULARLY ADVECTED DEEPER INTO THE ICE
REACHING A MAXIMUM DEPTH OF ~250 METRES FOR A TOTAL ICE THICKNESS OF ~600 METRES AT THAT LOCATION IN 1980
SUBJECTING THE BONES TO PRESSURE OF ~20 BARS
TURNED TO THE RIGHT AT THE CONFLUENCE OF KONKORDIAPLATZ BETWEEN 1980 AND 1990
AT THE SAME TIME ACCELERATING FROM ~100 TO ~200 METRES PER YEAR
AND WERE EXPOSED AT THE SURFACE OF THE GLACIER FOR SEVERAL SEASONS PRIOR TO 2012

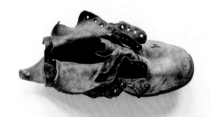

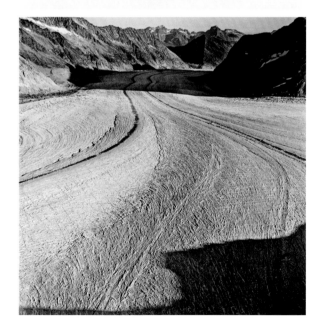

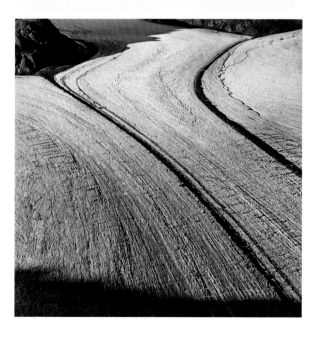

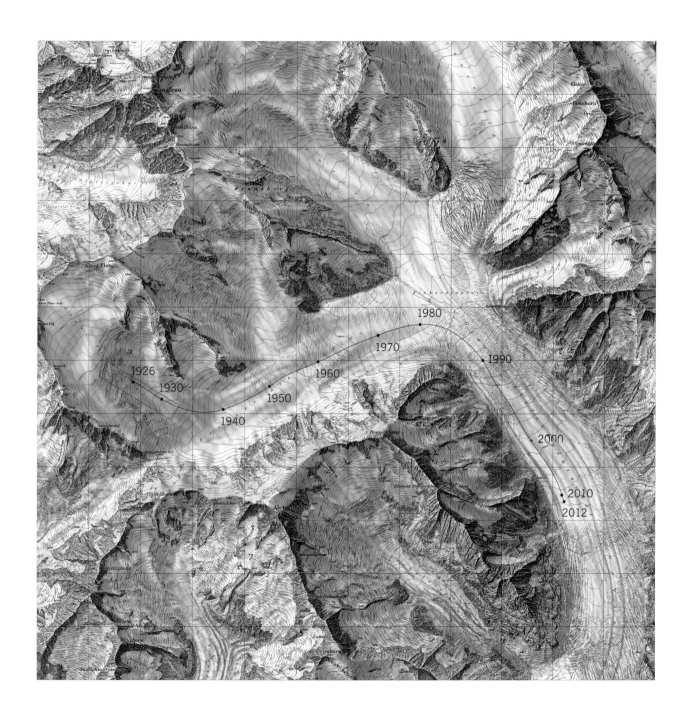

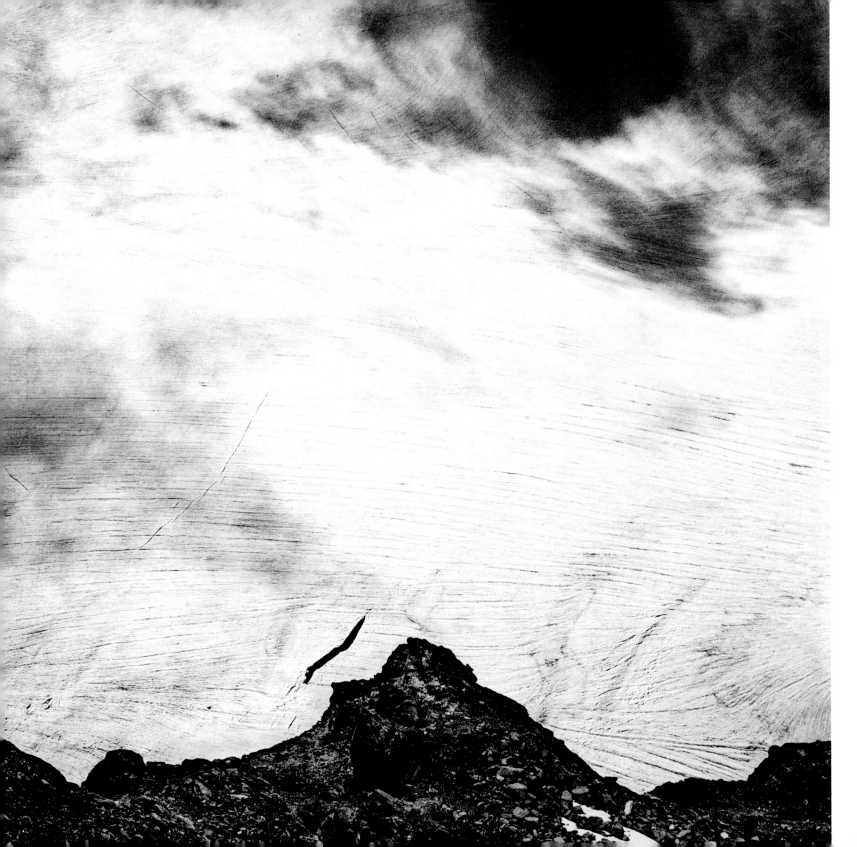

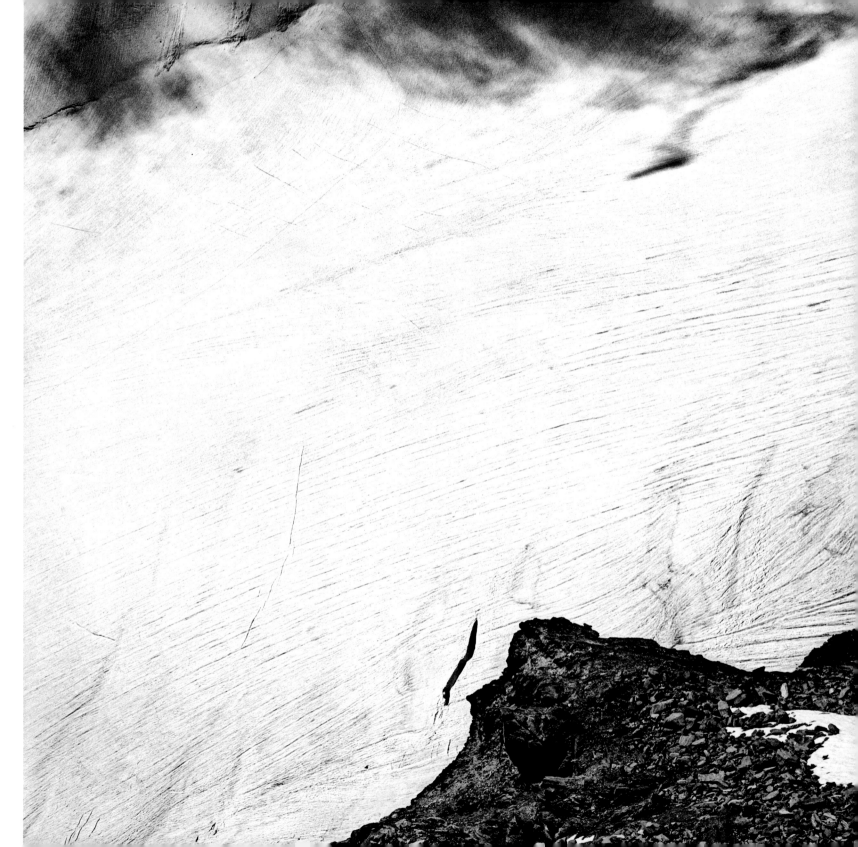

The equilibrium-line altitude (ELA) of a glacier is the altitude of the boundary between the zone of accumulation and the zone of ablation.
The ELA is the elevation at which the net accumulation in a given year is zero. When annual snow and ice accumulation exceeds the loss by melting and other processes
such as the calving of icebergs, the glacier has a positive mass balance and increases in mass. When the snow and ice loss exceeds the mass gain, the glacier has a negative mass balance.
Generally the headward part of the glacier, the accumulation area, has a net gain, and the lower part of the glacier, the ablation area, has a net loss.
The state of health of a glacier can be defined by its mass balance.

The average mass balance of 40 reference glaciers with available long-term observation series around the world continues to be negative.
Tentative figures for the hydrological year 2014 indicate a further thickness reduction of 0.6 metres water equivalent (m.w.e.). The data continues the global trend
in strong ice loss over the past decades, bringing the cumulative average thickness loss of the reference glaciers since 1980 to 18.5 m.w.e.
Regional differences occurring in the 1980s are not prescinded in the data.

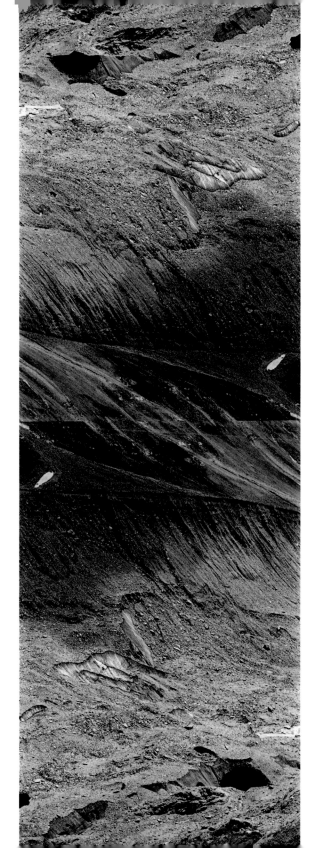

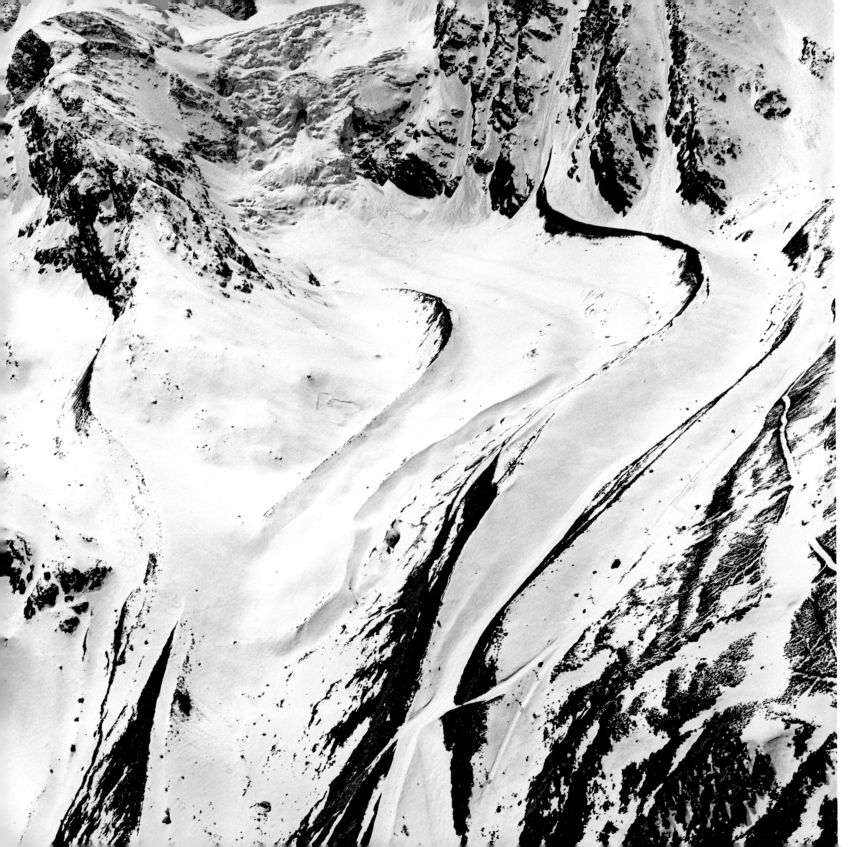

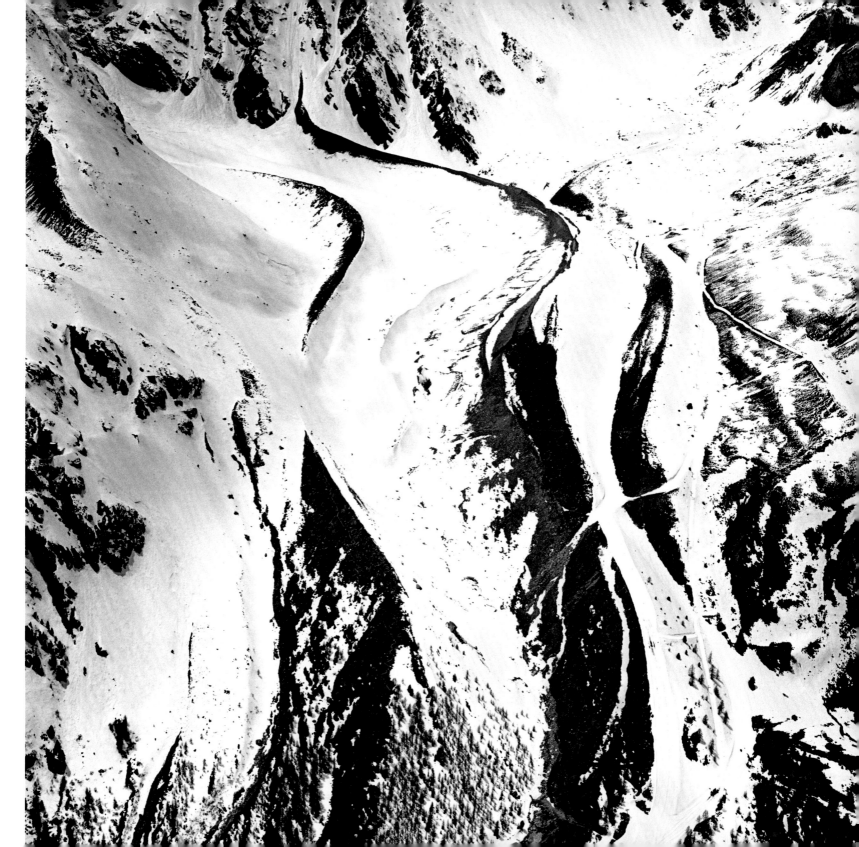

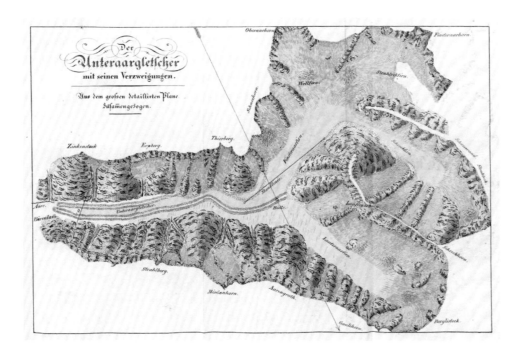

Franz Josef Hugi, *The Lower Aar Glacier and its branches*. 1830. Based on the survey by Urs Josef Walker

VIII

THEATRUM ALPINUM: LOWER AAR GLACIER – FACING PHYSICS

9,100 YEARS B.P.–2016

'As often as glaciers are confluent, the right lateral moraine of one blends with the left moraine of the other, and both are then carried down in the middle of the mass of ice produced by the union of the two glaciers, forming what is called a medial moraine. The number and position of these moraines will depend on the number and size of the tributary glaciers which join the main one. By such machinery, not only small stones and earth, but erratic blocks of the largest size are carried down from the mountains to the lower valleys and plains…' Charles Lyell, *Elements of Geology*, 1865

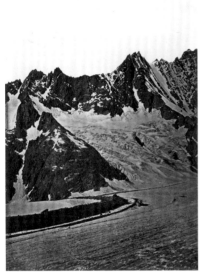 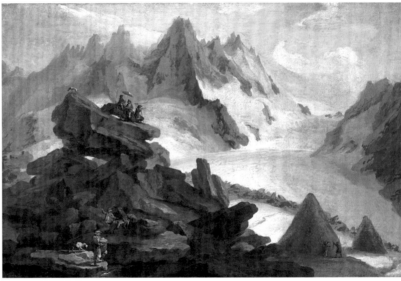

LEFT Camille Bernabé. *Lower Aar Glacier. Confluence of Finsteraar and Lauteraar Glaciers with Hugi-Block and Hôtel des Neuchâtelois boulders on the medial moraine where the two lateral moraines merge. 20 August 1850*. Reproduction by Maison Braun, Clément et Cie from the lost daguerreotype 1893

RIGHT Caspar Wolf. *The Lauteraar Glacier with view over the Lauteraarsattel*. 1776
Caspar Wolf's standpoint is the so-called Abschwung: the beginning of the middle moraine of the Lower Aar Glacier, resulting from the confluence of the left-hand lateral moraine of the Finsteraar Glacier and the right-hand moraine of the Lauteraar Glacier. This middle moraine transported two colossal granite boulders (see historic photograph above). Below one of these Franz Josef Hugi, discoverer of the ice crystal, set up his 'hut'. The camp is marked on his 1830 map *The Lower Aar Glacier and its branches* (see p. 148) and was the departure point of his expeditions between 1827 and 1831. A signpost, erected 1950 metres further down on an erratic boulder, marked the lower end of the LOP (line of position) of Hugi's trigonometric measurements. Three years later the block with the camp and the signpost had wandered 110 metres further down the valley, due to the movement of the glacier; in 1836 they were 1.3 kilometres from the original point. The glacial advance was a result of the Little Ice Age climate, favourable to glaciers, that ended in the 1850s. The dislocation of the 'Hugi-Block' that stimulated the Solothurn geologist's work on glacial movement and mechanics, was measured over 150 years, until it disappeared into a glacier funnel. A later version of Hugi's 'hut' and taking advantage of the second erratic's shelter seen in the historic photograph was the 'Hotel des Neuchâtelois', the research base of Louis Agassiz, used between 1840 and 1845 for carrying out the 'Studies on Glaciers' (*Études sur les Glaciers*, Jent & Gassman, Soleure 1840). *The Map of the Lower Aar Glacier* (see pp. 153–154), published in the atlas volume of *New studies and experiments on glaciers today* (*Nouvelles études et expériences sur les glaciers actuels*, 1847), was the first scientific glacier map.

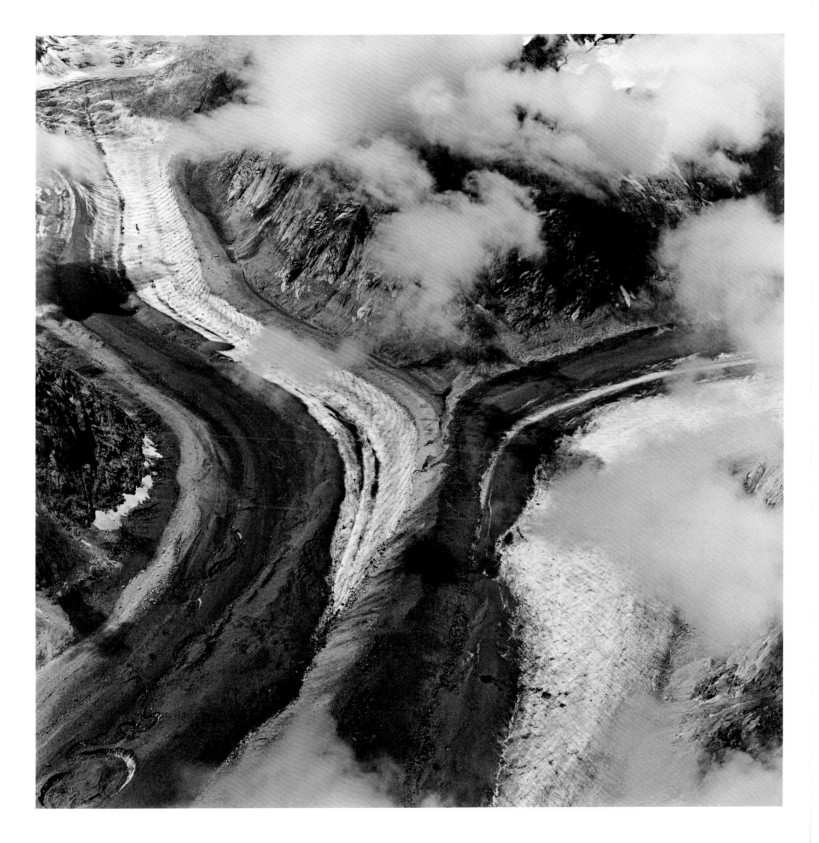

STAGNANT ICE. UNTERAARGLETSCHER. SWITZERLAND
2 NOVEMBER 2016

The glacier portal in this triptych is not identical with the portal seen in the aerial view of 2014 (opposite page). The comparison shows the glacier tongue changes in just two years. The 5 August 2015 outline (superimposed in black onto the 1842 map reproduced on the following pages) identifies the broad collapse crater (see also p. 223) which had disappeared by 2016. Its ice wall was cut by runoff from the slopes and the foremost front of the glacier became decoupled from the main glacier body. (See also p. 38.)

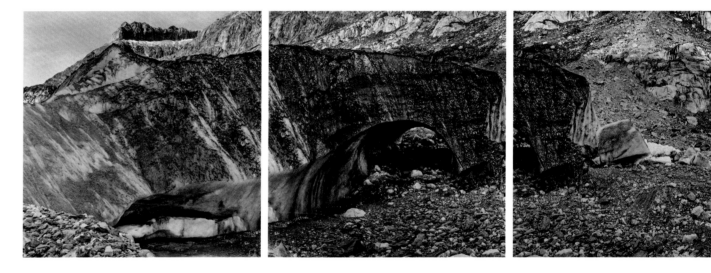

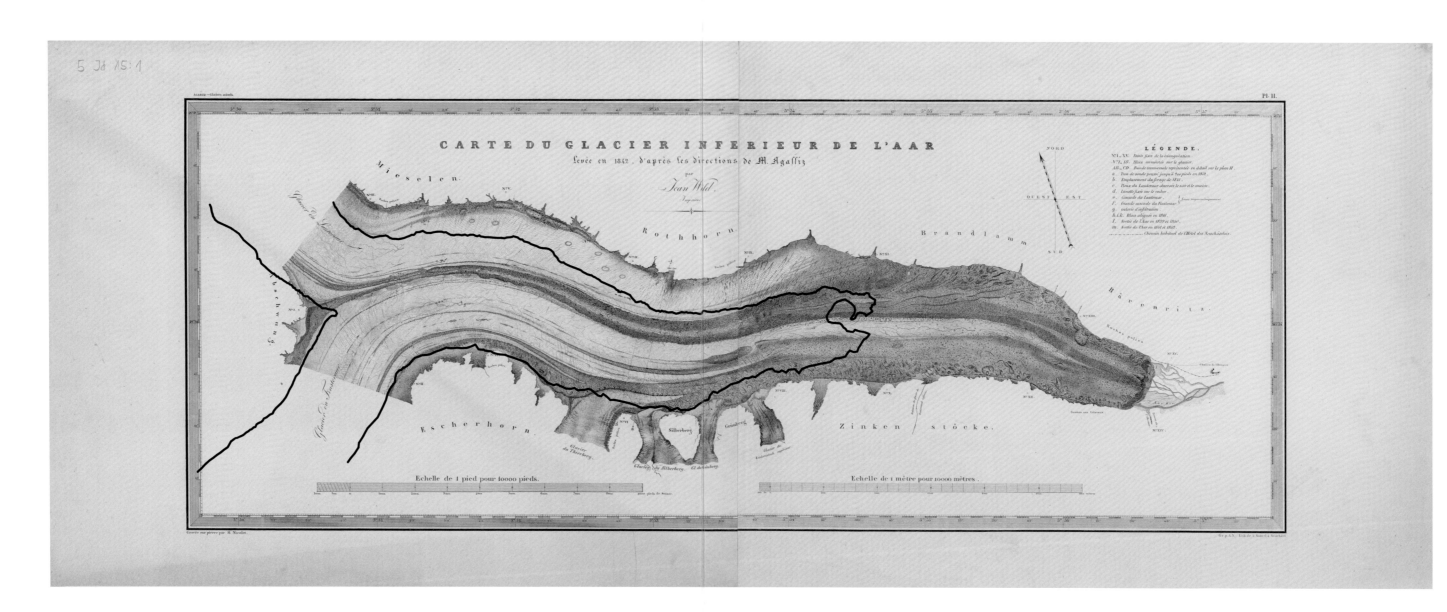

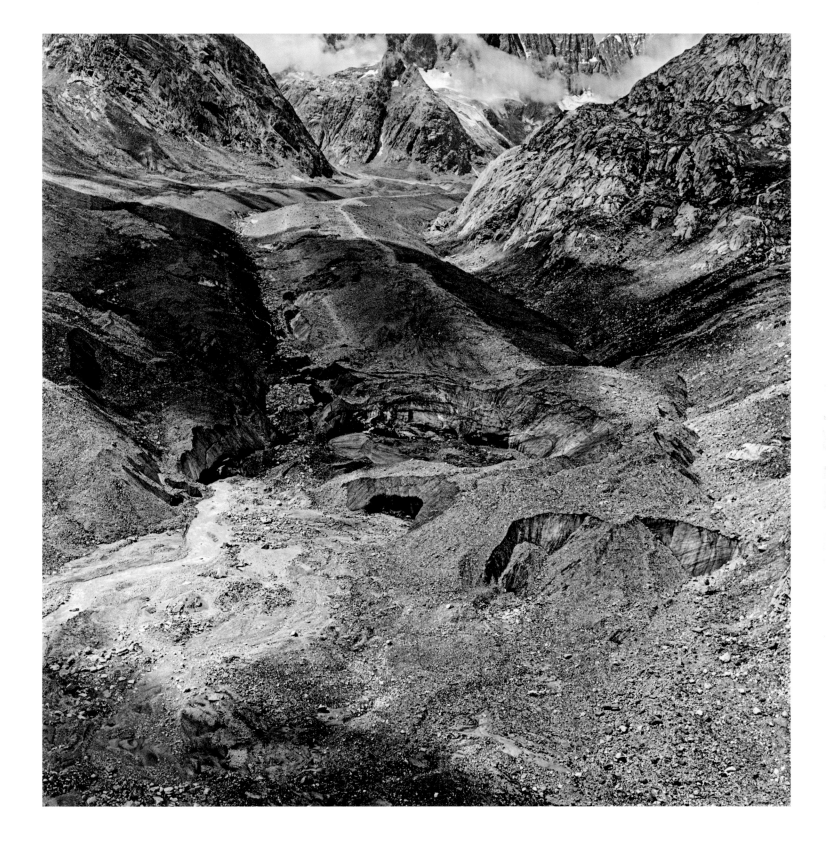

GREEN ALPS

PIECES OF WOOD MORE THAN 9,000 YEARS OLD
RINSED OUT BY MELTWATER FROM UNDER THE LOWER AAR GLACIER
INDICATING FORESTS AND EVEN MOOR
WHERE TODAY THERE IS ICE

TIMBER FROM THE HOLOCENE. UNTERAARGLETSCHER. SWITZERLAND
Left: Larch (*Larix sp.*) trunk fragment. 9,100 calendar years old.
2 NOVEMBER 2016

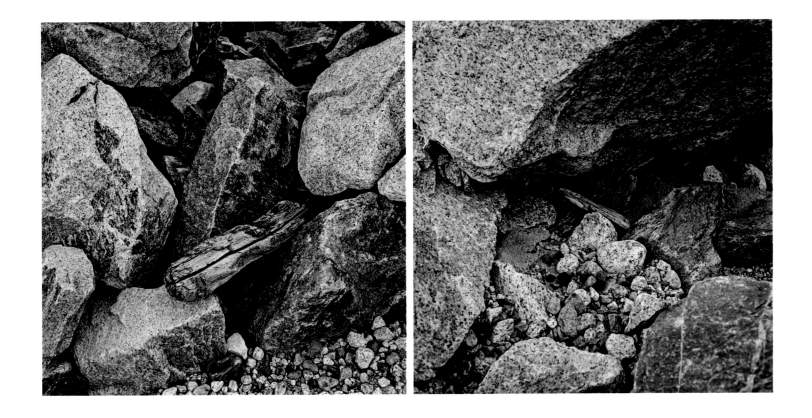

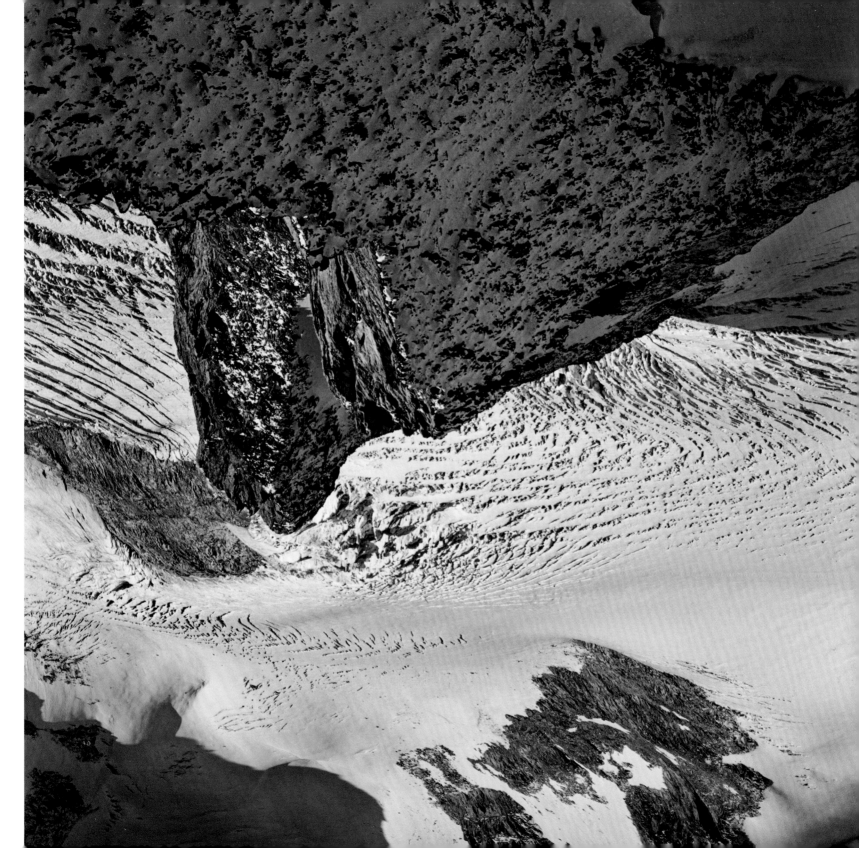

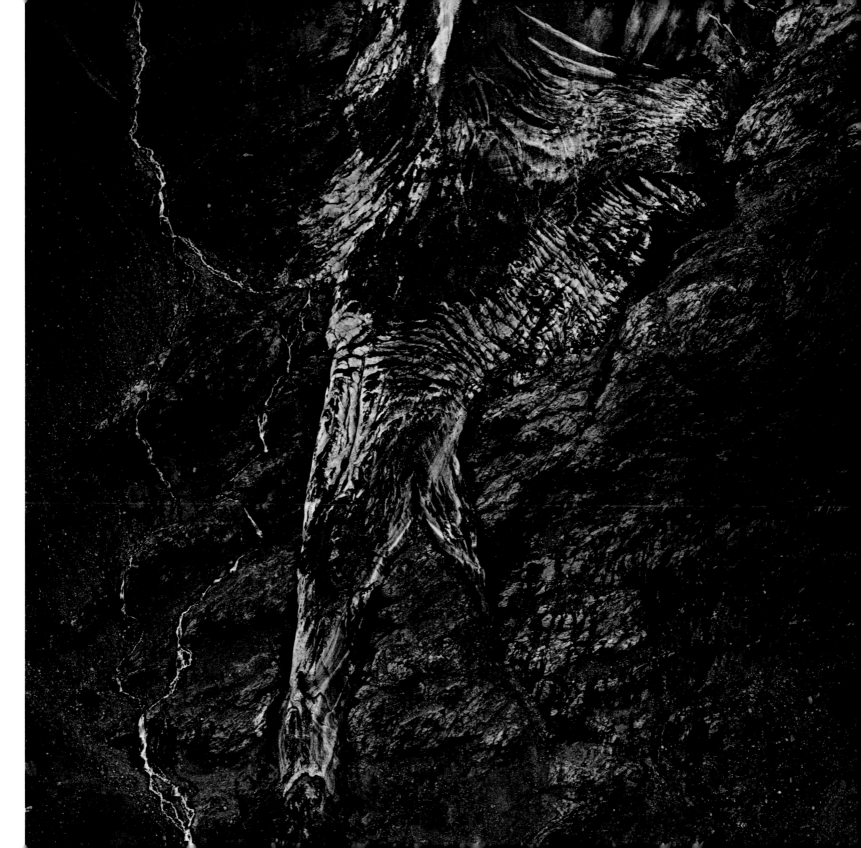

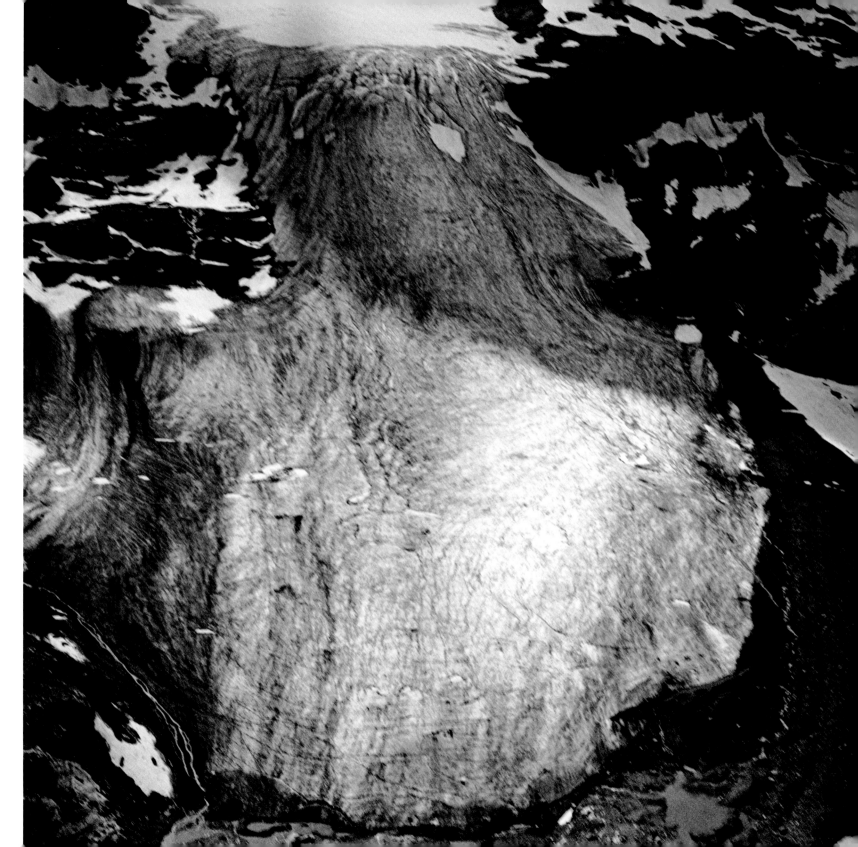

IX

ICE AGE OUR AGE: FURTHER GLACIATION POSTPONED

2.59 MILLION YEARS B.P.–2016

ULTAR GLACIER. KARAKORUM. PAKISTAN
14 SEPTEMBER 2015

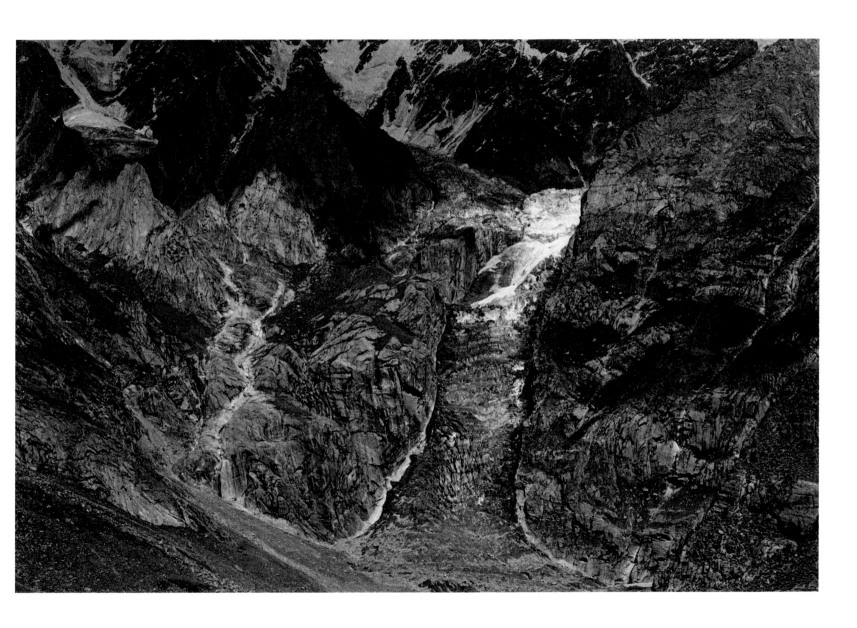

IT TOOK THE ALPINE ICE CAP 12,000 TO 14,000 YEARS TO BUILD UP TO ITS MAXIMUM DEGLACIATION HALF THAT TIME

A WALK FROM THE GEMMI PASS TO THE CHINDBETTI PASS VIA LÄMMERENBODEN, ROTE TOTZ LÜCKE AND TÄLLIGLETSCHER
SWITZERLAND
16 JULY 2012

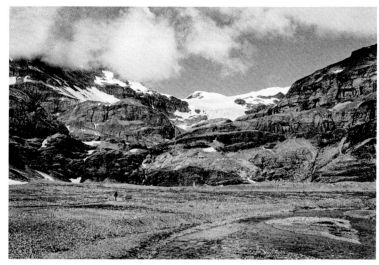

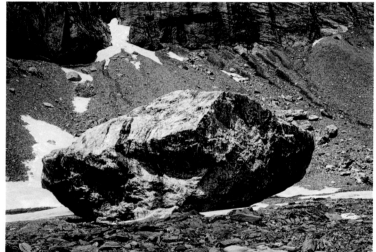

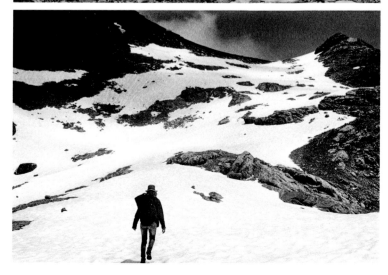

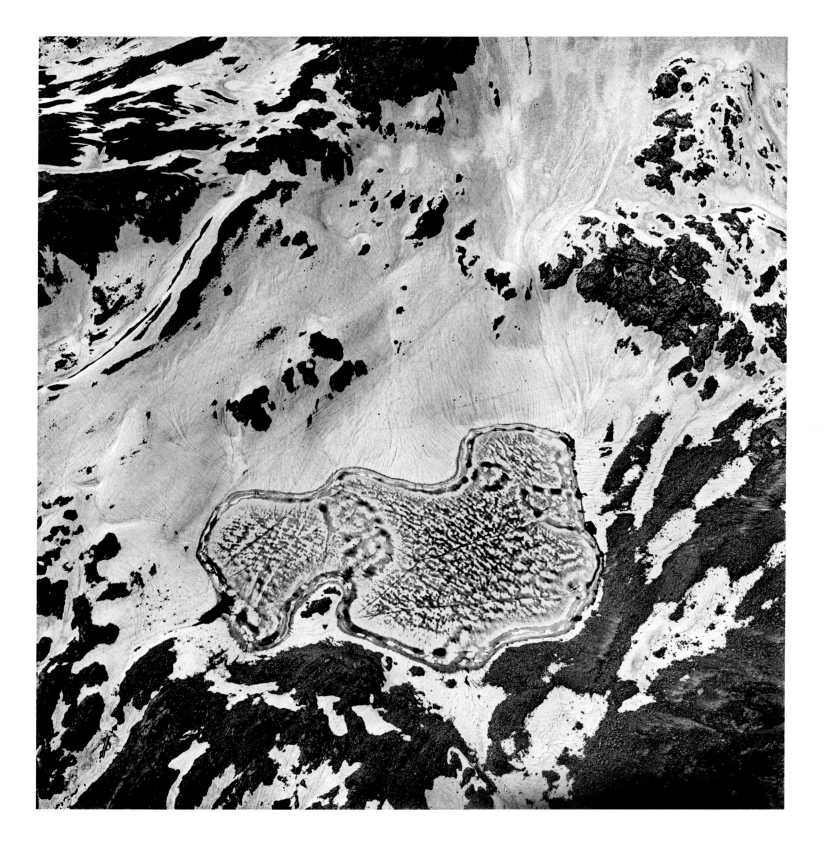

INKWILERSEE. SWITZERLAND
FORMED BY STAGNANT ICE DETACHED FROM THE RETREATING AARE/VALAIS GLACIER
13,000 YEARS AGO. IN DANGER OF SILTATION

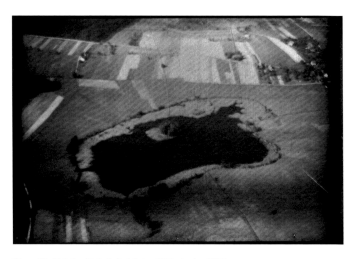

Werner Friedli. *Lake of Inkwil. Aerial view.* 27 September 1949

ICE AGE OUR AGE

KNOWN AS THE QUATERNARY ICE AGE
THE PERIOD FROM 2.59 MILLION YEARS AGO UNTIL TODAY
CHARACTERIZED BY VAST ICE SHEETS
SOME PERMANENT, SOME FLUCTUATING AND VANISHING
SHAPING THE FACE OF THE EARTH
AND BY ALTERNATING PERIODS OF GROWTH AND RETREAT OF CONTINENTAL GLACIERS
THE COLDER ONES GLACIALS
THE SHORTER WARMER ONES INTERGLACIALS
THE EARTH CURRENTLY BEING LOCKED IN AN INTERGLACIAL
THE HOLOCENE

BETWEEN 2.59 AND 1 MILLION YEARS B.P.

HOMO ERECTUS IN AFRICA BUILDING THE FIRST FIRE
THROWING HAMMERS AND ENTERING EUROPE AND ASIA
GLACIAL-INTERGLACIAL CYCLES
WITH A PERIODICITY OF 43,000 YEARS
DRIVEN BY CHANGES IN THE PLANET'S ORBITAL OBLIQUITY
THE GLACIALS AT THEIR COLDEST TOWARDS THEIR END

AFTER ABOUT 1 MILLION YEARS B.P.

GLACIAL-INTERGLACIAL CYCLES EVERY 100,000 YEARS
ELONGATION CAUSED BY THE PLANET LINGERING LONGER IN GLACIAL CONDITIONS
INTERGLACIALS AS WARM AS THE LAST FIVE
– AT ABOUT 450,000, 370,000, 300,000, 210,000 AND 125,000 YEARS B.P. –
ASSOCIATED WITH MUCH HIGHER LEVELS OF CARBON DIOXIDE THAN ANY PRECEDING THEM

30,000–10,000 YEARS B.P.

28,000 YEARS B.P. BEGINNING OF THE LAST GLACIAL MAXIMUM
THE ALPINE ICE CAP REACHING ALTITUDES OF APPROXIMATELY 3,000 M.A.S.L.
EXTENDING DOWN TO 420 M.A.S.L. IN THE NORTH AND TO 100 M.A.S.L. IN THE SOUTH
BY 21,100 +/– 900 YEARS B.P. THE VALAIS GLACIER IS ABANDONING THE OUTER MORAINES
WELL BEFORE 15,000 YEARS B.P.
DRAMATIC END OF THE LAST MAJOR COLD EPISODE OF THE ICE AGE
WITH AN INCREASE IN GLOBAL TEMPERATURES OF 6 °C IN LESS THAN 4,000 YEARS
DEGLACIATION COINCIDING WITH THE EARLIEST PERIODS OF WARMING
ABOUT 11,500 YEARS B.P. BEGINNING OF THE HOLOCENE
CHARACTERIZED BY A RELATIVELY STABLE CLIMATE
PERMITTING THE INVENTION OF AGRICULTURE AND CIVILIZATION

AT ABOUT 6,000 YEARS B.P.
FIRST PILE DWELLINGS ON THE EDGES OF THE DEADICE LAKE OF INKWIL

THE NEXT ICE AGE
ANOTHER 15,000 TO 50,000 YEARS AWAY FROM NOW
DEPENDING ON THE DECREASE OR INCREASE IN CARBON DIOXIDE EMISSIONS

JUNE 2012

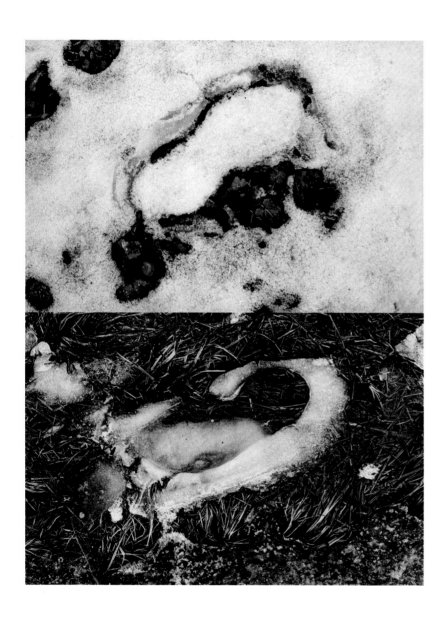

DEAD ICE LAKE DYING

GLACIER TABLES. BOULDERS PARTIALLY PROTECTING THE ICE FROM ABLATION.
RAIKOT GLACIER. KARAKORUM. PAKISTAN
27 SEPTEMBER 2015

FOLLOWING PAGES:
GLACIAL ROCK BASIN LAKE NCURANJA. ERRATIC BOULDER. TRACES OF 2012 FOREST FIRE.
NYAMUGASANI VALLEY. MOUNT LUIGI DI SAVOIA. RWENZORI. UGANDA
8 NOVEMBER 2015

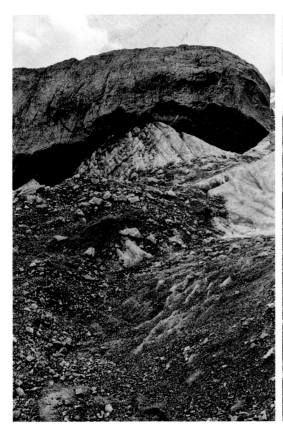
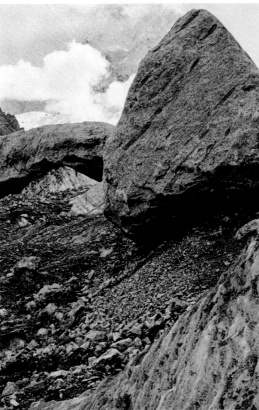

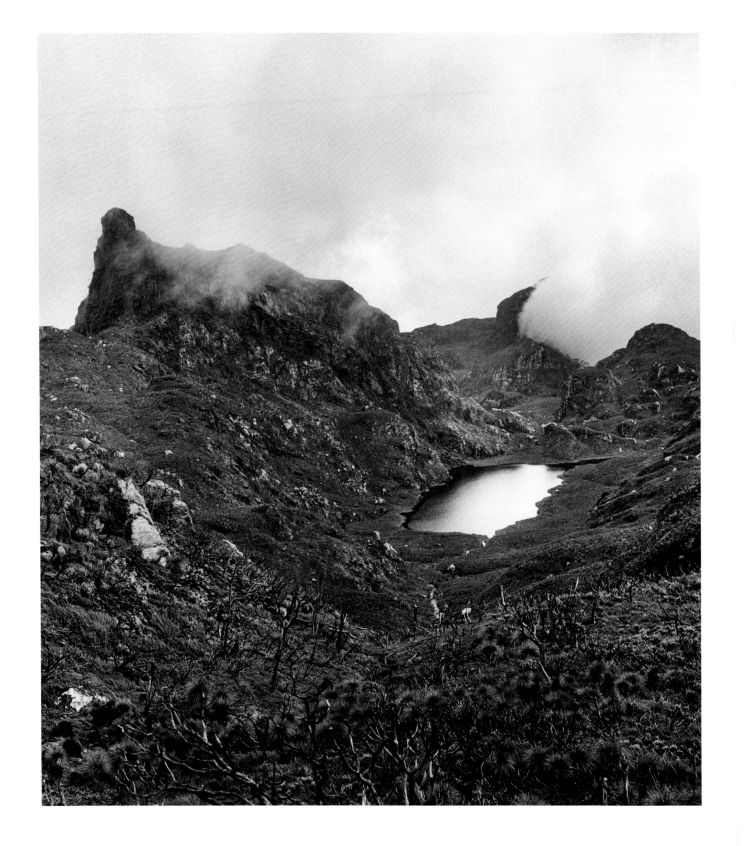

A YEAR LATER – THE BOULDER PHOTOGRAPHED ON 27 SEPTEMBER 2015 IN AN ENTIRELY DIFFERENT GLACIAL AMPHITHEATRE.
RAIKOT GLACIER. KARAKORUM. PAKISTAN
6 OCTOBER 2016

 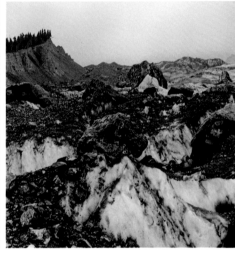 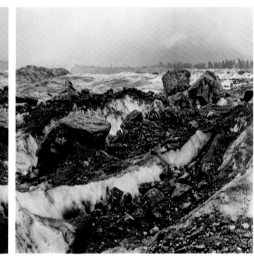

24 JULY 2011

A STONE'S THROW AWAY FROM THE LANGGLETSCHER TWIN PORTAL
ALMOST 2,000 METRES BEYOND THE LITTLE ICE AGE MAXIMUM EXTENT OF 1850
AN ESTIMATED 1,000 METRES BEYOND THE 1933 TERMINAL MORAINE

26 JUNE 2012

A STONE'S THROW AWAY FROM THE NOW ORPHANED PORTAL
AN INDEFINITE DISTANCE BEYOND A MORAINE OF THE SAME AGE AS MYSELF
SOMEWHERE BEYOND THE POINT OF MY FIRST VISIT AS A BOY IN 1965

SWITZERLAND

10 AUGUST 2014

A WALK FROM GRINDELWALD TO ROSENLAUI
PLAYING CHESS IN THE AUBERGE

11 AUGUST 2014

A WALK FROM ROSENLAUI TO THE GLETSCHERHUBEL
THE GLACIER TOO DISTANT TO SEE

SWITZERLAND

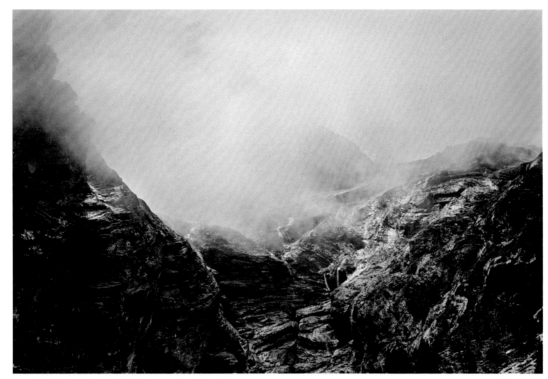

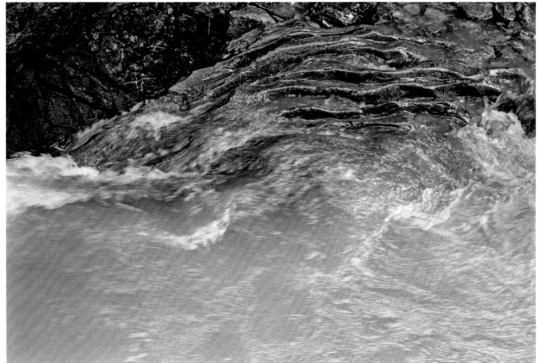

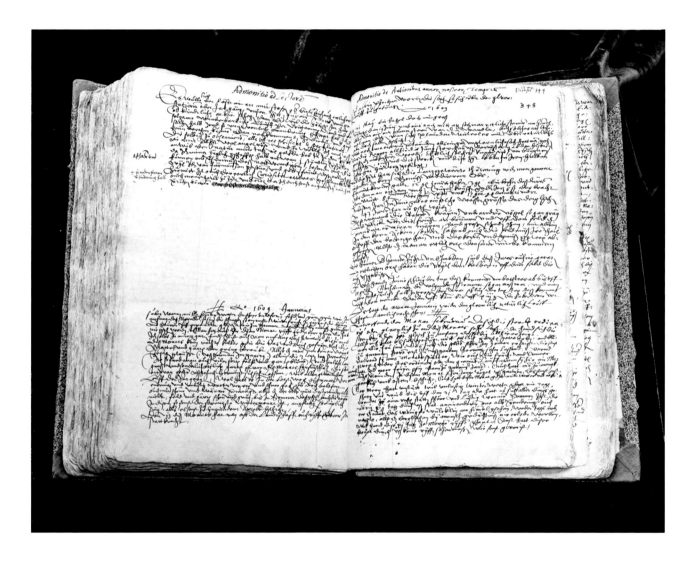

COURSE OF CONCERN

LUZERN

(LITTLE ICE AGE)

FLOODS IN THE ALPS FOLLOWING EXTENSIVE GLACIER ADVANCES

RENWARD CYSAT

FROM 1570 OBSERVING ATMOSPHERIC CONDITIONS THROUGH THE SEASONS

INCLEMENT WEATHER

RECURRENT SUBSISTENCE CRISES AND INFLATION

LOOKING BACK ON THE RECENT PAST IN ABOUT 1600

FELT COMPELLED TO STRESS

[THAT] THE WEATHER AND OTHER THINGS

HAVE TAKEN SUCH A PECULIAR AND ASTOUNDING COURSE

AND UNDERGONE SUCH EXTRAORDINARY ALTERATIONS

CHRONICLED THE SAME

AS A WARNING TO FUTURE GENERATIONS AND FOR THEIR BETTERMENT

BECAUSE – UNFORTUNATELY DUE TO OUR SINS – FOR SOME TIME NOW

THE YEARS HAVE SHOWN THEMSELVES TO BE MORE RIGOROUS AND SEVERE

AND DETERIORATION IN CREATURES

NOT ONLY HUMANS AND ANIMALS

BUT ALSO FRUITS AND CROPS OF THE EARTH

AS WELL AS ABNORMAL CHANGES IN THE ELEMENTS

THE CELESTIAL BODIES AND THE SYSTEM OF THE WINDS

HAVE BEEN NOTICED

LUZERN

(23 AUGUST 2005)

ALPINE AND URBAN FLOODING

CAUSED BY A LOW PRESSURE SYSTEM FROM THE BRITISH ISLES

WITH HUMID MASSES OF AIR ON ITS EASTERN FLANK FLOWING EASTWARDS FROM FRANCE

GIVING RISE TO HEAVY STORMS IN CENTRAL SWITZERLAND

AND BY A SURFACE LOW PRESSURE SYSTEM THAT FORMED OVER THE GULF OF GENOA

CROSSING NORTHERN ITALY

AS WARM AND HUMID AIR FROM THE MEDITERRANEAN

MOVING AROUND THE ALPS IN AN ANTI-CLOCKWISE DIRECTION

THE CONCAVE CURVATURE OF THE MOUNTAIN BARRIER ENHANCING Vb CYCLOGENIC FORMATION

THE RESULTING METEOROLOGICAL EVENT

CONTINUING A SERIES OF FLOODS WITH SEVERE PRECIPITATION

10–13 JUNE 1876 (Vb)

13–15 JUNE 1910 (Vb)

31 JULY 1977 (Vb)

23–25 AUGUST 1987

20–22 MAY 1999

PROLONGED AND INTENSIVE PERIODS OF PRECIPITATION TO BE EXPECTED IN THE FUTURE

POSSIBLY MORE VIOLENT THAN IN THE PAST DUE TO CLIMATE CHANGE

LUZERN

(OUTLOOK)

WARMER AUTUMNS AND EARLIER SPRINGS TRUNCATING WINTERS

SPEED BEING DEPENDENT ON TEMPERATURE AND OVERHEATING A THREAT TO RUNNERS

THE LUZERN MARATHON RANKINGS

– PROVIDED THE EVENT FIRST HELD IN 2007 CONTINUES FOR SOME DECADES –

FUTURE SOURCE FOR CLIMATE HISTORIANS LOOKING FOR CORRELATIONS

BETWEEN POTENTIALLY LONGER WINNING TIMES AND THE SUSPECTED WARMING TREND

WHEN USING AVERAGE TEMPERATURES

RECORDS TO DATE

OVER THE YEAR

8.7 ℃ FOR THE PERIOD 1961–1990

9.6 ℃ FOR THE PERIOD 1981–2010

10.7 ℃ IN 2011

10.1 ℃ IN 2012

9.5 ℃ IN 2013

10.9 ℃ IN 2014

10.8 ℃ IN 2015

FOR THE MARATHON MONTH OF OCTOBER

9.3 ℃ FOR THE PERIOD 1961–1990

10.2 ℃ FOR THE PERIOD 1981–2010

9.8 ℃ IN 2011

10 ℃ IN 2012

11.9 ℃ IN 2013

12.7 ℃ IN 2014

9.6 ℃ IN 2015

WEATHER CONDITIONS DEEMED A LIKELY FACTOR IN THE MARATHON

WOULD CONSTITUTE A DIRECT EFFECT OF A WARMER WORLD

ON HUMAN ATHLETIC PERFORMANCE

LIKE THE EXPECTED POLEWARD EXPANSION OF THE SUBTROPICAL DRY ZONE

RESPONDING TO AN INCREASE IN GREENHOUSE GAS EMISSIONS

AND THE VARIABLE EXPANSION OF THE HADLEY CELLS

CHANGING NORTH ATLANTIC ATMOSPHERIC CIRCULATION PATTERNS

WITH DESERTS AROUND 30TH PARALLEL NORTH GROWING LARGER AND BECOMING DRIER

CENTRAL SWITZERLAND TO FACE AN INCREASE IN WESTERLY AND Vb CYCLONE TRACKS

DURING COOLER SUMMERS

ASSOCIATED WITH AN INCREASE IN THE FREQUENCY OF INTENSE PRECIPITATION EVENTS

AND CONSEQUENTLY SEVERER FLOODS

PREDICTION SUPPORTED BY ALPINE FLOOD RECONSTRUCTION

BASED ON DATED SEDIMENTARY FLOOD DEPOSITS FROM TEN LAKES IN SWITZERLAND

RECORDING INDIVIDUAL EVENTS AS DISTINCT SEDIMENT LAYERS

HIGH FLOOD FREQUENCY DURING PERIODS OVER THE PAST 2,500 YEARS

COINCIDING WITH COOLER SUMMERS

APART FROM EARLIER TIMES WITH SPARSE HUMAN ARCHIVES

DATA FROM THE NATURAL ARCHIVE

CONGRUENT WITH 500 YEARS OF FLOOD RECORDS BASED ON HISTORICAL DOCUMENTS

HIGHEST FLOOD FREQUENCY AROUND 1740

ENHANCED FLOOD ACTIVITY DURING THE LITTLE ICE AGE (C. 1350–C. 1850)

OCCURRING MORE FREQUENTLY DURING SUMMERS WITH LOW TEMPERATURES

CONDITIONS FOR MAJOR GLACIAL ADVANCES

DURING THE PAST 1,500 YEARS PERIODS OF ENHANCED FLOOD FREQUENCY COINCIDING

WITH SIX OUT OF SEVEN MAJOR ADVANCES OF THE UNTERER GRINDELWALD GLACIER

AROUND 1575 UNTIL ABOUT 1600

LONG-TERM GROWTH PERIOD WITH AN ADVANCE OF ABOUT 1,000 METRES

THE MAXIMUM EXTENT DURING THE LITTLE ICE AGE

OBSERVED PERHAPS BY RENWARD CYSAT

X

ANTHROPOCENE: PENETRATING THE PLANET

1955–2016

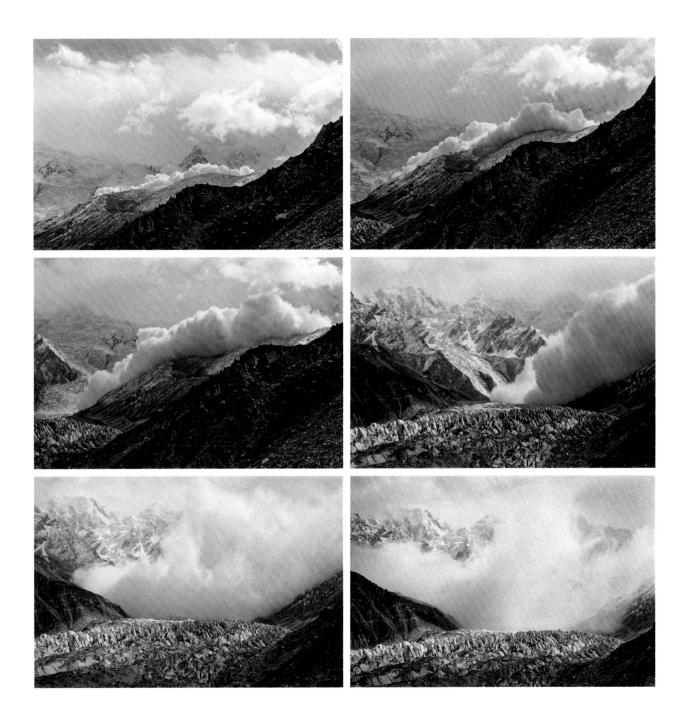

2 OCTOBER 2011

A CHILD BORN
FROM LOVEMAKING IN THE CLOVER FIELD
MIGHT JUST LIVE TO SEE THE VANISHING OF THE VALAIS GLACIERS
WHOSE ICE CAP AFTER 28,000 YEARS B.P. SHAPED
THE EROSIONAL SCARP AND WITH IT OUR LAIR ABOVE THE AARE RIVER

5 FEBRUARY 2012

THE CLOVER FIELD BURIED UNDER HARD SNOW
TODAY'S MIDWINTER TEMPERATURE OF –14/–12 °C
BEING APPROXIMATELY 9 °C COOLER
THAN THE ANNUAL MEAN TEMPERATURE
DURING THE LAST GLACIAL MAXIMUM
EAST OF THE ICE CAP BETWEEN LANGENTHAL AND BADEN

6 FEBRUARY 2012

KABUL. *DEADLY COLD STALKS CHILDREN IN KABUL CAMPS*
AT LEAST 22 UNDER AGE 5 HAVE FROZEN TO DEATH OVER THE PAST MONTH
INTERNATIONAL HERALD TRIBUNE

12 SEPTEMBER 2012

IN KABUL TOGETHER
LEARNING FROM ELDERS IN ONE OF THE CAMPS
THAT THE COMING WINTER
WILL AGAIN KILL SOME OF THEIR CHILDREN

31 DECEMBER 2012–1 JANUARY 2013
KABUL. *DEADLY WINTER RETURNS TO KABUL*
EXTREME COLD CLAIMS SEASON'S FIRST VICTIM, 3, IN CAPITAL'S REFUGEE CAMPS
INTERNATIONAL HERALD TRIBUNE

KABUL 8–16 SEPTEMBER 2012

THREE BORED DOGS
OCCUPYING THE ROUNDABOUT NEAR THE GATE OF BAGRAM AIR BASE
DRAWING YOUR ATTENTION

BLACK HAWK ROTOR BLADES
STEALING YOUR SLEEP

GETTING HOME FROM THE SCENE OF A SUICIDE ATTACK
A PIECE OF THE BOMBER IN HIS SHOE
THE REPORTER SAYS

IN AFGHANISTAN NOBODY THINKS ABOUT THE FUTURE
THE FRIEND SAYS

EVERYONE WANTS TO GET AWAY FROM THE THIRTY YEARS WAR
BEFORE CLIMATE CHANGE WILL BECOME PERSONAL TOO

LOOKING FOR EVIDENCE OF HUMAN-INDUCED WARMING
BEYOND THE RISE IN GLOBAL MEAN TEMPERATURES OVER THE LAST CENTURY
OBSERVING THE MELTING OF GLACIERS

Hans Schwartz: *Feegletscher*, Switzerland 1955

UPON DEPARTING THIS WORLD AFTER SIX DECADES OF EXPOSING WHAT IS BEING LOST
AMUSED BY THE CONCEPT OF CLOUD-SEEDING WITH SILVER IODIDE TO MAKE SNOW
SINCE IN WARMER WEATHER WHATEVER CLOUDS CARRY FALLS AS RAIN

GÜNSBERG SWITZERLAND
10–14 MARCH 2013

SURVEYING IN TIMES OF WAR

A TRILLION DOLLARS OF UNTAPPED AFGHAN MINERAL RESOURCES
INCLUDING COBALT COPPER GOLD AND LITHIUM ACCORDING TO A 2010 PENTAGON ESTIMATE

ANALYZING EARLY LOW-RESOLUTION SATELLITE IMAGES OF GLACIERS IN TIMES OF WAR
CONFOUNDING CLOUDS AND ROCKS OF HIGH REFLECTIVITY WITH SNOW AND ICE

ADVANCED SPACEBORNE THERMAL EMISSION AND REFLECTION RADIOMETER (ASTER)
ABOARD NASA'S TERRA SATELLITE
CAPTURING HIGH SPATIAL RESOLUTION DATA PROVIDING STEREO IMAGES FOR U.S. GEOLOGICAL SURVEY
REVEALING EVIDENCE THAT GLACIERS HAVE COMPLETELY DISAPPEARED
IN MOST CIRQUES BELOW ABOUT 4,000 M.A.S.L.
RETREAT HAS RESULTED IN DISCONNECTION OF TRIBUTARY GLACIERS FROM THEIR MAIN TRUNK

GLACIERS BEING THE SOURCE OF A VARIABLE PART OF THE MELTWATER
USED FOR CRITICAL LATE SEASON CROP IRRIGATION IN THE DROUGHT-TORN HINDUKUSH
AND POTENTIAL ECONOMIC AND INDUSTRIAL DEVELOPMENT INCREASING DEMAND
THE IMPENDING WORST-CASE SCENARIO IMPLIES DISPLACEMENT AND MIGRATION
TO DENSELY POPULATED AGRICULTURAL AREAS ALREADY INTENSIVELY USED
POTENTIALLY SPARKING CONFLICT OVER WATER AS AN ALREADY SCARCE COMMODITY

ANALYZING VIDEO IMAGES COLLECTED IN THE FOG OF WAR
BY UNMANNED AIRBORNE VEHICLES GENERICALLY REFERRED TO AS DRONES
CONFOUNDING FIGHTERS WITH CIVILIANS

ADVANCED VERSIONS OF DRONES TO BE USED TO CONDUCT
INTELLIGENCE-GATHERING AND SURVEILLANCE AND RECONNAISSANCE MISSIONS
AS WELL AS ELECTRONIC WARFARE
AS AN OPTION PREFERABLE TO PUTTING SOLDIERS IN THE LINE OF FIRE

DOWNWASTING OF THE FULADI GLACIER IN THE KUH-E-BABA RANGE CONTINUES
IN THE LATE PLEISTOCENE THE GLACIER HAVING PRODUCED SETS OF TERMINAL MORAINE LOOPS
AS LOW AS 2,600 M.A.S.L. ABOVE BAMIYAN

OUT OF REACH DUE TO WAR

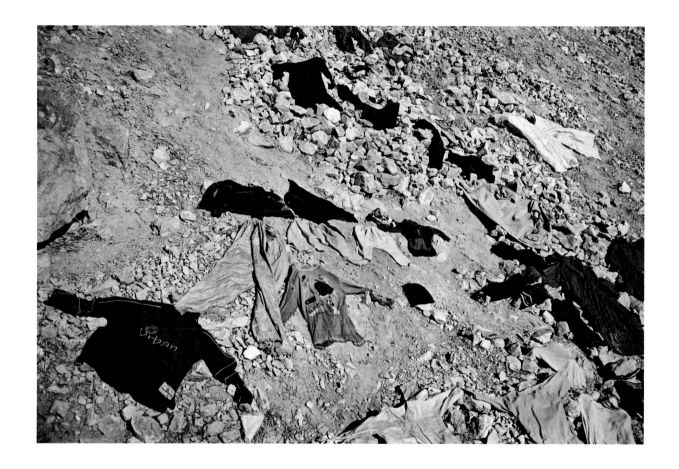

CROUCHING DOWN ON DISPATCH POINT ABOVE THE KUMTOR MINE

HEAD SPINNING FROM ALTITUDE SICKNESS

VOMITING ON THE DUST THROWN UP BY PROGLACIAL MINING

DUST ENHANCING THE GLACIERS' SOLAR ABSORPTION AND SURFACE MELT RATES

BELOW THE CENTRAL PIT

MEETING POINT OF THE THREE DAVIDOV GLACIER TRIBUTARIES PRIOR TO PRO- AND SUBGLACIAL MINING

ASKING FOR THE NAME OF THE MOUNTAIN BEHIND ME

ACCUMULATION BASIN OF THE LYSII GLACIER

NO NEED FOR A NAME THE ESCORT SAYS AS GLACIER AND MOUNTAIN HAVE NO FUTURE

Exploration in the Kumtor Mine area dates back to the 1920s. Recovery of subglacial gold deposits began in 1995 and reached 4,400 M.A.S.L. by 2015. Since 1997 rock and ice waste up to 180 metres thick was dumped onto the Davidov Valley Glacier and Lysii Cirque Glacier substantially increasing the driving stress of the ice beneath and ice velocity. The measures taken to displace the ice, to form a rock-fill buffer between the glacial flow and the mining area and to manage influx of waste rock and glacier ice creeping towards the open pit, included interception and diversion of water flowing along the ice-till contact. In the process of removing glacier-ice overburden, excavation of a section of the Davidov Glacier south arm (visible in the background of the left-hand image, now destroyed) resting on a relatively level basal till bed, buttressing the glacier ice further up in the accumulation area, resulted in accelerated sliding on the till-surface below the glacier and eventually in a surge. Between January and March 2014 movement rates at the face of the glacier surged from c. 30 millimetres/hour (22 metres/month) to as much as 180 millimetres/hour (130 metres/month). Subject to dumping of up to 0.437 cubic kilometres of spoil between 1998 and 2014 the Davidov Glacier advanced by 3.2 kilometres. The anomalous terminus advance in response to human-induced geo-technical intervention, i.e. massive supraglacial debris-dumping causing enhanced internal ice deformation, allows insight into past and present glacial response to instantaneous additions of substantial debris loads such as landslides.
A surge or accelerated advance over a short period of time may occur when a part of a steep or hanging glacier becomes unstable and dissociates from the bedrock to which it is frozen or from the rest due to enhanced meltwater in summer resulting in an ice avalanche – such as in the case of the Allalin Glacier in the Alps. (See pp. 82–85.)

SPOIL-COVERED DAVIDOV GLACIER. KUMTOR GOLD MINE MILL AND CENTRAL PIT (4,016 M.A.S.L.).
AKSHIIRAK MASSIF. TIENSHAN. KYRGYZSTAN
2 JULY 2004

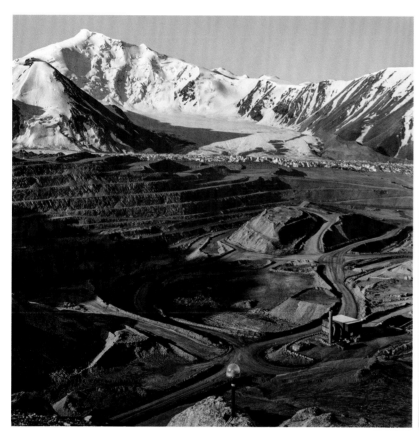
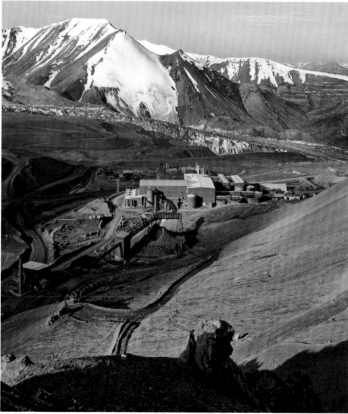

NASA ASTRONAUT PHOTOGRAPHY: PART OF THE 2,500 KM-LONG PEGUNUNGAN MAOKE OR CENTRAL RANGE OF EQUATORIAL NEW GUINEA (HIGHEST POINT: CARSTENSZ PYRAMID, 4,884 M.A.S.L.).

PHOTO CENTRE POINT: 4.1° S / 137.1°E. PAPUA. INDONESIA. 25 JUNE 2005. 23:10:05 GMT. SPACECRAFT ALTITUDE: 191 NAUTICAL MILES (354 KM).

To the right of the c. 4 km-wide open pit of the Grasberg mineral district (gold and copper deposits discovered in 1936.
Beginning of open-pit operations in 1990) the relics of the ice masses of Puncak Jaya massif.
Chronology of the Puncak Jaya massif glacier's disappearance on p. 231.

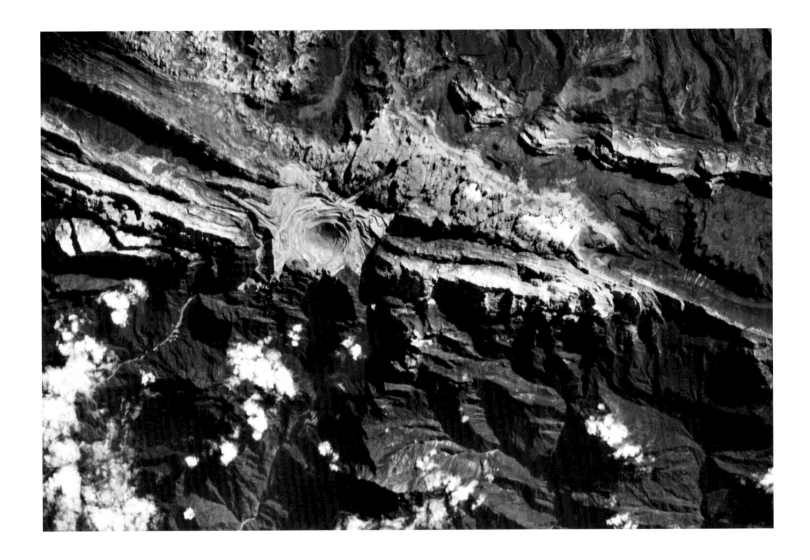

WHAT EARLIER SOCIETIES COULD NOT PREPARE FOR

11 APRIL 2012

LOOKING FROM A MONTREUX HOTEL BALCONY

TOWARDS THE TOP END OF LAKE GENEVA AND THE MOUTH OF THE RHONE

DEBOUCHURE OF THE VALAIS GLACIER COVERING THE WESTERN PART OF THE NORTHERN ALPINE FORELAND

AFTER 30,000 YEARS BEFORE PRESENT

RECALLING 1816

THE YEAR WITHOUT A SUMMER WHEN BYRON

A TOURIST AT THE LAKE

IN TIMES OF FAMINE

HAD A DREAM

THE POEM

DARKNESS

A RESULT OF THE PREVAILING CLIMATE NORTH OF THE ALPS

COLD AND WET UNDER A VEIL OF ASHES

CONSEQUENCE OF THE TAMBORA ERUPTION ON THE INDONESIAN ARCHIPELAGO THE YEAR BEFORE

CAUSING SNOWFALL IN THE ALPS LOWER THAN 800 METRES AT LEAST ONCE A MONTH

AS WELL AS CROP FAILURE

AND THREEFOLD INCREASE IN GRAIN AND POTATO PRICES

LEAVING MORE THAN 30,000 SWISS CITIZENS WITHOUT BREAD

FORCING SWISS CHILDREN TO GRAZE LIKE SHEEP

WHILE BANDITS INTERCEPTED CARGOES FROM NORTHERN ITALY ON THE ALPINE PASSES

BEGGARS SWARMED THE STREETS OF ZURICH

AND THREE WOMEN WERE DECAPITATED FOR INFANTICIDE

READING PAPERS CONCERNING OUR NEXT DESTINATION

THE GLACIERS OF THE PUNCAK JAYA MASSIF IN INDONESIA'S IRIAN JAYA PROVINCE

ONSET OF GLACIER RECESSION THERE 15,000 YEARS B.P.

DISAPPEARANCE BY 7,000 YEARS B.P.

REGENERATION BY 5,000 YEARS B.P.

IKONOS SATELLITE IMAGES OF 2000 AND 2002 SHOWING GLACIER SURFACE AREA SHRINKAGE

OF 2,326 TO 2,152 SQUARE KILOMETRES OR 7.48 PER CENT IN TWO YEARS

ONGOING RETREAT OBSERVED FROM MID-19TH CENTURY TO 2005: 19.3 SQUARE KILOMETRES TO 1.72 SQUARE KILOMETRES

AMOUNTING TO A 91 PER CENT LOSS OF SURFACE AREA SINCE THE LITTLE ICE AGE MAXIMUM OF C. 1850

ONE OF THE GLACIERS VANISHED ENTIRELY SOME TIME BETWEEN 1994 AND 2000

ACCELERATED RATE OF RETREAT OBSERVED FROM 1988 TO 2005 WHILE PRECIPITATION INCREASED

DUE IN PART TO THE AMOUNT FALLING AS RAIN RATHER THAN SNOW

TROPICAL ICE MASSES ARE PARTICULARLY SENSITIVE TO SMALL CHANGES IN AMBIENT TEMPERATURES

AS THEY ALREADY EXIST VERY CLOSE TO MELTING POINT

MOUNTING EVIDENCE OF RECENT SEVERE WARMING IN THE TROPICS SIGNALLED BY THE RAPID RETREAT

AND EVEN DISAPPEARANCE OF ICE CAPS AND GLACIERS AT HIGH ELEVATIONS

PALEOCLIMATE INFORMATION FROM PERUVIAN AND HIMALAYAN GLACIERS PROVIDING STRONG EVIDENCE

THAT PRECIPITATION CHANGES ARE NOT THE PRIMARY DRIVER OF THE RECENT ACCELERATION OF GLACIER RETREAT IN THESE REGIONS

ACCELERATION WELL UNDERWAY ON THE PUNCAK JAYA MASSIF GLACIERS

AS WELL AS ON THE RWENZORI IN UGANDA – AS WE SAW WITH OUR OWN EYES LESS THAN A MONTH AGO

9 DECEMBER 2015

STANDING ON A SIEM REAP HOTEL BALCONY

ON RETURNING FROM TONLE SAP LAKE

THE WATER FESTIVAL MARKING THE CHANGE OF DIRECTION OF THE RIVER FEEDING IT

CANCELLED FOR THE FOURTH CONSECUTIVE YEAR

THE GREAT LAKE DECIMATED BY PERSISTENT DROUGHT

TYPICALLY YIELDING SOME 300,000 TONS OF FISH ANNUALLY

THE SOURCE OF SEVENTY PER CENT OF THE COUNTRY'S PROTEIN

THE SURROUNDING FLOODPLAINS AND FORESTS CRUCIAL TO ITS AGRICULTURE AND ECOSYSTEM

A CONSTANT TEMPERATURE AND RHYTHMIC FIVEFOLD SWELL IN THE WET SEASON

FOSTERING REGULAR MIGRATION AND SPAWNING PATTERNS AMONG TONLE SAP'S FISH

FRAGILE CYCLES NOW THREATENED

BY FORECASTS OF HOTTER DRY SEASONS AND MORE INTENSE MONSOONS

CAMBODIA RATED SECOND TO THE PHILIPPINES AMONG THE 160 COUNTRIES

TO SUFFER HUMAN LOSSES FROM EXTREME WEATHER EVENTS

ITS ECONOMY THE MOST VULNERABLE TO EFFECTS OF CLIMATE CHANGE

GLACIER MASS BALANCE STUDIES OF TROPICAL ICE FIELDS

POINTING TO EL NIÑO SOUTHERN OSCILLATION (ENSO) AS AN IMPORTANT INFLUENCE

THE COMBINATION OF WARMER AIR TEMPERATURES OVER HIGHER ELEVATIONS

LOWER AMOUNTS OF PRECIPITATION DURING THE WET SEASON

AND LESS CLOUD COVER CONTRIBUTING TO HIGHER RATES OF ABLATION

OCEANIA'S LAST REMAINING ICE FIELDS ON THE PUNCAK JAYA MASSIF DOOMED TO VANISH

TOGETHER WITH PRESERVED CLIMATE AND ENVIRONMENTAL HISTORIES TO BE EXTRACTED FROM THREE ICE CORES

OF 26, 30 AND 32 METRES IN LENGTH RECOVERED IN A 2010 SALVAGE MISSION

YEARLY ACCUMULATIONS PRESERVED DOWN TO THE BEDROCK

9 DECEMBER 2015 (CONTINUED)

A REPLY FROM THE PHOENIX-BASED MINING COMPANY OPERATING IN IRIAN JAYA

WHICH IS NOT INTERESTED IN OFFERING ANY LOGISTICAL SUPPORT

FOR PHOTOGRAPHS OF THE REMNANTS OF THE GLACIERS OF THE PUNCAK JAYA MASSIF

IN THE VICINITY OF THE GRASBERG GOLD AND COPPER MINE

BECAUSE MY WORK ON DYING GLACIERS DOES 'NOT FIT WITH OUR CURRENT OBJECTIVES'

WONDERING IF THOSE OBJECTIVES CONSIDER THE FUTURE OF THE SHAREHOLDERS' CHILDREN

6 JUNE 2016

RECEIVE NEWS THAT PUBLICATION OF THE 2010 ICE CORE RECORDS FROM THE PUNCAK JAYA MASSIF IS IMMINENT

THE SAMPLES UNFORTUNATELY DO NOT CONTAIN ANY VOLCANIC ASH FROM THE KRAKATAU ERUPTION OF 27 AUGUST 1883

AS THEY EXTEND BACK ONLY TO C. 1920

THE GLACIERS NOW LOSING MASS FROM BOTH TOP AND BOTTOM

OVER FIVE METRES BETWEEN 2010 AND 2015

UNDER CURRENT CONDITIONS THE GLACIERS EXPECTED TO LAST LESS THAN TWENTY YEARS

WE WILL NOT PREPARE FOR

GHIACCIAIO DEL BELVEDERE. GHIACCIAIO DEL NORDEND. ITALY
2 NOVEMBER 2014

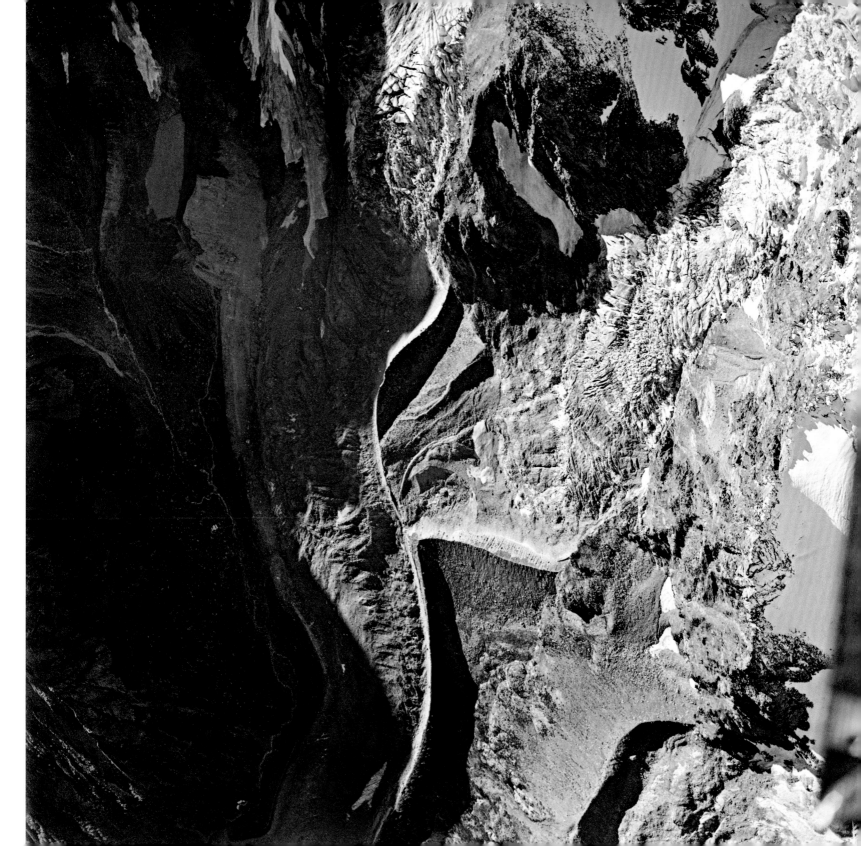

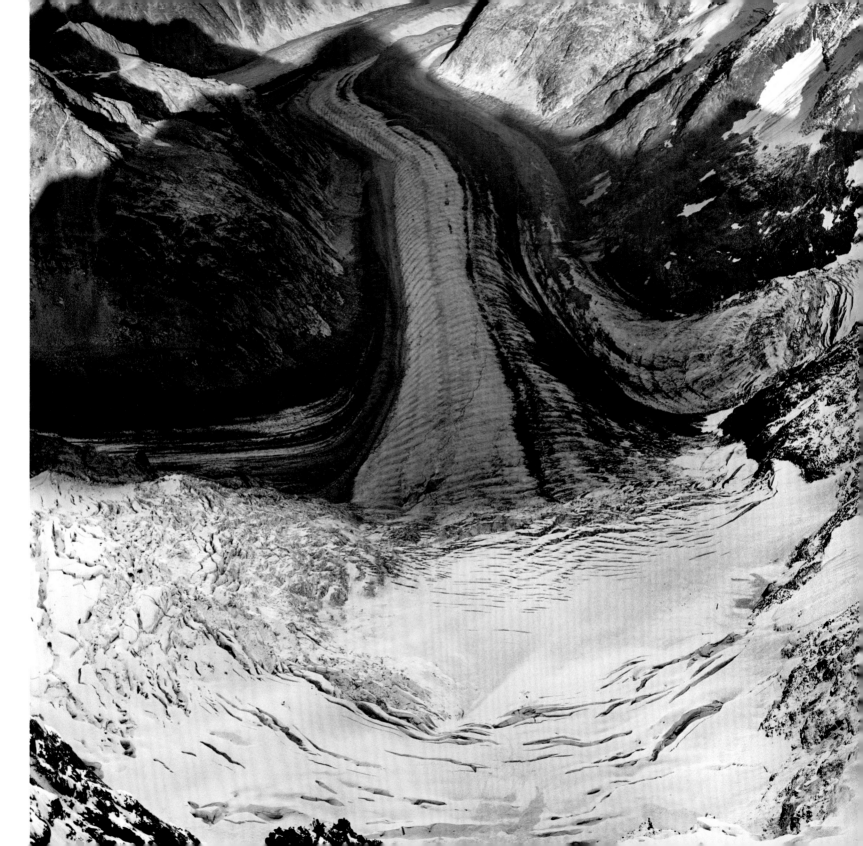

XI

EQUATORIAL THAW: RWENZORI

2015

RWENJURA

MEANING HILL OF RAIN OR KING OF CLOUDS

REFERENCE TO THE WHITENESS OF THE ICE-CAPPED PEAKS

IN THE LANGUAGE OF THE BATORO

LOCAL PLACE NAMES OF THE BAKONJO

REFLECTING THEIR INTEREST RESTRICTED TO HUNTING

NOT VENTURING INTO THE HIGHER PARTS

CONSEQUENTLY ONLY NAMES FOR LAKES RIVERS ROCK-SHELTERS

RIDGES OF THE LOWER SLOPES

BUT NOT FOR THE PEAKS

SNOW THE PROVINCE OF THE DEITY KITASAMBA

THE MOUNTAINS

BETRAYING THE EYE OF THE FIRST EXPLORERS

SAILING THE LAKES AND TRAVELLING THE REGION

NOT ONE OF THEM

SUSPECTING PEAKS OF SNOW AND ICE

TOWERING ABOVE THEM

HIDDEN IN THE IMPENETRABLE CLOAK OF CLOUD AND MIST

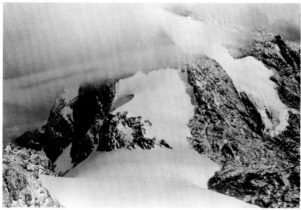

THE NORTHERN PEAKS OF MT. STANLEY SEEN FROM THE EAST ACROSS MT. SPEKE. RWENZORI. UGANDA
13 NOVEMBER 2015

OPPOSITE:
HOLOCENE GLACIAL LAC DU SPEKE. MT. SPEKE. RWENZORI. D.R. CONGO
14 NOVEMBER 2015

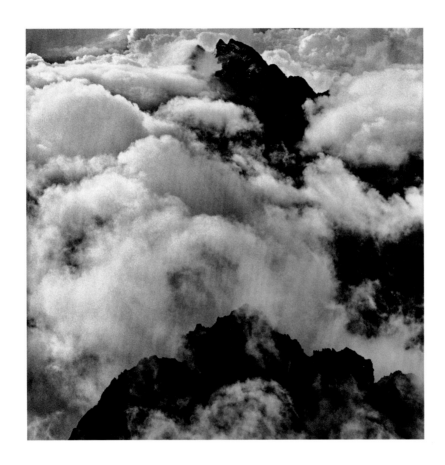

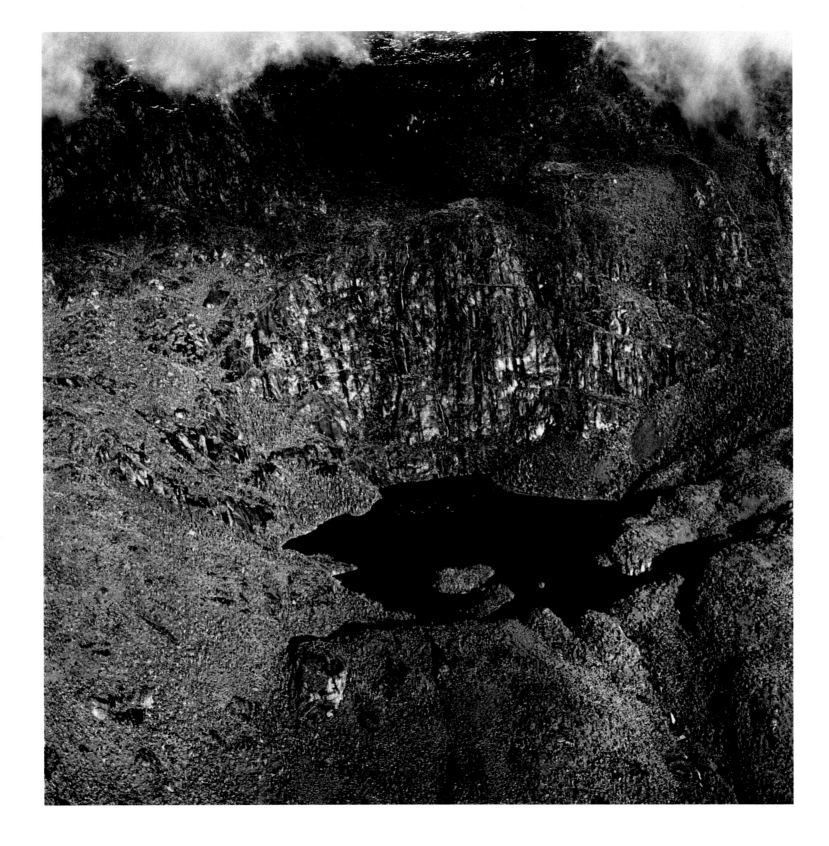

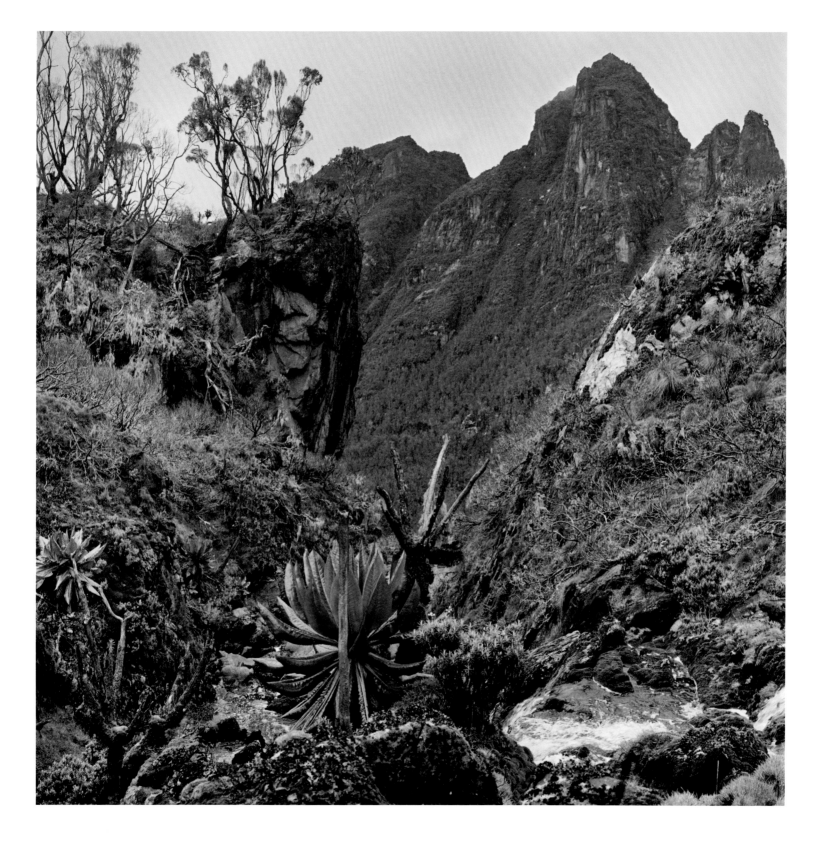

A WALK FROM KILEMBE TRHOUGH KAMUSONGI VALLEY AND NYAMUGASANI VALLEY TO LAKE BIGATA.

FROM 1,305 M.A.S.L. TO 4,010 M.A.S.L.
FROM THE GRASSY FOOTHILLS THROUGH MONTANE FOREST TO THE BAMBOO/MIMULOPSIS ZONE
FROM THE HEATHER/RAPANEA ZONE TO THE BOGGY ALPINE ZONE
FROM LAKE TO LAKE ALL OF GLACIAL ORIGIN AND DIFFERENT COLOUR
SLEEPING UNDER ICE-CUT CLIFFS AND BOULDERS
FOLLOWING MORAINE PATHS OF VALLEY GLACIATIONS OCCURRING 15,000 TO 20,000 YEARS B.P.

MOUNT LUIGI DI SAVOIA. RWENZORI. UGANDA
6–11 NOVEMBER 2015

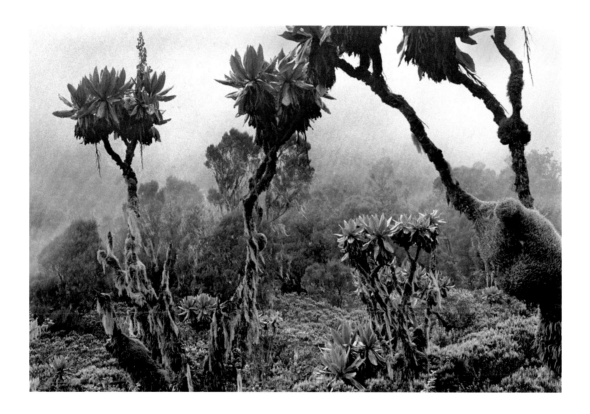

THE MOUNTAINS CONSIDERED THE SOURCE OF THE NILE BY THE ANCIENT EGYPTIANS

AESCHYLUS
SENDING IO TO THE FRUITFUL MEADOWS OF ZEUS
SNOW-FED BY SACRED NILE (*THE SUPPLIANTS*, 552/3)

HERODOTUS
RECORDING THE STORY
TOLD BY THE KEEPER OF THE REGISTER
OF ATHENA'S SACRED TREASURES IN THE CITY OF SAIS
THAT THE SOURCE OF THE NILE IS A LAKE IMPOSSIBLE TO FATHOM
SITUATED BETWEEN CROPHI AND MOPHI
TWO HILLS WITH SHARP CONICAL TOPS (*HISTORIES* II, 28)
POSSIBLY LAC DE LA LUNE BETWEEN MT. EMIN AND MT. GESSI

ARISTOTLE
REFERRING TO THE 'SILVER MOUNTAINS' AS THE SOURCE OF THE CHREMETES
LARGEST HEADWATER OF THE NEILOS (*METEOROLOGICA* 1, 13)

DERIVING THE NEWS FROM REPORTS BY THE FIRST GREEK NAVIGATORS OF EGYPT
FREQUENTING THE MARKETS OF EAST AFRICA
MARINOS OF TYRE
MENTIONING THE STORM-DRIVEN INDIA VOYAGE OF A CERTAIN MERCHANT DIOGENES
WHO REACHED THE LAKES FROM WHERE THE NILE FLOWS
SLIGHTLY TO THE SOUTH OF RAPHTA

PTOLEMY
USING MARINOS' INFORMATION (*GEOGRAPHY* I, 9)
BUT STATING A FAR MORE INLAND LOCATION
PLACING THE 'MOUNTAINS OF THE MOON' FROM WHICH THE LAKES OF THE NILE
RECEIVE SNOWY WATER
AT THE SOUTHERN LATITUDE OF 12°30' AND BETWEEN THE LONGITUDES OF 57° AND 67°
(*GEOGRAPHY* IV, 8)

GIVEN THE ABSENCE OF HIGH LAND IN EQUATORIAL AFRICA
UNDER THE LATITUDE SPECIFIED
ELEVATED ENOUGH TO BE DESCRIBED AS SNOWY
AND RISING ABOVE THE LINE OF PERPETUAL SNOW
CONSIDERING THAT A LATITUDE SO FAR SOUTH
WOULD PLACE SUCH HIGH LAND QUITE BEYOND THE UPPER BASIN OF THE NILE

AND THAT THE 'MOUNTAINS OF THE MOON' ARE NOT MENTIONED
WHEN TREATING THE NILE (*GEOGRAPHY* IV, 7)
BUT ONLY BRIEFLY IN THE SUPPLEMENTARY CHAPTER (*GEOGRAPHY* IV, 8)
THAT CONTAINS OBSCURE AND LITTLE KNOWN MATTERS
SUSPICION PREVAILS NOT WITHOUT JUSTIFICATION
THAT THE 'MOUNTAINS OF THE MOON' (JEBEL-EL-QAMAR) ARE OF ARAB ORIGIN
FOISTED INTO PTOLEMY'S OTHERWISE METHODICAL GEOGRAPHY

EL-NOWAIRI QUOTED BY MASUDI
ASSERTING THE MEANING OF 'QAMAR'
AS BOTH 'MOON' AND 'WHITE'

THE *NUZHAT AL-MUSHTAQ FI IKHTIRAQ AL-AFAQ*
OR *BOOK OF PLEASANT JOURNEYS INTO FARAWAY LANDS*
CONTAINING AL-IDRISI'S DESCRIPTIVE GEOGRAPHY
COMPOSED FOR KING ROGER II OF SICILY
A.K.A. *KITAB RUDJAR* OR *TABULA ROGERIANA*
A DETAILED MAP COVERS THE NILE UP TO ITS SOURCES
A LATER COPY DEPICTS TEN STREAMS
FLOWING FROM THE JEBEL-EL-QAMAR INTO TWO LAKES

ZHAO RUGUA
MEMBER OF THE SONG IMPERIAL FAMILY
SUPERINTENDENT OF MERCHANT SHIPPING IN QUANZHOU
PROVIDING EVIDENCE OF THE IMPORTANCE OF TRADE
BETWEEN THE CHINESE AND ISLAMIC WORLDS
(*ZHU FAN ZHI* OR *DESCRIPTION OF FOREIGN LANDS*)
KNOWING ABOUT THE NILE WELL ENOUGH TO UNDERSTAND
THAT ITS SOURCES WERE A MYSTERY

ECHOING ROMAN ERRORS AND UNCERTAINTIES

LUCRETIUS
PERCHANCE HIS WATERS WAX AMONG THE ETHIOPIANS' LOFTY MOUNTAINS
WHEN THE ALL-BEHOLDING SUN WITH THAWING BEAMS
DRIVES THE WHITE SNOWS TO FLOW INTO THE VALES (*DE RERUM NATURA*, VI, 730)

HORACE
[THE] NILE THAT WILL NOT TELL HIS BIRTH (*ODES*, IV, 14)

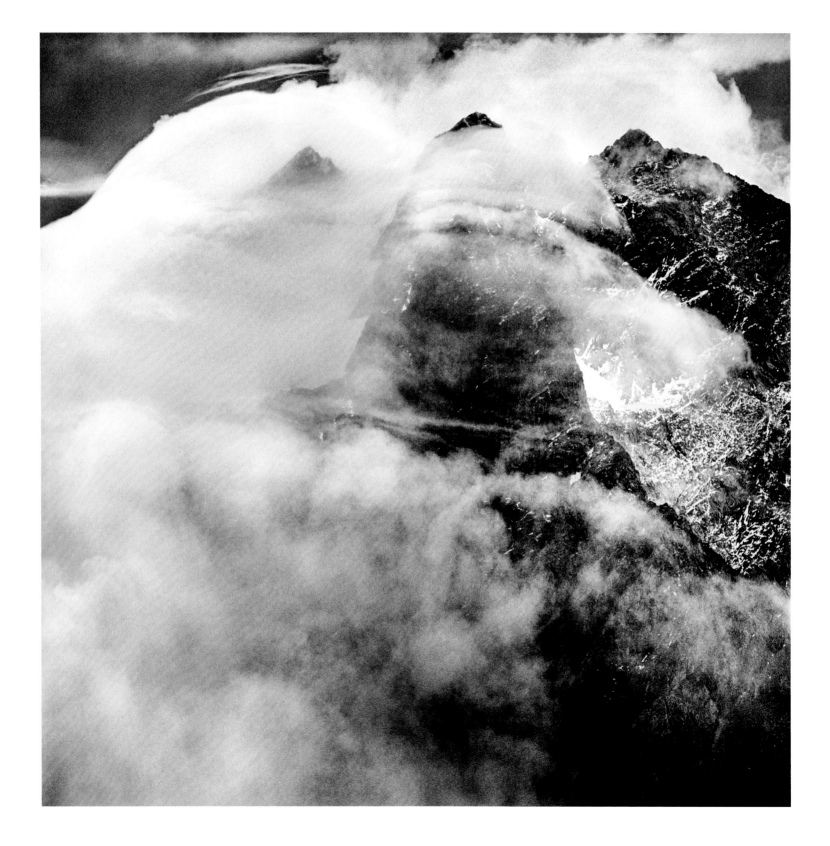

MT. STANLEY FROM NORTHWEST.
ALBERT, MARGHERITA AND ALEXANDRA PEAKS. ALEXANDRA GLACIER AND WEST STANLEY GLACIER. RWENZORI. D.R. CONGO
13/14 NOVEMBER 2015

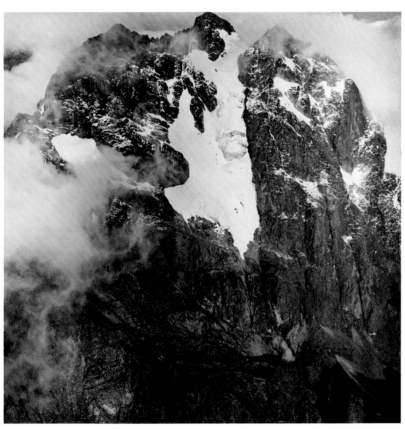
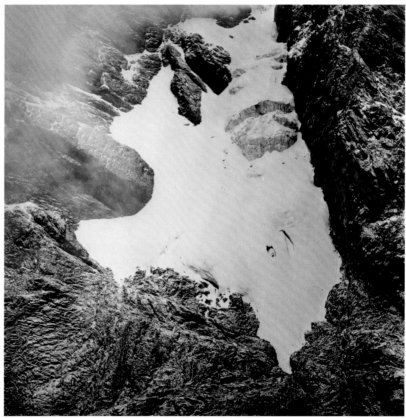

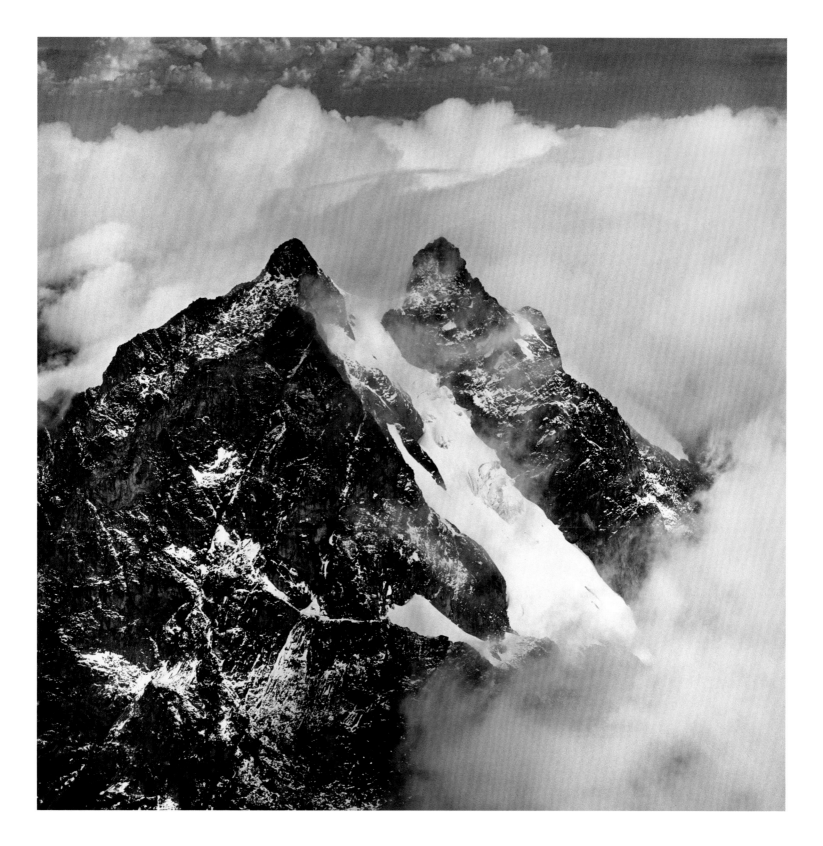

MOEBIUS GLACIER. MT. STANLEY WEST FACE. RWENZORI. D.R. CONGO
14 NOVEMBER 2015

OPPOSITE
GLACIALLY-SCOURED BASIN WITH NEW LAKE IN LIEU OF EXTINCT NORTHEAST MARGHERITA GLACIER.
MT. STANLEY. RWENZORI. UGANDA
13 NOVEMBER 2015

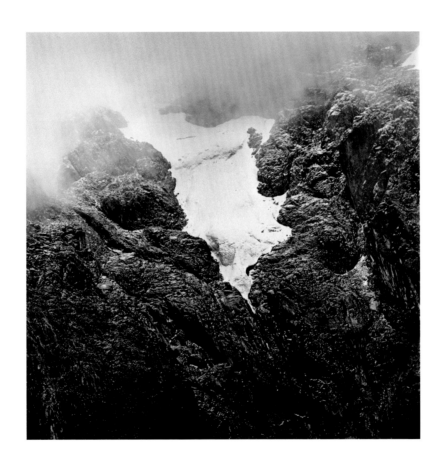

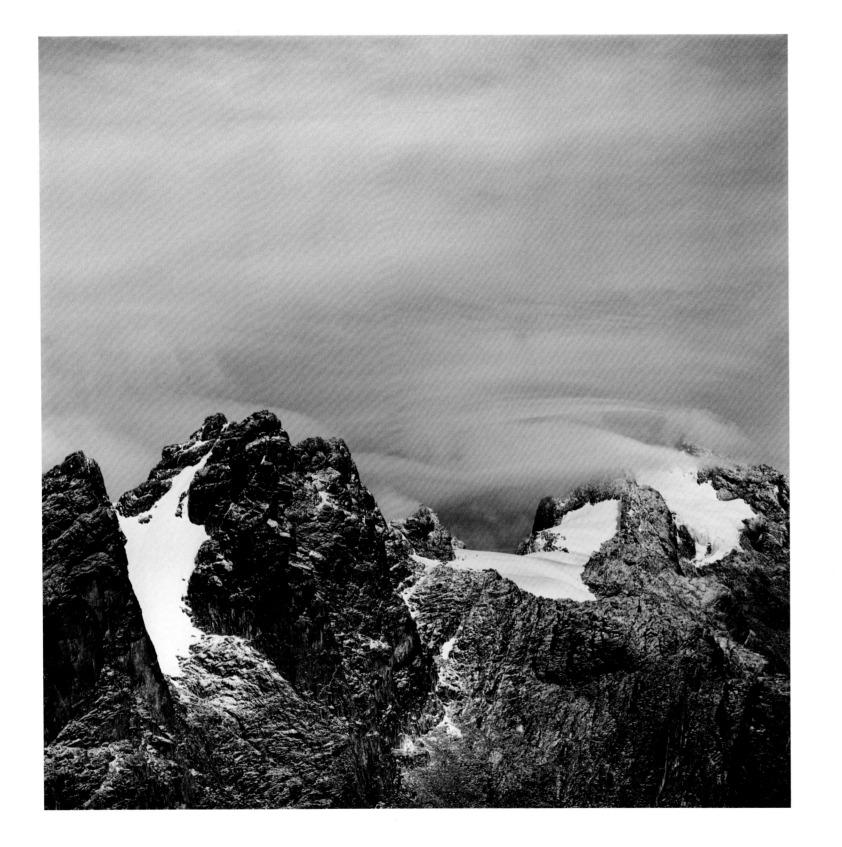
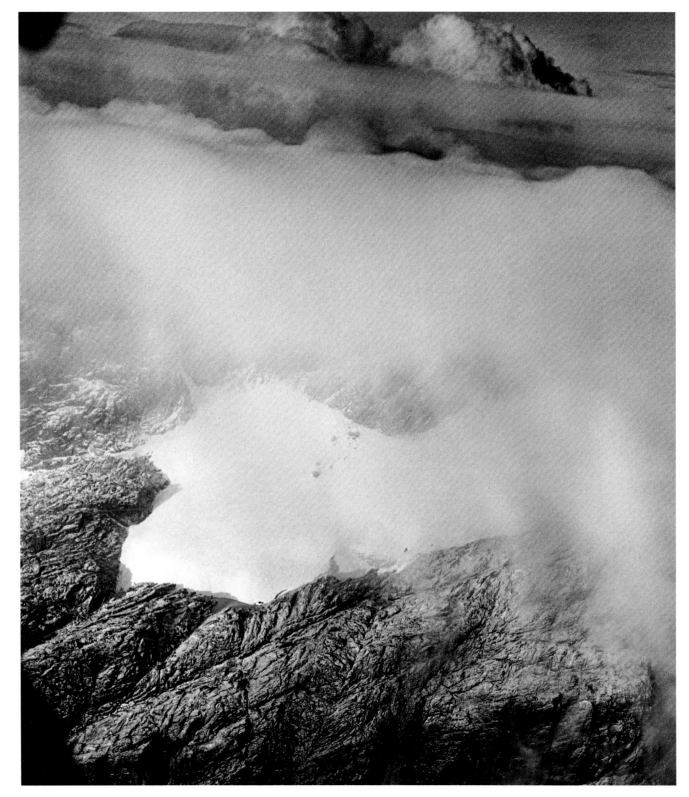

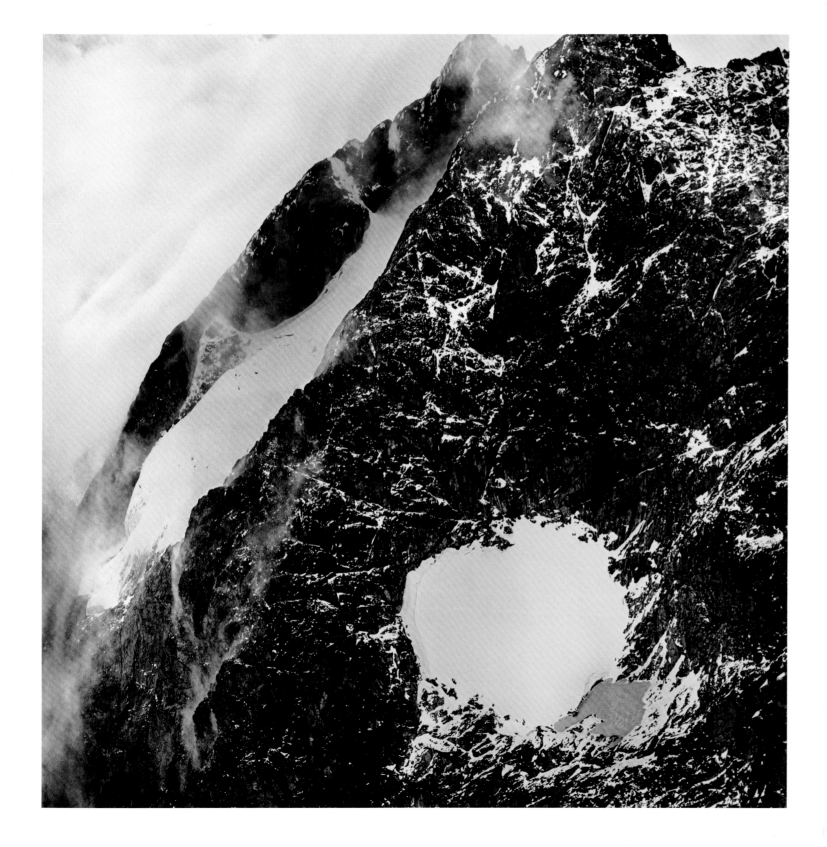

RELICS OF Y-GLACIER AND EDWARD 1 GLACIER.
MT. BAKER. RWENZORI. UGANDA
14 NOVEMBER 2015

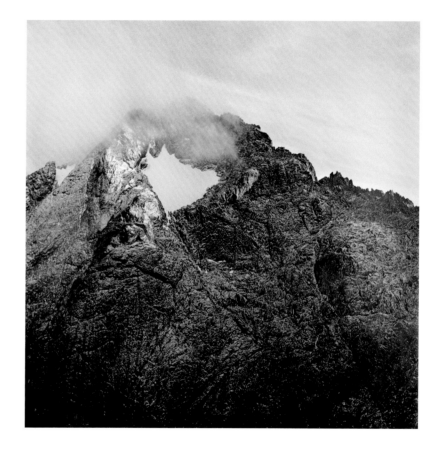

FOLLOWING PAGES
THE SOUTHERN PEAKS OF MT. STANLEY.
ELENA GLACIER, STANLEY PLATEAU AND MARGHERITA GLACIER
SEEN FROM ACROSS SEMPER PEAK OF MT. BAKER. RWENZORI. UGANDA
14 NOVEMBER 2015

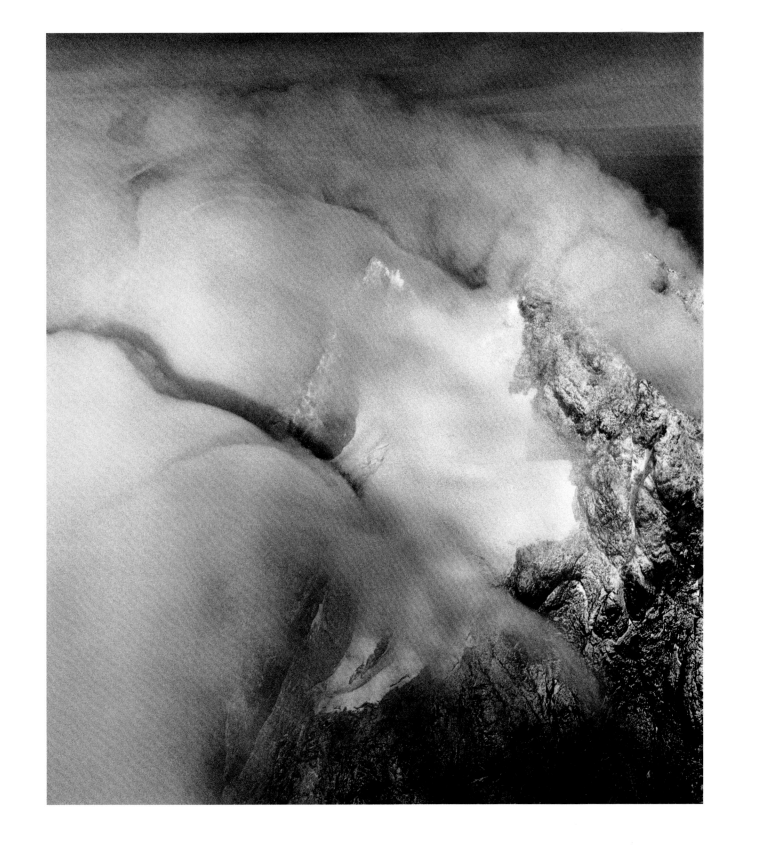
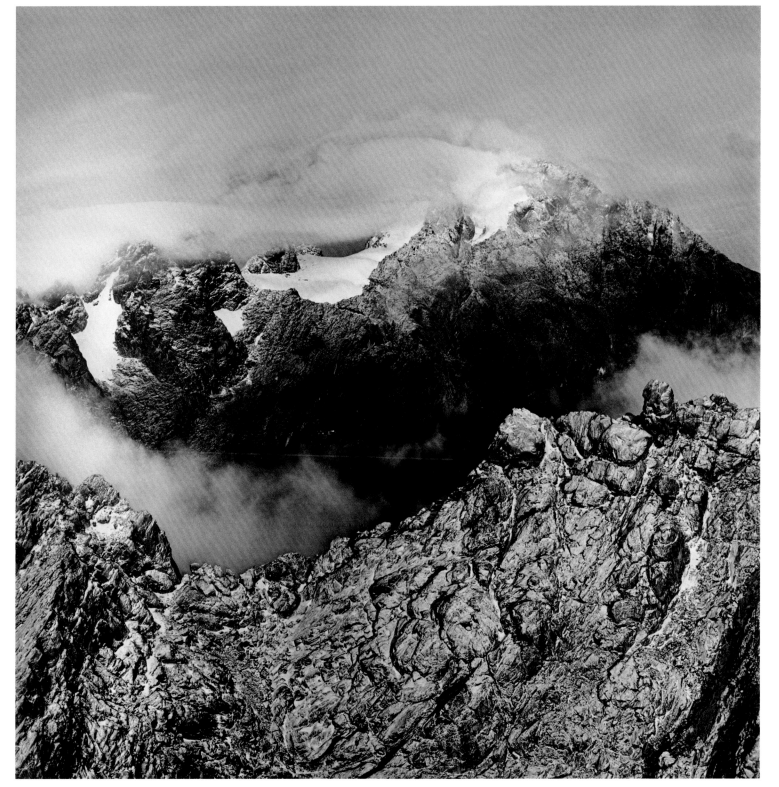

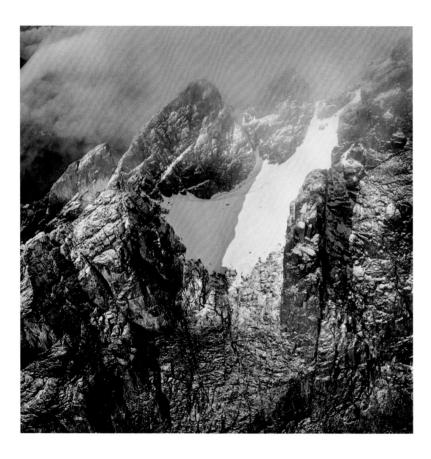

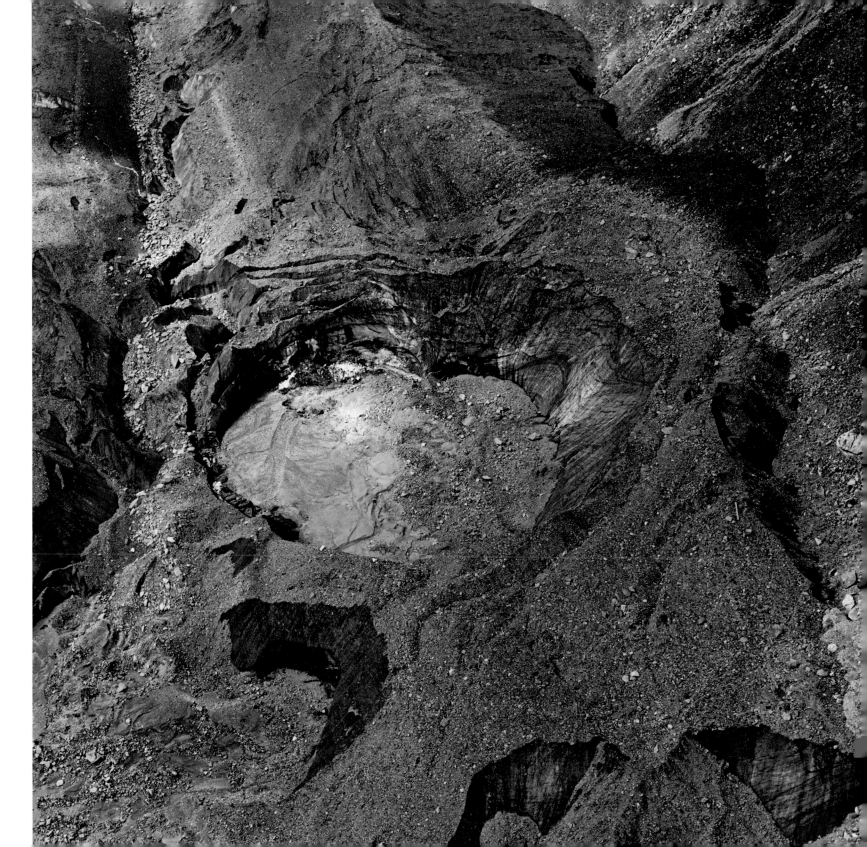

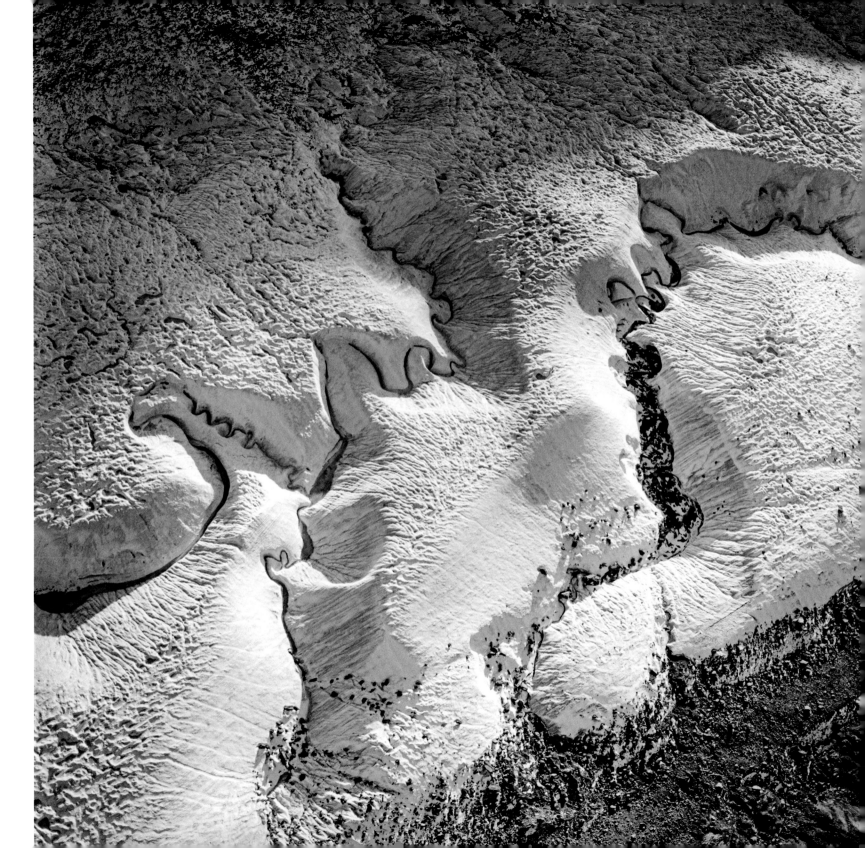

ROCKGLACIER. PERMAFROST MASS MOVEMENT WITH DISTINCT FLOW PATTERN.
CANTON GRISONS. SWITZERLAND
7 JULY 2016

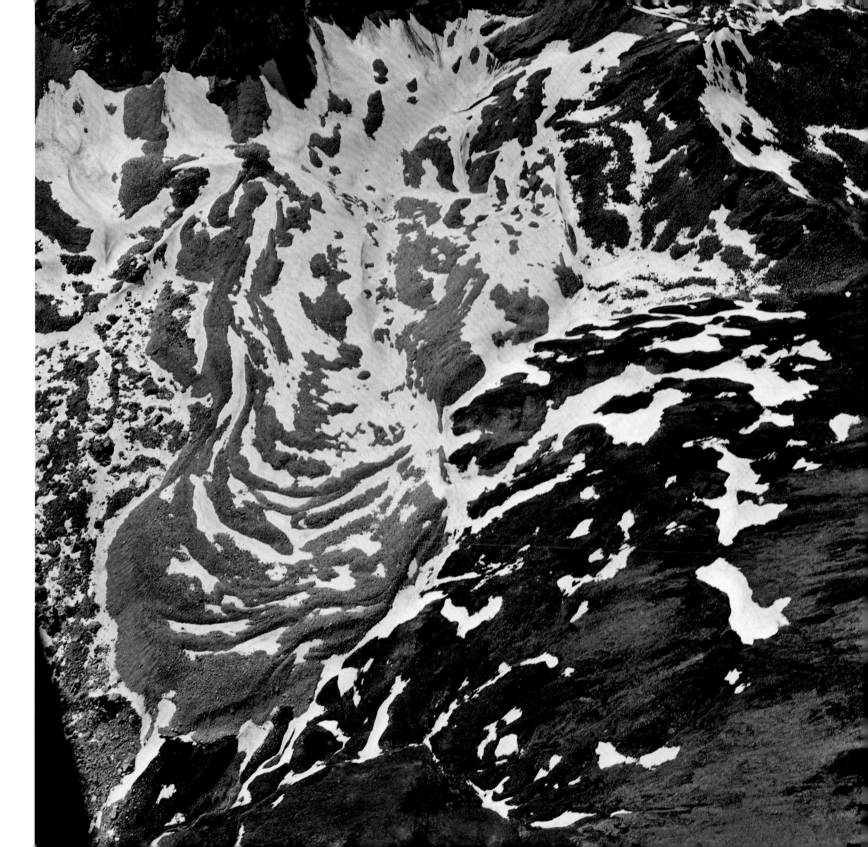

With wind speeds of up to 225 km/h, the cyclone made landfall on the islands and on the coast, bringing in its wake a tidal surge over six metres high. One hundred and forty thousand people perished. Late April, shortly before the monsoon, is the time of the annual rice harvest. But when the waters receded into the Bay of Bengal, they left behind rice fields that had been turned into a wasteland of brackish ponds, rimmed by decomposing cattle cadavers and the bodies of the drowned, their entrails bulging out of grotesquely bloated bellies. Two little boys were bound together by a rope, their hands still clutching at each other, their scalps peeling off. Pits were hastily dug in the dikes and the putrefying remains of the dead – clawed from the contaminated water with branches – were rolled into them, their limbs and rumps hideously contorted like discarded ragdolls. My steps were guided by a macabre trail of lives suddenly extinguished: chickens, infants gnawed by dogs, goats, fish snared in bushes, and everywhere amphibians, venomous snakes, and reptiles. The salty sea air was rank with rotting flesh and faeces. Diarrhoea and dehydration were already claiming still more lives; and there were rumours of cholera. I stepped aside from the path to let a group of girls pass. One pointed to the dead at my back and smiled. She was wearing a nose ring, the kind of ring I had previously seen used to identify corpses. The girls had been given rice and had twisted their saris into pouches to carry it. Where they were going with these emergency rations was not clear. Then I saw a procession of veiled figures sitting on boards suspended from bamboo poles. An old man was standing firm on a row of dried mud bricks, laying claim to what was his. Those who had believed the severe weather warnings were trickling back. In previous years, the alarm had not been followed by a calamity. People had taken themselves to safety and relinquished their homes and livestock to the fatalists.

Making my way to the coast, I encountered the first thatched roofs and warped sheets of corrugated iron long before I reached the destroyed villages themselves. A woman squatting in the forked branch of a tree stretched out her braceleted arm to me and snatched up the Taka notes I proffered. Above me were the ravaged crowns of date, betel, and coconut palm trees. Thanks to their growth structure, they had withstood the force of the cyclonic winds. The night had been as bright as day, I heard survivors say. The heat in the eye of the storm was estimated at 300°C. The leaves of the mangroves and the mango and jackfruit trees had been scorched, even incinerated. The ground was littered with uprooted evergreens and lumber, making progress difficult. When, finally, I noticed the complete absence of birds, I had already forgotten what I was looking for amid this devastation. I had simply marched on ahead, past shards of fired clay to swollen copies of the Qur'an and onward. The blind sky was oppressive. There was one newspaper image – a corpse hanging in the snapped branches of a tamarind tree – that I could not get out of my head. Hours later, back on the road to Cox's Bazaar, I threw up.

I had travelled to the delta in Bangladesh in 1991 with the aim of getting to know the people named in the Intergovernmental Panel on Climate Change's First Assessment Report – published a year previously – whose coastal habitat would be destroyed by the rising sea levels expected as a result of the melting of the polar ice caps caused by global warming. Now I saw how their everyday lives continued even as the disasters themselves were still in progress. Their experience of having to adjust to the problem of erosion – which robs millions of people of both land and livelihood every year – was proving to be of great service to them

in the aftermath of this latest 'act of God'. The topography of the coast had changed dramatically, though not through the creation of monstrous toxic landfills. The images of Hurricane Katrina in the US in 2005 reminded me just how few possessions the fishermen and farmers had, and how everything that might possibly be reused was salvaged – down to the single grains of rice painstakingly prised out of the caked mud. In Louisiana there had been 5 million tons of waste to dispose of: 2,800 tons for every one of the 1800 victims. Measured in monetary terms, that disaster was the most costly tropical storm in history. And because civil society allegedly degenerated into chaos and anarchy in record time the US government had to deploy troops. Since 1991 Bangladesh has improved its cyclone warning system and no longer interprets its geographical vulnerability as the 'will of Allah'. The predicted flow of climate refugees – now topping one million a year – has become a reality, however, inducing neighbouring India to erect a wall to keep out the flood.

The climate, meanwhile, has taught us that it is not a condition, but a dynamic process. Even tropical storms are veering off their customary paths. One extreme weather event chases the one before, producing a cascade of calamities all round the globe. Rising temperatures, moreover, increase the probability of their occurrence several times over. When I began taking photographs in the deltas of the Ganges, Irrawaddy, and Mekong rivers, anthropogenic climate change was no more than an academic hypothesis based on estimates. Today, we know from evidence obtained from ice cores that it is a reality. Warmer seas and warmer air are destabilizing the ice shelf in Western Antarctica. Satellite images of its accelerating fragmentation provide us with a premonition of the collapse of a chunk of ice some thousand square kilometres in size that may be no more than a harbinger of a greater disaster to come. It is another epic scenario, for what is at stake now is no longer just the mangroves of the Sunderbans, where I met otter fishermen and honey collectors, but the future of Shanghai and New York.

In the mountains, meanwhile, far removed from the sinking megacities compacting the earth beneath them along the seashore, the agony of the glaciers is both visible and palpable. That it is in the nature of glaciers to advance and retreat was evident to me from the moraines that I climbed in my youth. That a glacier can lose its gate faster than a child learns to talk, however, felt like a personal loss. To me, it was as if the collapse of the stagnating ice of the glacier, whose reaction to climate change is delayed, had collapsed the time frozen within it all over again – not just my own lifetime since those days in Bangladesh a quarter of a century ago, but also the timespan punctuated by conferences, treaties, and protocols, during which greenhouse gas emissions have actually risen by 40 per cent and politicians have proved themselves incapable of taking concerted preventative action, while a million fires burn.

40 Henri Hogard (1808–1880), *Glacier du Rhône, Partie inférieure. 26 août 1848.* Watercolour, 24.2 x 75.3 cm. Cabinet des Estampes et des Dessins, Strasbourg. Photo: Musées de Strasbourg, M. Bertola

43 Charles Lyell, *Elements of Geology or the Ancient Changes of the Earth and its Inhabitants as Illustrated by Geological Monuments* (6th edition), John Murray, London, 1865, p. 140

44 Amt für Umwelt Kanton Solothurn, Abt. Boden, Geoarchiv, Solothurn. Archiv-Nr.: GEA-201:001. *Topographischer Atlas der Schweiz* (Siegfriedkarte) 1:10,000. Sheet 112 Weissenstein. Reproduced by permission of swisstopo (BA17006)

50, 52, 56, 60, 64, 68 Heinz Leuzinger (born 1931), *Switzerland during the Last Ice Age*, Plate 6, *Atlas of Switzerland*, 1969/1970. Original scale 1:550,000. Shaded relief drawing. Hill shading in pencil and washed ink, 50 x 70 cm, on laminated aluminium, 60 x 80 cm. © 1970 Editorial office of the *Atlas of Switzerland*, ETH Zurich. Reproduced and supplemented on pages 52, 56, 60, 64 and 68 with artwork conceived by the author with permission of the Institute of Cartography and Geoinformation, ETH Zurich, 2012/2016. The relief drawing was used for the map *Switzerland during the Last Ice Age* (1:550,000) by Heinrich Jäckli (1970). A revised and updated version entitled *Switzerland during the Last Glacial Maximum* was published in 2009 by the Federal Office of Topography swisstopo (Schlüchter, C. [Kompil.], *Die Schweiz während des letzteiszeitlichen Maximums (LGM)*, 1:500,000. GeoKarten500, Bundesamt für Landestopografie swisstopo, Wabern 2009). This new map depicts observed regional and paleoglaciological differences. New reconstructions are the valley glaciers in the Southern foreland, a local glaciation in the Napf area, the ice cap on the high parts of the Jura mountains as well as the accumulation areas of the ice domes Engiadina, Vorderrhein and Rhone and the Zermatt glacier plateau. Just as in the case of the precursor map, because of dating uncertainties, it is not possible to ascertain that all glacier margins depicted are exactly of the same age.

61 Postscript after: Akçar, N., Tikhomirov, D., Ivy-Ochs, S., Nowak, B., Meichtry, N., Mettler, K., Reber, R., Claude, A., Litty, C., Vockenhuber, C., Christl, M. Schlunegger, F., Schlüchter, C., *The last Deglaciation of the Northern Alpine Foreland: New Insights from depth-profile dating with cosmogenic 36Cl*, Institute of Geological Sciences, University Bern (in preparation)

70 Hans Schwartz (1920–2013). Photographic negative, 24 x 36 mm. Author's archive

72 © 2017 *Swiss World Atlas*. Reproduced with permission of the Institute of Cartography and Geoinformation, ETH Zurich, 2017.

84 (top to bottom) Adolphe Braun (1812–77), *Mattmarksee.* Photographic print, 22 x 46 cm on mount 32 X 54 cm. ETH-Bibliothek Zürich, Bildarchiv
Unknown photographer, *Allalingletscher. 10.10.1910.* Glass slide, 9 x 12 cm. ETH-Bibliothek Zürich, Bildarchiv
Unknown photographer, *M[Mattmark] 1934, Station 4, Bro[...?].* Negative, 10 x 15 cm. ETH-Bibliothek Zürich, Bildarchiv
Unknown photographer, *Mattmark 1946, Station 6, Instrument Wild*

No. 105. Negative, 10 x 15 cm. ETH-Bibliothek Zürich, Bildarchiv

85 (top to bottom) Unknown photographer, *Zunge des Allalingletschers, 3.9.1947, 10h.* Gelatin-silver contact print, 5.5 x 6 cm. ETH-Bibliothek Zürich, Bildarchiv
Unknown photographer, *Mattmark. 19.9.1964.* Negative, 23 x 23 cm. ETH-Bibliothek Zürich, Bildarchiv / Stiftung Luftbild Schweiz
Peter Kasser (1914–96). Photographic print (size unknown). Archiv VAW / ETH Zürich
Unknown photographer, Keystone/Photopress-Archiv, Zürich. Negative, 6 x 6 cm

89 Aimé Civiale (1821–93): *Bloc Erratique de serpentine au lac Mattmark.* Albumen-silver print, 26.8 x 35.3 cm, on mount. BnF, Département des Cartes et Plans, Société de géographie, Paris

94 Charles Lyell, *Elements of Geology or the Ancient Changes of the Earth and its Inhabitants as Illustrated by Geological Monuments* (6th edition), John Murray, London, 1865, pp. 138–39

98 Paul-Louis Mercanton (1876–1963), *Plan No. 4. Die Gletscherzunge – Les fronts du glacier, 1874–1913.* Scale 1:5,000. From *Vermessungen am Rhonegletscher 1874–1915. Neue Denkschriften der Schweizerischen Naturforschenden Gesellschaft (SNG)*, Bd. LII. Basel/Geneva/Lyon, 1916. Colour-separated lithographic print. 90 x 70 cm. Scan: Institute of Cartography and Geoinformation, ETH Zurich

99 Samuel Wiesmann, *Rhone Glacier Disappearance 2000–2100.* Rendered perspective views using simulated orthophotos and digital elevation models of future glacier surface, bed and forefield lakes, 2012. Data: VAW ETH Zurich. Visualization: Samuel Wiesmann, Institute of Cartography and Geoinformation, ETH Zurich, 2012

100 Johann Melchior Füssli (1677–1736), *Rhodans Scaturigines ex Montibus Glacialibus (Die aus den Eisgebirgen sprudelnden Quellen der Rhone)*, 1707. From *Beschreibung der Natur-Geschichten des Schweizerlands von Johann Jacob Scheuchzer*, 3. Teil, Nr. 25, 22 June 1707, facing p. 100. Copperplate engraving, 20 x 13 cm. Zentralbibliothek Zürich, Graphische Sammlung und Fotoarchiv. Zurich. (Signatur: VS Rhonegletscher I, 1)

102 Paul-Louis Mercanton (1876–1963), *Plan No. 7. Die gelbe Steinreihe – La châine jaune, 1874–1892.* Scale 1:2,000. From *Vermessungen am Rhonegletscher 1874–1915. Neue Denkschriften der Schweizerischen Naturforschenden Gesellschaft (SNG)*, Bd. LII. Basel/Geneva/Lyon, 1916. Colour-separated lithographic print. 55 x 104 cm. Scan: Institute of Cartography and Geoinformation, ETH Zurich

109 'Anno Christi 1546, quarta Augusti, quando trajeci cum equo Furcam montem, veni ad immensem molem glaciei cujus densitas, quantum conjicere potui, fuit duum aut trium phalangarum militarum; latitudo vero continebat jactum fortis arcus, longitude sursum tendebatur, ut illius recessus et finis deprehendi nequiret, offerebat intuentibus horrendum spactaculum. Dissilierat portio una et altera a corpore totius molis magnitudine domus, quod horrorem magis augebat. Procedebat et aqua canens quae secum multas glaciei particulas rapiebat, ut sine

periculo equus illam transvadere non posset. Atque hunc fluvium putant initium esse Rhodani fluvii.'
First edition 1544. Twenty-seven amended and expanded editions were published in various languages 1545–1650. Quoted here is the first Latin edition, 1552. English translation from Emmanuel Le Roy Ladurie, *Times of Feast, Times of Famine. A History of Climate Since the Year 1000*, George Allen & Unwin Ltd, 1972

110 (top to bottom) Gustave Dardel (1824–99), *Glacier du Rhône. Août 1849.* Reproduction by Maison Braun, Clément et Cie of the lost daguerreotype. Albumen-silver print, 15.3 x 20.7 cm, on mount, 27 x 35.9 cm. From *Collection de 28 daguerréotypes représentant les plus anciennes reproductions héliographiques des Alpes, reproduits en photographie et accompagnés d'extraits tirés des Matériaux pour l'Etude des Glaciers* (facing p. 26), Gustave Dollfus, 1893. ETH-Bibliothek Zürich, Bildarchiv. Zurich
Emil A. F. Nicola (1840–98), *Rhonegletscher. Der Eissturz, bei Abendbeleuchtung, vom Längishorn aufgenommen. Sommer 1874.* Albumen-silver print, 29 x 37 cm, on mount, 44 x 51.5 cm. ETH-Bibliothek Zürich, Bildarchiv. Zurich.
Leonz Held (1844–1925), *Zunge des Rhonegletschers vom Fels ob Belvédère aus. 24. August 1888.* Albumen-silver print, 17 x 22 cm, on mount, 22 x 29 cm. ETH-Bibliothek Zürich, Bildarchiv. Zurich

132 Francis Frith (1822–98), *Aletschgletscher (Wallis) von der Belalp aus gesehen*, c. 1880. Albumen-silver print, 16 x 26 cm, on mount, 25.5 x 34 cm. ETH-Bibliothek Zürich, Bildarchiv. Zurich

139 Anonymous photographer. Courtesy: Walliser Bote, Brig

140 Textwork IN THE ICE after Guillaume Jouvet, Department of Mathematics and Computer Science, Freie Universität Berlin, and Martin Funk, Laboratory of Hydraulics, Hydrology and Glaciology, ETH Zurich, *Modelling the trajectory of the corpses of mountaineers who disappeared in 1926 on Aletschgletscher, Switzerland* in *Journal of Glaciology*, Vol. 60, No. 220, 2014, pp. 255–61

141 Space-time trajectory by Guillaume Jouvet, Department of Mathematics and Computer Science, Freie Universität Berlin, and Martin Funk, Laboratory of Hydraulics, Hydrology and Glaciology, ETH Zurich, *Modelling the trajectory of the corpses of mountaineers who disappeared in 1926 on Aletschgletscher, Switzerland* in *Journal of Glaciology*, Vol. 60, No. 220, 2014, pp. 255–61. Map reproduced by permission of swisstopo (BA17006)

144 Compiled from 'The Place of Glaciers in Natural and Cultural Landscapes', in Ben Orlove, Ellen Wiegandt, and Brian H. Luckman (eds), *Darkening Peaks. Glacier Retreat, Science, and Society*, University of California Press, Berkeley/Los Angeles/London 2008
Source: World Glacier Monitoring Service wgms. http://wgms.ch accessed on 15 September 2016

148 Franz Josef Hugi (1791–1855), *Der Unteraargletscher mit seinen Verzweigungen*, plan from Franz Josef Hugi, *Naturhistorische Alpenreise*, Amiet-Lutiger, Solothurn & Friedrich Fleischer, Leipzig, 1830. Coloured etching, 20.5 x 28 cm. Courtesy Zentralbibliothek Solothurn. Signatur: L 244

150 Charles Lyell, *Elements of Geology or the Ancient Changes of the Earth and its Inhabitants as Illustrated by Geological Monuments* (6th edition), John Murray, London, 1865, p. 138
(left) Camille Bernabé (1808–?), *Glacier inférieur de l'aar. Confluent du glacier du Finsteraar et du Lauteraar, blocs Hugi et Hôtel des Neuchâtelois. 20 août 1850*. Reproduction by Maison Braun, Clément et Cie of the lost daguerrotype. Albumen-silver print, 15.3 x 20.7 cm, on mount, 27 x 35.9 cm. From *Collection de 28 daguerréotypes représentant les plus anciennes reproductions héliographiques des Alpes, reproduits en photographie et accompagnés d'extraits tirés des Matériaux pour l'Etude des Glaciers* (facing p. 18), Gustave Dollfus, 1893. ETH-Bibliothek Zürich, Bildarchiv. Zurich
(right) Caspar Wolf (1735–83), *Der Lauteraargletscher mit Blick auf den Lauteraarsattel*, 1776. Oil on canvas, 54.8 x 82.6 cm. Kunstmuseum Basel. Photo: Kunstmuseum Basel, Martin P. Bühler

153 VAW/ETH Zürich: Lower Aar glacier, with co-registered* outline of the state of 5 August 2015.
* transposed and orthorectified between different coordinate systems
Johannes Wild (1814–94), *Carte du Glacier inférieur de l'Aar, levée en 1842, d'après les directions de M. Agassiz par Jean Wild, Ingénieur*. Original scale 1:10,000. Lithograph, 36 x 98 cm. Plate II of the Atlas from Louis Agassiz, *Nouvelles études et expériences sur les glaciers actuels: leur structure, leur progression et leur action physique sur le sol*, Victor Masson, Paris, 1847. Zentralbibliothek Zürich, Kartensammlung. Zurich. Signatur: 5 Jd 15: 1
GLAMOS, Glacier Monitoring in Switzerland (2015): Unteraargletscher. State of 5 August 2015. Digital data: www.glamos.ch, VAW, ETH Zürich, Zurich

157 Age dating by dendrochronology: Kurt Nicolussi, Institute of Geography, University of Innsbruck. Collection Christian Schlüchter, Münchenbuchsee

172 Werner Friedli (1910–96), *Inkwilersee*, 27 September 1949. Glass negative, 13 x 18 cm. ETH-Bibliothek Zürich, Bildarchiv / Stiftung Luftbild Schweiz

180 Author's photograph of Ms.101.fol.347V-348R. Reproduced with permission by ZHB Luzern (Eigentum der Korporation Luzern), Lucerne. Transcription from Renward Cysat (1545–1614), *Collectanea chronica und denkwürdige Sachen pro chronica Lucernensi et Helvetiae. Erster Band. Collectanea zur Geschichte der Stadt Luzern. Zweiter Teil*, edited by Dr. phil. Josef Schmid. Diebold Schilling Verlag, Luzern, 1969

188 Hans Schwartz (1920–2013): *Feegletscher*. 1955. Still from an N8 Film. Author's archive

189 The author's father Hans Schwartz (1920–2013) on his deathbed looking at his last digital images, taken at the author's exhibition *Ice Age our Age. Ballads and Inquiries Concerning the Last Glacial Maximum*, Kunsthaus Langenthal, Switzerland (29 November 2012–27 January 2013). On the camera display are two of his own images of the Feegletscher included in the exhibition. Left: the 1955 N8 film still (reproduced on p. 188); right: a 2006 digital image depicting a fleece blanket placed in the hope of slowing down glacial melting of a neuraligic spot and to secure skiing.

192 Text (page 192) based on:
Centerra Gold Inc.: Technical Report on the Kumtor Mine, Kyrgyz Republic, NI 43-101 Report, March 20, 2015
http://www.centerragold.com/sites/default/files/centerra_kumtor_technical_report_final_march_20_2015.pdf accessed on 22 September 2016
William Colgan, 'Artificial Glacier Surges at Kumtor Mine, 27 July 2015.'
http://williamcolgan.net/blog/?m=201507 accessed on 22 September 2016
Stewart S. R. Jamieson, Marek W. Ewertowski, David J. A. Evans, 'Rapid advance of two mountain glaciers in response to mine-related debris-loading', *Journal of Geophysical Research: Earth Surface*, Vol. 120, issue 7, July 2015, pp. 1418–1435
http://onlinelibrary.wiley.com/doi/10.1002/2015JF003504/full accessed on 22 September 2016

194 NASA Astronaut Photography of Earth: NASA Photo ID: ISS011-E-9620. Image courtesy of the Earth Science and Remote Sensing Unit, NASA Johnson Space Center. http://eol.jsc.nasa.gov
North of the Meren Valley the plateau glaciers of the west (small white patch) and east (large white patch) Northwall Firns are visible. Opposite, to the south (bottom of the image) and less clearly visible, are two valley glaciers: the Southwall Hanging glacier (disappeared by 2009) and Carstensz glacier at the eastern end of the Yellow valley. Increasingly higher rates of ice mass recession have been observed since 2005 (date of the image). Changes in mass balance and areal extent is more likely representative of current, and not cumulative trends because the small size of tropical glaciers is reducing response time to climate change.

195 Textwork based on: Lonnie G. Thompson, Byrd Polar Research Center and School of Earth Sciences, The Ohio State University; Ellen Mosley-Thompson, Byrd Polar Research Center and Department of Geography, The Ohio State University; Mary E. Davis and Henry H. Brecher, Byrd Polar Research Center, The Ohio State University: *Tropical glaciers, recorders and indicators of climate change, are disappearing globally* in Annals of Glaciology 52(59) 2011, pp. 23–34.

Chronology of disappearance of the Puncak Jaya massif glaciers
Five ice masses mapped in 1972: (1) Carstensz Glacier system including Harrer, Wollaston and Van de Water glaciers, (2) Southwall Hanging glacier, (3) West and (4) East Northwall Firns and (5) Meren glacier.
Total ice area by 1942 9.9 km², by 1972 7.3 km² and by 2005 1.72 km².
(1) Carstensz glacier system: between 1850 and 1972 Carstensz glacier had retreated by more than 2 km. By 2000 it had been reduced to half its 1972 size of 0.9 km² and six smaller ice masses had separated from the main body of which three remained in 2002. The Wollaston glacier had nearly disappeared by 1994 and by 2000 it appeared to have vanished. Measuring 0.15 km² in 1936 the Van de Water glacier had disappeared by 2002, the Harrer (or the east Meren) glacier during the course of the century.
(2) Southwall Hanging glacier: identified as small ice mass in 2002. By 2009 it had disappeared.
(3) / (4) Northwall Firn: in 1936 the plateau glacier was reported as contiguous. Its eastern portion providing ice-flow to both the western Meren glacier (thus being part of the Northwall Firn) and an eastward-flowing lobe of the Meren glacier, the east Meren or Harrer glacier. Between 1942 and 1962 the Northwall Firn split into two ice masses. Further separation occurred since before 1981. In 1982/1983 further disintegration into four independent ice masses was observed by

landsat mapping and aerial photography. By 1987 the east Northwall Firn separated from the Meren glacier. Four ice masses within the west Northwall Firn area and one large east Northwall Firn mass were identified by an IKONOS image in 2000. By 2002 two portions to the northeast and to the southwest separated from the east Northwall Firn.
(5) Meren glacier: having had an area of 1.9 km² in 1972 it had separated from the accumulation area (the Northwall Firn) by 1994 and by 2000 the dead ice had disappeared.
Chronology based on: (1) Joni L. Kincaid and Andrew G. Klein, Department of Geography, Texas A&M University: *Retreat of the Irian Jaya Glaciers from 2000 to 2002 as Measured from IKONOS Satellite Images*. 61st Eastern Snow Conference, Portland, Maine, USA 2004. (2) Andrew J. Marshall and Bruce McP. Beehler: *Ecology of Indonesian Papua. Part Two*. Tuttle Publishing, 2007. (3) Ian Allison, Australian Antarctic Division, Kingston, and James A. Peterson, Department of Geography, Monash University, Clayton: *Glaciers of Irian Jaya, Indonesia. Satellite Image Atlas of Glaciers of the World*. http://pubs.usgs.gov/pp/p1386h/indonesia/indonesia.html (accessed 17 September 2016). (4) Vijay P. Singh, Pratap Singh, Umesh K. Haritashya: *Encyclopedia of Snow, Ice and Glaciers*. Springer Science & Business Media, 2011. (5) http://earthobservatory.nasa.gov/IOTD/view.php?id=79084 (accessed 24 September 2016).

210 Textwork based on: *La Géographie d'Edrisi (Terminé en 1154/548 H.). Traduite de l'Arabe d'après deux manuscrits de la Bibliothèque Nationale, par Pierre-Amédée Jaubert. Réimpression de l'édition Paris 1836–1840*, Philo Press, Amsterdam, 1975
Filippo de Filippi, *Ruwenzori: An Account of the Expedition of H.R.H. Prince Luigi Amedeo of Savoy, Duke of the Abruzzi*, E.P. Dutton and Company, New York 1908
Ludwig Amadeus von Savoyen, Herzog der Abruzzen (F. de Filippi, ed.), *Der Ruwenzori. Erforschung und erste Ersteigung seiner höchsten Gipfel*, F.A. Brockhaus, Leipzig 1909
H.A. Osmaston and D. Pasteur, *Guide to the Ruwenzori. The Mountains of the Moon*, West Col Publications, 1972
J. Lennart Berggren and Alexander Jones, *Ptolemy's Geography. An annotated translation of the theoretical chapters*, Princeton University Press, Princeton and Oxford, 2000
Hyunhee Park, *Mapping the Chinese and Islamic Worlds. Cross-Cultural Exchange in Pre-modern Asia*, Cambridge University Press, Cambridge 2012
http://penelope.uchicago.edu/Thayer/E/Gazetteer/Periods/Roman/_Texts/Ptolemy/4/8*.html accessed on 23 September 2016
https://thenilearchive.wordpress.com/2015/10/14/nile-maps-4-al-idrisi-and-the-mountains-of-the-moon/ accessed on 23 September 2016

ACKNOWLEDGMENTS

The present work was realized between 2009 and 2016.

The concluding exhibition *Eine Gletscher-Odyssee* will be organized by the Bündner Kunstmuseum/Grisons Museum of Fine Arts, Chur, Switzerland, 20 January–8 April 2018. It was conceived by the artist with Stephan Kunz, Director and Curator of exhibitions.

As a work in progress the project has been exhibited in a series of venues: *Ice Age Our Age. Ballads and Enquiries Concerning the Last Glacial Maximum* (Kunsthaus Langenthal, Switzerland, 29 November 2012–27 January 2013); *theatrum Alpinum* (Kunstraum Medici, Solothurn, Switzerland, 7 June–22 August 2015); and *De glacierum natura* (USM Showrooms in Hamburg, Düsseldorf, Berlin, Munich, Paris and New York from September 2016 to May 2017, and Tokyo in 2018

I owe a debt of gratitude to Miriam Maina for much that I would have never thought possible.

Profound thanks are to be extended to many. Particularly to Brigitte Plüss Medici and Roberto Medici, Judith Stuber Schärer, Alexander Schärer and Marco Strahm, and to Carl Stadelhofer for their action and commitment throughout the endeavour, as well as to Fanni Fetzer who acted as an early curatorial advocate when the project gained momentum, and Lara Studer, who self-confidently, and to his delight, edited my late father's historic amateur movies. It was he who took me to the Alps in the first place and introduced me to the phenomenon of nature.

I would like to thank for their assistance, enthusiasm and skills – in Afghanistan Shireen Agha Rahmat; in Germany Marcus Bensmann, Tobia Bezzola, Wolfgang Hörner, Bernd M. Scherer, Frank Vorpahl; in Pakistan Shukur Ulla Baigh, Kamal Hyder (Al Jazeera), Rehmat Nabi, Mahfuz Raes (World Travel and Tours Gilgit); in Peru Koky Castaneda, Felix Benjamin Vicencio Maguina (Vicencio Expeditiones EIRL); in Switzerland Max Aeschlimann, Hampi Amacker, Nanni Baltzer, André Bellmont, Lorenz Boegli, Monica Burger Häfeli, Gabriela Bussmann, Moni Faist, Christoph Flückiger, Alain Gantenbein, Andrea Hadem, Ursula Heidelberger, Jonas Jäggy, Vadim Jendreyko, Beat Jung, Lis Mijnssen, Marcel Morf, Regula Müdespacher, Sylvie Müller, Christian Pflugshaupt, Thomas Rieder, Bronwen Saunders, Roswitha Schild, Markus Schürpf, Eve Schütz, Malgorzata Stankiewicz, Nicola Steiner, Peter Tremp, Mark Welzel, Sabine Wagner, the pilots of Air Zermatt AG, Raron, and of Heli Bernina AG, Samaden; in Uganda Sascha Hemmerich and Klaus Schramm (KEA Kampala Executive Aviation), Aubrey W.T. Price (Ndali Lodge), John Hunwick, Samuel Ociti and Kule Uziah (Rwenzori Trekking Services) as well as to all who worked on this book.

From its inception the project greatly benefited from the participation of a group of academics. Our shared ambition was a synthesis of scientific observation and artistic approach which helps to understand environmental processes. For their expert advice and their guidance outdoors as well as in the garden of science I would like to thank the following individuals and organizations: Amt für Umwelt, Kanton Solothurn, Solothurn: Yvonne Kaufmann (Abteilung Boden, Geoarchiv). ETH, Swiss Federal Institute of Technology, Zürich: Atsumu Ohmura (Institute for Atmospheric and Climate Science); Lorenz Hurni and

Samuel Wiesmann (Institute for Cartography and Geoinformation); Andreas Bauder, Martin Funk and Guillaume Jouvet (Laboratory of Hydraulics, Hydrology and Glaciology). INAIGEM, El Instituto Nacional de Investigacion en Glaciares y Ecosistemas de Montana, Huaraz: Benjamin Morales Arnao and Cesar Portocarrero. Lötschentaler Museum, Kippel: Rita Kalbermatten. The Ohio State University, Columbus OH: Lonnie Thompson (Byrd Polar and Climate Research Center). University of Bern, Bern: Naki Akçar, Flavio Anselmetti and Christian Schlüchter (Institute of Geological Sciences); Stefan Brönnimann and Peter Stucki (Institute of Geography).

I wish to offer special thanks to the Institute for Cartography and Geoinformation (ETH, Swiss Federal Institute of Technology), Zürich; Landis & Gyr Stiftung, Zug; Kantonales Kuratorium für Kulturförderung Solothurn, Feldbrunnen-St. Niklaus; UBS Kulturstiftung, Zürich; Calle Services Management Ltd, Zürich; Renova Management AG, Zürich for decisive subsidy in 2012 and 2015.

The artist and publisher gratefully acknowledge the generous assistance of the Fondation USM. www.fondationusm.org towards the production of the present volume.

In 2016 and 2017 the final stages of the project were the subject of a film. A portrait of the artist, it places the work in the context of his endeavours spanning more than three decades. More about the film can be found on the website www.whilethefiresburn.com